Franklin Cox's *Marist Football: Inside the War Eagle Tradition* is a unique and interesting insight into the world of high school football. Having been a graduate of Marist and a former member of the Long Blue Line, the author and former letterman brings together all the characters, qualities, relationships, goals and challenges of Marist Football. From the dog days of August practices to the elation of fourth-quarter victories, as well as the bitter disappointment of playoff defeats, Franklin gives each reader an Eagle's-eye view into the heart of the tradition-rich program that is Marist War Eagle Football.

—Alan Chadwick, Head Coach, Marist War Eagles

Marist Football: Inside the War Eagle Tradition by author Franklin Cox is a classic. Cox, a profound writer, will stir the excitement and high interest of every reader. He takes a true story and lives it literally day by day. As I read through the book, I could not put it aside because I could not wait to get into the next part or chapter. Just as Marine Lieutenant Cox did in his book *Lullabies for Lieutenants*, about his service in Vietnam, where he actually faced the adversity of war, he has captured the highly successful Marist High School program and how it became a champion of champions. Cox puts the reader in practice after practice, team and coaches' meetings, the game and preparation for battle each and every moment. He brings to life the traditions of a champion and how its leader, a detailed and caring head coach, demonstrates superb and positive leadership. The story comes to full life. This is an extraordinary manuscript.

—Homer Rice, Former Cincinnati Bengals Head Coach and Director of Athletics at Georgia Tech

MARIST FOOTBALL

MARIST FOOTBALL

INSIDE THE WAR EAGLE TRADITION

FRANKLIN COX

Charleston | London

THE
History
PRESS

Published by The History Press
Charleston, SC 29403
www.historypress.net

Cover image courtesy of Toni James Photography.

First published 2012

Manufactured in the United States

ISBN 978.1.60949.809.2

Library of Congress CIP data applied for.

To Alan Chadwick, the finest high school football coach in America, who shows young men how to find the courage that lives in their hearts.

Contents

Acknowledgements

I must thank Reverend John H. Harhager, SM, president; Reverend Joel M. Konzen, SM, principal; and Mr. Tommy Marshall, director of athletics, Marist School, for granting me full access to the institution to work on this project.

Alan Chadwick's hardworking coaching staff went the final mile in opening my eyes to what championship football is all about. So I thank each of them—Dan Perez, Jef Euart, Paul Ethridge, Matt Romano, Danny Stephens, Mike Coveny, Matt Miller, John James and Michael Day—from the bottom of my heart for their kindness and patience.

Robert Fisher, director of communications, and Toni James (Toni James Photography) were invaluable in delivering the photographs.

I thank my children, Carolina Cox Medlin and Franklin Cox III, for continuing to show me what love is all about.

My editor, Letitia Sweitzer, made sure I kept my eye on the goal line.

Finally, I thank all the players who ever put on the Marist blue helmet and became proud members of the Long Blue Line.

Part I

The Program

Chapter 1

The Ghosts

Nancy Creek is a major stream that flows southwest just behind the west end zone of Marist School's Hughes Spalding Stadium. It empties into Peachtree Creek south of Buckhead, in north Atlanta. Ultimately, the water flows into the Gulf of Mexico. During heavy rains, the stream resembles a turgid, muddy river.

In autumn, on Friday evenings, a whirl of fog sometimes rises from Nancy Creek and floats across the football field. The phantasmagoria glides dreamlike until it envelops the field. Then…*poof*! It dissipates like a specter.

For decades the apparition has been called "the Ghosts of Marist Football." Tradition holds that it represents the Great Spirit that Marist football has been for one hundred years. The players have believed in these Ghosts for generations. They point to over six hundred victories, a trophy case filled to the brim memorializing championships and thirty straight years of playoff appearances in mighty Georgia high school football. The coaches believe in Ghosts, too. How else could one explain that Marist won twenty-eight playoff games in a row at home? What else explains the extraordinary manner in which so many last-minute victories have been salvaged by the resolute young men in proud blue helmets?

The Ghosts and the line of succession that passes from one class to the next are part of the tradition that creates the mystical Marist Long Blue Line. No team dares to allow itself to dishonor the glorious roll call of the history it joins. It would be the ultimate disgrace.

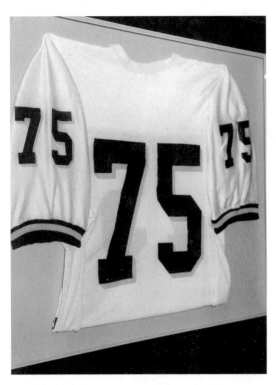

Left: Jersey No. 75, worn by former Marist great Patrick Mannelly, class of '93, hangs in the Marist Athletic Center. *Marist High School Photo Corps*.

Below: The first Marist football team in front of the school armory on the old Ivy Street campus, 1913. *Marist High School Photo Corps*.

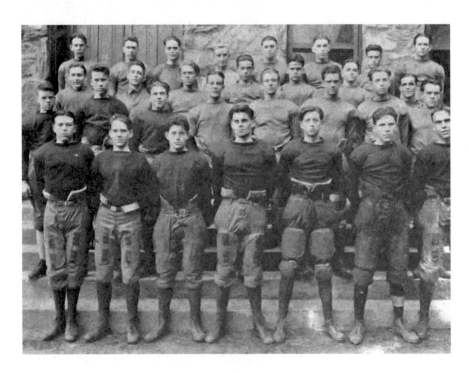

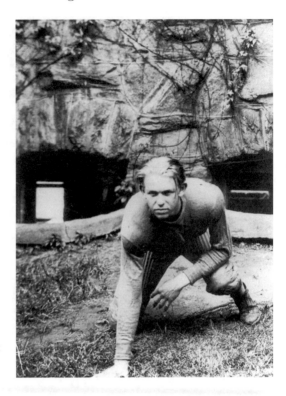

A Marist lineman prepares for a tackling drill on the old Ivy Street campus, 1936. *Marist High School Photo Corps.*

As the years fly by we see changes—changes in the seasons, in politics, in technology, in the Dow Jones Industrial Average and in the boundaries of countries changed by conflict. Our globe has spun inexorably in orbit, but its inhabitants have been on a roller coaster of wars, natural disasters and social collisions. The world morphs perpetually.

But there is one essence that never changes. Its past year fades to black as a new year bursts forth. It undergoes a seamless transition, as it did twenty-five years before and shall twenty-five years from now. Nothing changes because it is intangible, a spirit and eternal. It is called Marist Football, and the hundreds of young men who have sustained its one-hundred-year existence are called the Ghosts of Marist Football. They are part of the long line of succession, players as dedicated as King Arthur's knights and as passionate and committed to a common ambition as a hive of worker bees. As one team reluctantly leaves the stage, it passes the gauntlet of tradition to the next team that has already been birthed. Nary a beat is missed.

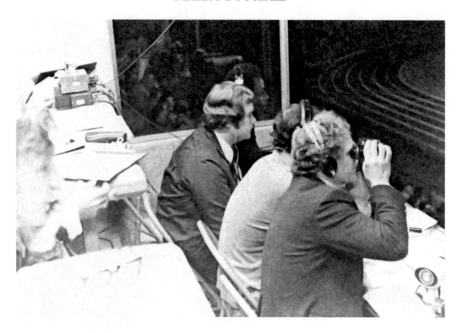

Above: The Marist play-by-play announcer describes game action in the old press box, 1976. *Marist High School Photo Corps.*

Left: A rally button for the annual Fish Bowl Game against bitter rival Saint Pius X, 1971. *Marist High School Photo Corps.*

The goal for the new year is immutable—no wiggle room here. The vision and dream is to win each game and become state champion. It is an almost impossible task, but each year as August begins, the dream is renewed under the torrid Georgia sun at summer camp. The slate is clean, and Marist will make another run for the ring. With it will come both throbbing heartache and boundless joy. There is no middle ground for zealots.

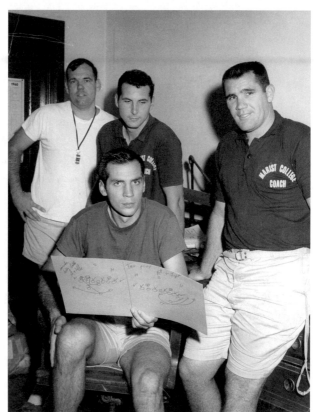

Above: Marist cheerleaders just before a pep rally, 1984. *Marist High School Photo Corps.*

Right: Marist head coach Lou Loncaric (seated) and assistant coach Don Shea (front right) map strategy before the season begins, 1960. *Marist High School Photo Corps.*

In early August 2011, Jordan Barrs tilted his head back and squeezed the water container. A stream of the precious liquid flowed into his mouth. The third torturous practice of the day at summer camp had mercifully ended. The young man was a senior now, and he aimed to carry this year's team on his broad shoulders. He wore the mantle of team leader well. He led not with bravado but by example.

He talked about how he prepared for, and what he expected of, his senior year:

> I've always set my expectations incredibly high. I want to be the best ever. Period. I fully expect to win State. Anything short of that is failure. And at Marist we don't fail at anything. We're winners. It's what we've been bred to do. I expect to win every game because losing is failure.
>
> Everyone always says that losing is just part of the game. That's untrue. It's not just a game. It's so much more than that. The teams that treat football like it's just a game are the teams that lose. If you want to be the best, you have to make it your life. That has been my biggest goal this year. To make football my life.

He grabbed a small Dixie cup of red Gatorade and downed it in one gulp.

> I also want us to have the toughest, nastiest and most hard-nosed offensive and defensive lines in the state. We want to make the other team quit because we are so nasty. I want people to fear us.
>
> My main goal is to be the best leader I can possibly be. It doesn't matter to me if I'm elected captain at the end of the season. No big deal. I want to be there to encourage and carry my teammates forward. I want to be the best team player possible.

Such is the nature of Marist football as each new season is born— unbridled optimism fueled by the legacy of past championships.

No matter the success or failure of the prior year, the new team will take the baton and train just as relentlessly, buy into the demands of discipline from the coaches with the same enthusiasm, keep the same schedule, grow as one organism through commitment and love and put on the same blue helmets that the Ghosts of Marist Football before them did.

Some things never change.

Chapter 2

Sudden Death
(Part One)

November 11, 2011, appeared to be the perfect day to set a record or two. At 2:00 p.m., Hughes Spalding Stadium's verdant carpet was brightly lit by an arching autumn sun, its rays unfettered by a cloudless, radiant sky, already starting its descent. The air was chilled. By the 8:00 p.m. kickoff, the temperature would be a frigid forty degrees and plunging lower. The wind was merciful and lay low.

Alan Chadwick paced quickly around the perimeter of his football field, appearing absent-minded yet stopping occasionally to reach down and fetch a piece of tape or other debris left over from recent practices, marring his otherwise pristine gridiron. A full house was expected, and some fans were already securing choice seats. Georgia Public Broadcasting was setting up shop outside the west end zone's goal posts for its statewide television broadcast of the Georgia High School Playoff Game of the Week. The scoreboard was already lit. And behind it flowed Nancy Creek.

Kell High School would be the opponent. The team had lost to Grayson High, ranked Number 6 in the country by *USA Today*, 7–0 on opening day and had but one eyelash loss since. The school's enrollment stood at 1,806 students, at the top of the ninety-four schools in the Georgia AAAA classification.

Marist's enrollment of 780 made it the smallest school in the classification. Based on sheer student numbers, Marist was originally assigned to the AA classification. But Marist always appeals to the

Georgia High School Association to play up two classifications for the very challenge of it. A few years ago, *Sports Illustrated* magazine dubbed Marist as "The Little School That Thinks It Can" while placing it at Number 15 among the Top 25 high school athletic programs in the United States.

The head coach's path traced just inside the four-hundred-meter oval track bordering the football field. With his head lowered, his glance never wavered from the few feet in front of his path. He was oblivious to the squadron of TV workers unloading lights and setting up cameras and an outside studio, much like ESPN's *College Gameday*. His concentration was focused on the hundreds of items on his gameday mental checklist.

The demanding practices all week had been exceptional. The players exulted in the fast-paced physical drills. On Tuesday, after the required stretching period, the offense ran the "Bone Drill," a series of fifteen scripted plays executed at fast pace, against the scout team defense. Offensive Coordinator Paul Etheridge had designed the plays after viewing films of Kell's defense for the previous three days. The coach conducted the drill with upbeat humor, challenging his halfbacks and fullbacks. The plays were executed smoothly and flawlessly; the crisp execution seemed to feed off the coach's energy. He playfully slapped the helmet of his most consistent halfback, William Curran, who had missed a block for the first time in a month. The coach teased him, "Can't you do *anything* right today?"

After each play, each position coach quickly offered positive instruction to his individual players. The atmosphere on the practice field became giddy, fueled by the intensity of effort.

Soon, Defensive Coordinator Jef Euart sent his defensive backs against scout team halfbacks in a brutal open-field tackling drill. "It's 'Bloody Tuesday,' men. If you don't bleed, you're not giving it everything you have!" the coach roared.

Linebackers coach Michael Day instructed the offensive blockers to illegally grab and hold his linebackers trying to sprint to the ball carrier. Linebackers began muttering, frustrated. The coach responded, "It's not supposed to be easy, men. It's supposed to be hard."

The drills presented both physical and mental challenges. The players cheered when bone-rattling hits occurred, the noise coming from all sections of the field. It was blue-collar work, the stuff that makes champions.

The head coach, still pacing around his field, glanced at the flagpole anchored in the soil between the stadium's front entrance and the east goal post. Old Glory gave barely a flutter, good news for the power-legged all-American Marist kicker, Austin Hardin.

Is there anything I've overlooked? Alan Chadwick wondered. He let that thought loll around in his mind for a few steps. Then he dismissed it.

The horse is in the barn now, he thought.

Then he teased himself. *It's just another game.*

Indeed, it wasn't just another game. At stake was the whole season, and more. It was the opening round of the state playoffs. Win, and live to play another week. Lose, and turn out the lights, the party's over, stack up the helmets in the equipment room and hang up the key to the locker room—end of story.

All week the media had extolled the drama. Marist would be gunning for its twenty-ninth consecutive playoff game victory at home. It already held the all-time Georgia state record of twenty-eight straight. The War Eagles had not lost a playoff game at home since 1994.

The most successful programs in Georgia consider the playoffs the start of the real season. All the sacrifice and toil, from the scorching days at August summer camp until now, when daylight is short and winter lurks just around the corner, was endured to reach this point, the playoffs, a grueling stretch of five games. Lose just one and you're done. Win each one and you continue to advance. Win all five and you are state champion.

Yet there was another record on the table, one the assistant coaches and players whispered about—number 300! Chadwick's record stood at 299 wins and a paltry 52 losses. His .852 winning percentage was the highest of any coach in the history of Georgia schoolboy football with more than 200 wins.

S-s-s-s-h, don't even mention it; we don't want to jinx it! the coaches quietly said. They knew the no-nonsense head coach would hear nothing of the matter. He abhorred distractions.

Promptly at 2:45 p.m., Chadwick slowly guided his silver Tahoe down the main road that cuts through the campus, heading for the pregame meal. He left for the same restaurant at the same time he had for the past twenty-four years before each game. The man is a stickler for consistency and a creature of habit. He sat at the same seat at the same corner table he always occupied in the Mad Italian restaurant to observe his players who would arrive fifteen minutes later. He ordered the same meal as always, iceberg lettuce salad and spaghetti with meat sauce.

At 3:00 p.m., the final bell rang. Seventy football players and seven female team managers hopped in automobiles and made their way to the restaurant. They surged through the entrance with youthful vigor and scattered to tables with red-and-white vinyl tablecloths. Most of the team enjoyed hearty Philly cheese-steak sandwiches while engaged in fraternal banter. The female managers swirled around the room carrying pitchers of ice water, wearing their school uniforms of white cotton blouses and short plaid skirts. Coca-Colas, iced tea and coffee for the players were verboten by order of the head coach. Any substance with caffeine that could lead to dehydration was to be avoided.

The head coach's eyes darted across the room. His players seemed excited and in the moment. That pleased the coach.

At 3:30 p.m., Chadwick stood and addressed his team. "Remember, no speeding when you drive back to the campus. If you get in trouble, I'll yank your helmet away. I called the DeKalb County police and they *will* be watching you."

At 4:00 p.m., the coach entered the school chapel for the pregame Mass. His players, Catholics and non-Catholics alike, were already present. When he reached his usual seat, Father David Musso, school chaplain, dressed in a stark white habit, immediately walked from the sacristy to the raised altar to celebrate the Mass. There was an undercurrent of tension. The players seemed more energized than usual. Jaw muscles clenched, and eyes stared into space, locked onto something a long way away. Even the coach showed nervous energy, tapping the Order of the Mass card into his left palm repeatedly.

Just before Communion, the players rose and exchanged hugs and pats on backs. If you looked closely, you could sense the love for one another. Four players distributed Holy Eucharist in the corners of

the chapel. Catholics bowed and received the host. Non-Catholics approached and received a blessing on the forehead. Steve Wallace, nose guard and non-Catholic, made the sign of the cross after receiving the blessing and then looked up at the ceiling, kissed his fingers and gave his God the peace sign.

At 4:50 p.m., Coach Etheridge paced confidently into a classroom in the athletic building. Seated at desks were his skilled position players. "We're the better football team. But it will be a fistfight. So you throw the first right hook and knock them out."

Alan Chadwick, seated in a desk next to the window, nodded approvingly.

Etheridge fired questions while showing individual responsibilities on the blackboard.

"Quarterbacks, what plays will work best when they show a 5-2 defense?"

"Fullbacks, which backer will you block when we call our belly series?"

"Halfbacks, who are you going to block when we run triple from our power set?"

William Curran's hand shot up. "Coach, I go after the corner."

"That's right!" answered the coach. "But what if they do this—they switch to a cover four?"

"Well, then I go after the strong safety," replied Curran.

"You're hot today, Willie Boy!" beamed the coach.

At 5:20 p.m., Coach Euart, wearing an aged Marist football T-shirt and khaki shorts, walked into the film room. He was followed by his five-year-old son Jack, who promptly took a seat at a desk against the wall. Euart diagrammed Kell's offensive formations on the blackboard. The child sat motionless, staring at the formations like he understood what he was looking at.

Guys, they only have four running plays when they're in shotgun, which they usually are. If the running back is parallel to the quarterback, they will run a jet sweep or a counter-trey. And we will know the counter-trey is coming when they put a man in motion. If they line up with running backs on both sides of the quarterback, they will run misdirection. If a running back lines up behind the quarterback, they'll run a cross or a

bootleg. We will let them tell us what the play is by the formation they utilize. Just recognize formations and keep your responsibility. And we must hit them like they've never been hit before!

The players bolted from the film room and headed downstairs to begin dressing. Some sat in lockers, meditating. Others stared into space while listening to music from iPhone playlists.

Defensive end Jordan Barrs sat in his locker, speaking softly. The senior leader pulled his tight Under Armor T-shirt down over his head. His biceps bulged through the sleeves, and the garment outlined his flat stomach. The long season had taken its toll physically. He came into summer camp at a muscular 215 pounds. But after going both ways on offense and defense all season, he had to consume almost five thousand calories a day just to keep his weight above 200 pounds.

"It's been an unforgettable week for me," he allowed. "Monday night my dad came into my room to say goodnight. He then told me his senior year in high school his team lost in the first playoff game. He said the pain was almost as bad as when he lost his mom."

The youth took a deep breath and glanced at the fierce-looking War Eagle mural on the far wall. His adrenaline was surging, and his pupils had narrowed in his blur irises. "My dad told me to do everything in my power to win tonight, even if I have to claw my way to succeed. I never understood this before, but all my life my dad has been preparing me for tonight. Whatever it takes, I just have to make sure my team comes out the winner."

He stood up, pulled his white plastic shoulder pads over his head and tightened the straps. "Yesterday it hit me that this might be my last game ever. My first true love would be completely gone. I can't let that happen."

Streams of perspiration broke free and rolled down his temples. "Last night I read my scouting reports five times, making sure I knew the other positions, just in case. I quizzed myself each time to make sure I knew it. I can never sleep on Thursday nights so I watch Animal Planet shows. Ferocious animal shows are on at that time. They get me in the mood to do whatever needs to be done on Friday nights. Last night I crashed around 4:00 a.m."

Then the young man struggled to pull his tight blue jersey over his pads. He was proud of his number 58. He had worn it honorably the past three

years. He continued, barely audible: "This morning I parked in the spot I marked with a cone last night so no one would take it. I'm very superstitious. All day I've been telling myself this is just another game. You've been there before, keep your calm and don't think about tonight yet. Don't waste your energy. Keep drinking water. Go out there and do what you do and you will be the best. Go play the game of your life and don't look back."

Jordan Barrs took a deep breath and briefly smiled. "I know I'm ready."

At 6:35 p.m., members of the special teams lined up to rehearse proper personnel and positioning.

At 6:50 p.m., the packed locker room became as silent as a ready room for pilots just before the squadron commander enters the room. Most of the team was in full uniform now. The only noises heard were deep, pulled volumes of breath, the nervous tapping of fingers against kneepads, a final rip of tape.

Then Alan Chadwick entered the area to deliver his final words. He walked the length of the locker room, absent-mindedly wiping his hand across his cheek, glancing at different players in the room, and paced back to the middle of the room.

He spoke in a controlled voice.

Play with the poise and pride that are the earmarks of Marist football. We really like the chemistry of this team. You have a chance to go a long way, a chance to claim your dream. Seniors, you have made us proud. You weren't the most talented class back in the seventh and eighth grades. But you didn't quit. You bonded together and paid your dues through determination and sacrifice. Today you provide great leadership.

He paused and then began again, now with a loud, stirring voice. "Hold the hand of the guy in that blue hat next to you. Fight together! And give us everything you have."

Due to the TV broadcast timetable, the kickoff had been moved back thirty minutes. Nonetheless, Chadwick's pregame routine would be followed to the second. The backs and receivers left the locker room ten minutes after the kickers and punters.

Jordan Barrs jumped from his locker as Coach Dan Perez came in for his linemen to walk out to stretch. He leaped twice at the threshold that

led out of the locker room, tapping the motto each time. It urged, "Play Like a Champion!"

He later captured the moment:

> *My emotions ran high. I saw the lights and knew as a senior this was our time as a team, and also my time, to shine. I saw the crowd and the cameras. The little kids held out their hands staring at us as we walked by. It reminded me of when I was their age and when I looked up to the players. The kids always gave me that extra pump of emotion that helped me really turn my motor on.*
>
> *I followed the War Eagle feet painted in blue leading from the locker room to the field. Whenever I step on our field I feel invincible, that no one can touch us. When the coaches tell stories about the Ghosts of Marist Football, I completely believe them. You can call me crazy, but I never feel alone out there. It always seems to me there are more than eleven in the huddle.*

Forty-five minutes before kickoff, Hughes Spalding Stadium was ablaze with bright stadium lights and TV production crew lights. The stands were rapidly filled with adults leaving pregame tailgate buffets. Pre-adolescents by the hundreds scampered excitedly about. Young girls marveled at the cheerleaders carrying the huge banner they had painstakingly made. Energized young boys pointed at Marist players. "Look at Number 87! That's Greg Taboada. That's what I'm gonna be—a great linebacker when I play here!"

As the team stretched in eight perfectly aligned vertical rows nine deep, Chadwick walked the rows, shaking hands, tapping others on the helmet and stressing to the leaders how he was counting on them.

Players from both teams curiously glanced across the field, measuring their counterparts. The Kell band members sashayed through the gates and filed into the swelling stadium, their snare drums ripping a staccato beat through the chilled late autumn air. The atmosphere energized the players. They ran their basic plays crisply, straining at the leash like young colts wanting to be turned loose. Yet butterflies churned through their cores when they heard the cacophonous noise and watched their opponents. They knew from experience the butterflies would evaporate once the combat began.

At midfield, Chadwick met with the two senior members of the officiating crew. He advised them to be ready for a trick play he might call and that his coaching staff had noticed on film that Kell offensive linemen often lined up in the backfield.

After warm-ups, Georgia Public Broadcasting announcer Jon Nelson sidled up to the head coach as he made his way to the locker room. "Coach Chadwick, what does the team think about your having the chance to win number three hundred tonight?"

The coach looked at the announcer and pointedly said, "Nobody around here has said anything about it. We haven't talked about it. This game is about this team, this year, with a chance to advance in the playoffs. And that's it."

Ten minutes later, back in the locker room, Coach Euart issued a few pointers about things he had observed during the Kell warm-ups.

"Their quarterback puts more zip on the ball than we saw on film. So you cornerbacks be ready to react. Their punter is getting the ball away slow tonight. Punt-return team, be ready for us to turn you loose. Let's block one!"

Players pounded one another's shoulder pads, tightened chin straps and adjusted equipment for the final time. Heads in blue helmets bobbed up and down confidently.

Coach Chadwick entered the locker room. He remained silent, glancing around the room, making eye contact with one player and then another. The tension in the room was all consuming. With a pointed finger, he selected, one by one, four senior game captains. There was a cheer after each selection. He instructed them if Marist won the toss he wanted the ball.

He glanced at his watch and began calling upon his coaches.

Danny Stephens, the linebacker coach, challenged them. "We haven't lost a playoff game here since 1994. This is our home, and we own it. This is sacred ground and our holy grail. So someone named Kell is going to come in here and take it away from us? I don't think so! Let's go out there and put them back on that bus and get them out of here."

He pointed to the head coach. "Go win it for that man right there!"

For Coach Etheridge, there had been a lot of heartache in recent days. His younger brother, Mark Etheridge, Marist class of 1991, had

succumbed to brain cancer after a valiant three-year battle. After the
original diagnosis, he had been given only a 10 percent chance of making
it more than a year. The coach walked past a plaque in the anteroom that
stressed, "Winning Is More Than a Philosophy; It's a Way of Life," into
the locker room and spoke.

"I can't describe what I'm feeling. But I sense fear in the air. That
happens in playoff football. Someone is in our house trying to end our
season. Our senses are heightened. We're focused. But there is danger
out there. Guys, we control that danger. They can't take what we have
unless we let them."

Etheridge turned and walked back the other way. "If you're willing to
lay down your life for your program, for your brother, for your school, then
they can't take what we have. Refuse to let them take it. All your blood,
all your sweat, all your soul, all your heart, all you have…everything that
makes you who you are…lay it out there! Nothing bad can happen if you
do. Let's get after them!"

Coach Euart jumped on a bench in the middle of the locker room.
The team gathered around him, anticipating his fiery words. He didn't
disappoint them. In the heat of the moment, his last-second challenge
rang forth:

> Last week at the funeral for Coach Etheridge's brother, there was an
> overwhelming sense of pride about how many times Marist football was
> mentioned. And about the legacy that Mark helped create at Marist.
> Legacies are not built in games one through ten. They start at game
> eleven and they carry to the title game, the fifteenth. Gentlemen, Mark
> Etheridge was 28-1. What is your legacy going to be? The formation
> of your legacy is waiting out there for you. Let's go take it.

In one long file, the players left the locker room, leaping and touching
the painted words above the doorway.

"Play Like a Champion!"

And the Marist War Eagles raced out into the chill of the night to the
battlefield to face the enemy. (to be continued…)

Chapter 3
The Head Coach

Fifty years ago, Marist was the poor relative of Georgia high school football. The students were schooled in antique buildings in downtown Atlanta. There was no booster club and no home stadium, so the football team went on the road to inhospitable places every Friday night. The paltry budget was spent after paying two coaches and buying fuel for the bus, so the equipment was antiquated. Nonetheless, Marist showed up for every game and fought as hard as possible.

In 1962, Marist changed for the better. The school moved north to a peaceful setting on spacious property with new school buildings. Females were admitted, and military was dropped. A revitalized football program was created, and an active booster club helped build a football stadium. And then two coaches created a football powerhouse—first Dean Hargis and then Alan Chadwick.

Alan Chadwick was an all-state quarterback for Decatur High in a suburb east of Atlanta. Later, he shattered all passing records at East Tennessee State University. After a stint with the Chicago Bears, he became a graduate assistant coach at his alma mater and pursued his master's degree in physical education.

Legend has it that in 1975, fate dictated a major life change for the young coach. His father, Walter Chadwick, was part of a group that met a couple of times a month for poker. The group included Dean Hargis, the Marist head coach, and Franklin Brooks, a legendary ex–Georgia Tech football player who had been Alan's coach at Decatur. In December

1974, Hargis was looking to hire an offensive coordinator who was also qualified to teach physical education at Marist. Hargis employed the wishbone offense taught to him by Pepper Rodgers, the head coach at Georgia Tech.

One evening, a large five-card draw poker hand had been bid up. One by one, each participant folded until only two players remained, Dean Hargis and Walter Chadwick. Chadwick surveyed his hand, tapped his cards on the table and challenged Hargis. "If I win this hand, you have to hire my son." Hargis agreed.

Chadwick's full boat topped the two pair in Hargis's hand.

The bet itself may be just another part of the urban myth that surrounds someone as spectacularly successful as Alan Chadwick. In any case, on January 13, 1976, he made his debut at Marist.

During his first week on the job, he was assigned the secondary duty of junior wrestling coach just before his team traveled across town to rival Westminster for a match. It was the first time Chadwick ever attended a wrestling match. When he shook hands with the opposing coach, he asked where the ropes were. The other coach was speechless for several seconds and then broke into laughter. He figured his opponent was joking or playing some weird kind of gamesmanship.

Coach Chadwick recalled, "Everybody on the bench was yelling, so I started yelling, too. I didn't know what else to do. Somehow we won the match."

He coached under Hargis for nine years. In 1985, he was handed the reins of the Marist football program as head coach. He had two assistant coaches. A few years later, he initiated the Marist community coach program. Today, Marist varsity has four full-time coaches who also teach at the school and five community coaches. The community coaches do it for the love of Marist football. They don't do it for the money. They receive from $2,000 to $4,000 per year based on longevity. Since Marist is always expected to make the playoffs (the squad has done so for the last thirty consecutive years), the community coaches assume they will be required to devote forty to fifty hours a week for four to five months as coaches. These men also own businesses or have full-time jobs. And they have wives to keep happy and children to help raise. They get little rest during football season.

Colleges made overtures as Coach Chadwick began taking his team to the semifinals and finals of the state championship football tournament regularly. He decided to remain at Marist. His passion to teach and coach was fulfilled exactly where he was, he decided. In addition, he didn't want to move his young family every three or fours years, as is customary for assistant coaches at the collegiate level. He had simply fallen in love with the school, and he intended to send his children there.

He has guided his War Eagles to twenty-seven straight playoff appearances while capturing fifteen region championships. His teams have made it to the state championship semifinals eleven times and played in the state championship final game five times. Under Chadwick, Marist has won two state championships. He has been named Georgia Coach of the Year twice by the *Atlanta Journal-Constitution*.

He has surrounded himself with a staff of knowledgeable coaches who have the expertise to teach and motivate. Marist football under Chadwick is a paragon of continuity. The tenure of his dedicated assistant coaching staff gives testimony to that:

Assistant Head Coach Dan Perez (offensive line): twenty-three years, Marist graduate
Defensive Coordinator Jef Euart: eighteen years, Marist graduate
Offensive Coordinator Paul Etheridge: twelve years, Marist graduate
Defensive Line Coach Matt Romano: twelve years, Marist graduate
Defensive Ends Coach Danny Stephens: twelve years
Receivers Coach John James: eight years
Halfbacks Coach Mike Coveny: four years, Marist graduate
Linebackers Coach Michael Day: two years
Dr. Pat "Doc" Spurgeon—consultant, scout: nineteen years

Despite his success, Chadwick realizes the extraordinary hurdles confronting his storied football program. "While we are the size of a AA school, we like the challenge of playing at the AAAA level. Of course, the schools at the higher level have twice as many boys as we do to build a football team."

Chadwick described other challenges his program faces:

There is the problem of economics. It is very expensive to send a child here. The tuition alone is currently $16,300 per year. That prohibits a lot of young, talented football players from applying here.

And we are a Catholic school. Consequently, 75 percent of our students are Catholic. Non-Catholic young men form a bigger pool than Catholics here in Atlanta. Therefore, another large number of prospects are eliminated. We are not a parochial school like the other Catholic high schools in metro Atlanta. We get no money from the church. So that means it is more expensive to send kids to Marist than other Catholic alternatives.

The administration intentionally keeps the enrollment at 780 students in grades nine through twelve. But many more bright students are beating our doors down to get accepted than we have room for. We refuse to lower our academic excellence. If a student athlete is only an average student, Marist may not be the place for him. The administration will not lower admission requirements for anyone, even if he's a superstar.

As long as I'm head coach, we will run the wishbone or triple-option offense. We don't throw the ball around a whole lot. Some kids that want to play quarterback and wide receiver at the college level don't want to play in a Marist running offense. So sometimes we lose out in that area, too.

Then Alan Chadwick smiled.

It's all just part of the challenge the coaches face here. We have success here because we get real smart players who commit to giving everything they have for their teammates. They play with courage for the team, the coaches and the school. Most importantly, they sacrifice for and love each other.

Coaching here is the only thing I know how to do well. I've been blessed and fortunate to be able to draw strength from so many people. When you have the backing of all these people through the decades—the parents, the administrators, the teachers and the coaches—it's hard not to be successful.

Then he addressed the material he is handed to work with:

We don't have the talent, the speed or the depth that many of our opponents have. While we may be at a physical disadvantage, our whole philosophy governing our entire program is finding ways that give us a better chance of winning games. We have to prepare and practice our system for the types of student athletes we have here. Our style of coaching is heavy on intangibles—character, resilience, heart, physicality and determination.

And tradition. Chadwick knows the tradition handed down from one class to the next is the main driver responsible for the success of the program. Indeed, he gives life to the tradition. He recently called up a seventh-grader, Ian Gibson, and invited him to come join the varsity for a voluntary summer workout. The coach knew the youngster was destined to be a key leader of his class for the next five years. Ian ran exhaustive 110-yard gassers with the team. He worked so hard he threw up. But he will never forget that day.

One Saturday morning, Chadwick reviewed the previous night's game DVD of his next opponent. The region title would be at stake, yet he left the film room and headed to the stadium to see how his eighth-grade team was faring. They might need a little support, he decided.

The eighth-grade team was locked in battle with private school rival Lovett in overtime. Marist was down by three points with a third down on Lovett's seven-yard line. Chadwick swept into the team's huddle on the sidelines during the final timeout. The youngsters stared at him like he was a messiah. He spoke: "You've got two chances to get this touchdown. We're going to win this game. You hear me?"

The players nodded.

"Make me proud of you. Now let's go out there and win it!"

And they did.

The head coach wears his intensity on his sleeve. His burning desire to succeed is contagious, permeating his football program and fueling his coaches and players to reach for the stars. His focus, charisma and intelligence give him the same leadership qualities great U.S. Marine generals possess.

The best football coaches are also consummate psychologists. And they are masters of the art of intimidation. Vince Lombardy, Paul "Bear" Bryant and Steve Spurrier all knew exactly when to apply pressure. Alan Chadwick is no different.

His new starting quarterback, Andy Perez, was a junior with six starts under his belt. He was still trying to master the sophisticated decision-making required when running the triple option. Marist was having its way with Central Forsyth. Just before the half, Perez culminated a well-executed drive with a touchdown. The young quarterback dropped back to pass, rolled to his right and sprinted the final twenty-four yards around the right end to put Marist up 28–0.

The quarterback was met on the field by Chadwick, who yelled, "You should have pitched the ball on the previous play! Instead you kept it. Our halfback had a clear path for a sure touchdown. Couldn't you see that? Use your head. Think!"

There was no mention of the athletic touchdown run. Perez obediently strolled to the end of the bench, his head hanging down.

Chadwick turned and whispered to his newest member of the coaching staff, "You always have to keep them guessing."

Chadwick demands the ultimate commitment from his coaches and players. And the young men of Marist buy into his unswerving call for discipline and sacrifice. After his team showed up for a Friday night game and gave a listless performance, he challenged them at the following Monday's practice.

> *I don't know everything that's going on around here, but whatever it is, on and off the field, we coaches want to know about it. We told you the first day at summer camp to believe in the process. It's been working for the thirty-seven years I've been a part of this. We've won two state championships and been to the semifinals eleven times. Believe in your coaches and your teammates. Realize that Monday practice is always tough—it's part of the process. If you don't want to go through the kind of physical practice the way we do it here at Marist, then turn in your football helmet.*

The coach pointed at the athletic building's equipment room and then continued: "Realize that we call Tuesday practice here 'Bloody Tuesday'

for a reason. If you don't want to go through this kind of physical practice then turn in your helmet. I've got a rack for it right in there."

Again he pointed toward the equipment room. "And if you can't put the effort in during Wednesday practice and run the gassers hard then turn in your blue hat. I've got a rack for it right in there."

Alan Chadwick is a junkie for discipline: "I believe in attention to detail. I like everything to be orderly with no distractions. That's why we practice our plays with endless repetitions. Practice makes perfect."

His practice schedule is set in stone. It is non-changing, just as the whole program is. It is the same, each day, at each practice:

Pre-practice
Stretching
Bone Drill (fifteen to twenty basic offensive plays run quickly)
Special Teams
(Break)
Fundamentals (JV Offense; Varsity Defense)
Group Drills
Team Drills (Scout Team Offense versus Varsity Defense)
(Break)
Fundamentals (Varsity Offense; JV Defense)
Group Drills
Team Drills (Varsity Offense versus Scout Team Defense)
(Break)
Team Drills
Conditioning
Announcements

Alan Chadwick notices everything. At 3:00 p.m. on the afternoon of the 2009 opener against Saint Pius X, several coaches joined Chadwick at the Mad Italian restaurant pregame meal. Chadwick sat in his usual seat with the team's videographer two chairs down, leaving a seat open between him and the head coach.

Two weeks later on a Friday afternoon at the pregame meal, the coach looked at his videographer. "You can't sit there. Sit here." And he patted the chair to his right.

"Why not?"

He stared at the videographer.

"Because that's where you sat the day we lost to Saint Pius. We can't have that."

And he was serious.

He is governed by a rigid moral code. After a heartbreaking last-second loss on the road at a new school out in the eastern Atlanta suburbs, some of his disheartened players banged their cleats against the visiting team's locker room walls. Muddy smudge marks besmirched the soft white paint, and cruddy pieces of mud fell on the floor of the polished wooden halls. Alan Chadwick directed his players to clean up their mess. "Marist players don't behave like that!" Coach Chadwick ordered. "They were great hosts, and I care a lot about their place," he later told an assistant.

Chadwick is a taskmaster and an old school, no-nonsense disciplinarian. He coaches and teaches with a zealous commitment. He demands the same dedication from both coaches and players to achieve the ultimate goal. And that goal is to be as good as you can be, by following the rules, by sacrificing individuality for the whole of the team, by being unflinchingly disciplined and by being mentally tough.

Chadwick does not display emotions, but though he may appear taciturn and stern, there is a soft side just under the surface, filled with compassion and love.

After a recent heart-wrenching, season-ending loss on the road, the head coach consoled and comforted each player in the locker room, thanking him for his dedication, praising him for his courage, insisting he hold his head high. And he told them he loved them.

Andy Perez, the quarterback, described how the usually rigid coach opened himself up in the gloom of despair that night: "He is usually somewhat removed and is an intimidating figure. But the team has learned to love him from afar. He doesn't usually show affection, but we saw it when he opened up after the overtime loss. It was almost shocking to see him emotional. He came up to me with a single tear rolling down his cheek. He told me, 'Players like you are what Marist football is all about.'"

The young athlete spoke softly: "Getting hugged by him was so unexpected. It meant so much."

Chapter 4
Summer Camp

If you're not getting better, you're getting worse.
—Alan Chadwick

By 10:00 a.m. on Sunday, the players and coaches were wringing wet, stowing boxes of royal blue Gatorade concentrated powder into the bays of the buses. The Marist football team was heading to summer camp at Riverside Military Academy in Gainesville, the poultry capital of Georgia.

They also loaded boxes of tape and bandages, medical supplies, radio headsets, whistles, footballs, tees, uniforms, shoulder pads, football cleats of every brand and type and, of course, the blue helmets. For almost one hundred years, young men have been buckling the chinstraps to those Marist blue helmets. When each player puts on that blue hat for the first time, he understands he has just become part of the Long Blue Line, a very special, proud fraternity, and will be held responsible by all who have worn it in the past to uphold the tradition, sacrifice and toughness that is the essence of Marist football.

The players had worked hard, theoretically on a "voluntary" basis, throughout the summer to get bigger, stronger and faster, in the school weight room and on the practice field running laps and sprints. Some went to off-campus training facilities where professional trainers provided speed, agility and strength instruction. A very few were good enough to be invited to major college recruiting camps.

The caravan of vehicles left the campus at 10:30 a.m. bearing one hundred players, ten coaches, two trainers and seven female student managers. Team doctors would be just a phone call away in Atlanta if needed.

The day was terribly hot, as all days had been for the previous two months, the hottest Georgia summer in memory. The players knew this was a day of reckoning. The very first practice would begin promptly at 2:00 p.m., consisting of the conditioning test. They would have to run against the clock. Indeed, they had pushed themselves all summer to be able to pass the test. They understood the unsaid message: *woe betide those who fail.*

The cavalcade of vehicles pulled up to the Riverside dormitory, and the unloading of equipment, personal goods and bedding began. Players and coaches were assigned two to a room on the second floor. The female student managers were billeted on the fourth floor. Volunteer mothers of the girls would hold vigilant watch throughout the day and night for the duration of the six-day camp.

By 2:00 p.m., the team had unpacked, donned shorts and T-shirts and reported to the practice field, located down a steep grade several hundred yards from the dormitory. Players were to run a series of 110-yard sprints against the clock according to their positions. Interior linemen were expected to run each sprint in under nineteen seconds, linebackers and fullbacks were tasked to make it under sixteen seconds and halfbacks, quarterbacks, cornerbacks and safeties had to beat fourteen seconds.

Failure to make the time limit would result in severe discipline— reporting for "Breakfast Club" conditioning promptly at 5:30 a.m. the next morning. No one wanted this punishment; it would be quite a daunting way to begin a day that would include three grueling, hard-nosed, two-hour practices in pads and helmets.

The first line of players, the interior linemen, took their marks at the end line in the back of the end zone. In their stances they eyed the imaginary tape stretched across the far goal line, 110 yards away. Coach Euart tooted his whistle, the line of players took off and, at the finish line, Coach Matt Miller punched the start button on his stopwatch. Justin Olderman, the senior tackle and team leader, crossed the line first, sweat flying off his brow, his hair a mass of wet, golden ringlets. At the nineteen-second mark, Miller hit the stop button on his stopwatch. He noted the players who were still bearing down on him. They had failed to meet the time target.

He smiled at number 66, Steven Wallace, a five-foot, ten-inch, 254-pound sophomore who had just failed to meet the required time. "Hey, Wally, see you at Breakfast Club in the dark tomorrow!" shouted the coach.

"Yes, sir," the player dutifully responded and then bent over, gasping for breath, before turning around and toeing the line. After a half-minute rest, the phalanx of linemen sprinted back the other way down the length of the football field. Next came the fullbacks and linebackers, racing down the gridiron for 110 yards, resting for a few seconds and then turning around, getting in their stances and, at the whistle, running back to where they had started. Then it was time for the members of the backfield to run.

The players then learned the full extent of their misery.

"Twenty times?" a fullback asked incredulously. "Like *twenty*?"

That, indeed, was the number. Down and back ten times, in the broiling ninety-five-ish-degree heat with the sun gleaming like a white disc in the humid Georgia sky. The coaches had plenty of Gatorade and water available to prevent heat stroke. And the coaches tried to make the ordeal more bearable by cheering the players on while challenging them to make it.

Even though some failed to meet the time limit, the team persevered. Nobody quit. Nobody even lost his lunch. The young men had worked hard all summer. Each had pushed himself in June and July while his buddies who didn't play football were chilling at the swimming pool checking out the chicks.

It was tough hoofing it back up the terraced hill with several levels of twenty brick steps to the sanctuary of the dormitory with its beckoning cool showers. Three times a day they would don their practice uniforms, walk down the hill to the practice field, endure hellish practices and then slowly climb back up the hill for food and rest.

At 5:00 p.m. on Sunday afternoon, the players shuffled into the mess hall and inhaled meals of spaghetti with meat sauce, green beans, iceberg lettuce salad, rolls, spice cake, Gatorade and lemonade. On a table in the middle of the vast hall capable of seating almost two hundred diners were big tubs of butter, peanut butter, jelly and loaves of bread—just to make sure the athletes consumed enough fuel to allow their bodies to endure the physical challenge of each arduous day.

At 6:30 p.m., the players began the evening practice. Alan Chadwick and Paul Etheridge, his offensive coordinator, oversaw the offense, which practiced the fundamental triple option play, 43 Triple to the left, 42 Triple to the right, over and over. The team had lost its whole backfield to graduation save quarterback Andy Perez. The two coaches knew they had their work cut out for them. So to create success they did it the only way they knew how: through hard work, calling endless repetitions of plays and constantly educating and challenging the players.

In the full-speed scrimmage, Perez called the play in the huddle, "L Power, 43 Triple, break!" This play is the genesis of the triple option. The tight end is on the left side, and the backfield is lined up in the pure vanilla wishbone, the fullback seven feet directly behind the quarterback with a halfback on either side a yard behind him.

As the ball is snapped, the fullback will plunge toward the gap between the center and the left guard. The quarterback (in this case, Perez) will place the ball in the cradle of the fullback's hands and stomach while looking to see if a defensive player is about to fill the hole. If not, the fullback keeps the ball and surges forward to gain yardage. If there is no daylight for the fullback, Perez will keep the ball while gliding to his left, reading the defense to see if he can cut up-field for positive yardage. If that option looks stymied because an end or a linebacker is in the way, he will continue to his left and pitch to the trailing right halfback, who will turn the corner, hopefully for positive yardage. Meanwhile, the other halfback must block the closest player on the perimeter—maybe a linebacker, maybe a cornerback.

Coach Dan Perez, the offensive line coach, had the daunting responsibility of teaching his linemen all the nuances and subtleties that will be required to communicate with one another while recognizing the different defenses they face. He also taught them to stay low and attack aggressively, to pound the opposing linemen and linebackers so often they choose to back off. In order for the Marist triple option to succeed, each of the eleven players on offense must solve the algorithm puzzle of the opponent's defense.

The first six times 43 Triple was called, the play resulted in a loss. The fullback plunged to the wrong gap, the halfback blocked the wrong defender, the left guard and left tackle failed to execute a combo block

on the man across from them or the quarterback pitched too wide to the trailing halfback, resulting in a fumble.

Alan Chadwick said the only thing he could in that situation. "Run it again," he bellowed.

On the ensuing play, the left halfback blocked the cornerback instead of the strong safety, who caused a fumble when he tackled the quarterback. "Run it again, guys!" yelled Etheridge. "This time *think*, if it's not asking too much!"

The center snapped the ball too quickly, resulting in another fumble. Alan Chadwick shook his head, placed his hands on his knees, shook his head again, looked up and yelled, "Run it again! Guys, we look terrible. Think like Marist football players are supposed to."

Finally it worked. Perez cut it up field for a touchdown.

"Run it again!"

Halfback Gray King took the pitch, turned the corner, cut inside the strong-side linebacker and then broke toward the sideline and outran the free safety to the end zone.

"That's better, that's more like it, guys," Etheridge said, clapping his hands. "Let's use our heads and execute these plays like we're capable of."

Promptly at 9:00 p.m., the whole entourage met in the mess hall for a mandatory meeting. The head coach spoke:

> We have a great challenge in front of us. We have a lot of question marks and a lot of holes to fill. Some inexperienced, younger players will have to step up, work hard and become real Marist football players for us to be the kind of football team we're used to here at Marist. I'm not going to ask too much of you. But I will demand that you give us 100 percent effort at all times.

The head coach looked around the room, scanning his players. "Believe in yourself. Believe in your teammate and respect him. Be tough."

He pointed to a T-shirt that all players had just been issued, a navy blue shirt with gold lettering. The front bore the words "Marist Football." Under the words was the outline of a Marist blue helmet. On the back in block letters were the words "Believe in the Process."

The head coach spoke again:

We've been playing football the same way since I first came here as an assistant coach in 1976. Nothing has changed. We do the same things. We still run the same offense—the wishbone. In 1985, when Coach Dean Hargis departed, several seniors went to the president of Marist and said, "Whomever you hire, make sure he continues to employ the wishbone offense."

I was named head coach, and we still use the wishbone. Our system works. We've made the playoffs twenty-eight straight years. Hundreds upon hundreds of players through the past years sacrificed to become part of the Long Blue Line. It is now up to you. Together, with hard work, the coaches and you have a chance to accomplish some great things this year.

He crossed his arms and continued, his words coming out measured: "Believe in the process."

The coach continued, spelling out common-sense rules: "Always wear your shoes or flip-flops outside of your room. We don't want anyone to slip and get hurt. There will be no horseplay and no yelling in the halls. And no slamming of doors!"

He smiled and continued: "The student managers are up on the fourth floor. If I see any boys up there, you will be in trouble and running gassers at 4:00 a.m. Those who didn't make their times in the sprints today, meet Coach Euart in the courtyard at 5:30 a.m. for Breakfast Club."

Muffled groans came from more than twenty players.

Assistant Head Coach Dan Perez addressed the gathering:

Everything we do is part of the process. Meals are at 7:00 a.m., 12:00 p.m. and 5:00 p.m. Do not miss a meal, no matter how tired you are. Practices are at 8:30 a.m., 1:30 p.m. and 6:30 p.m. Do not be late or you will be running at Breakfast Club the next morning.

Because of the type of student athletes that play here, we must work harder than our opponents. Nothing ever comes easy for us. Everything we gain must be earned. So remember: believe in the process.

No sounds echoed in the dormitory hallways that night, nor were many lights on after 11:00 p.m. The players were already exhausted, and the days of three practices each day would begin the next day.

At Monday morning practice, for twenty minutes the offense dashed through the Bone Drill, where plays are run quickly, one after another, from a play sheet with a preplanned script. But there was a problem. Kendall Baker, a freshman man-boy at six feet, four inches, 240 pounds, destroyed four consecutive offensive plays from his position on the scout team at right defensive end. Freshmen aren't supposed to be able to do that. Coach Perez turned away from his players, looked up at the sky, shook his head in disbelief and tried to hide his smile. The fourteen-year-old already had the look of a premier NFL lineman.

After the high-spirited practice, the team surrounded Chadwick and sprawled to the earth to hear his remarks. The morning had been unusually cool. "I like your spirit I just saw. I hope you will give us the same effort when it's ninety-five degrees. For us, practice is the hardest thing we do each day. For our opponents, practice is the easiest thing they do each day. Be sure and get off your feet when you get the chance. And remember to hydrate, hydrate and hydrate!"

At the evening practice, offensive and defensive linemen squared off and engaged in a very physical one-on-one drill. A tall dummy, representing a quarterback about to pass, was placed eight yards behind an offensive lineman who faced a lone defensive lineman across an imaginary line of scrimmage. The job of the offensive lineman was to block the defensive lineman and deny him access to the dummy. The job of the defensive lineman was to get to the quarterback by one of three means: by a frontal power bull-rush, by taking a quick inside route or by swimming past the blocker from the outside. Sometimes the offensive player won by keeping his opponent off the dummy and drove the defender into the dirt. Sometimes the defensive player blasted through the blocker and slammed into the dummy. The competition was brisk, and the players rollicked in the physicality of the action, cheering on teammates when it was not their turn.

Justin Olderman dominated the drill on both sides of the ball with his power and quickness. Senior defensive end Sean Manzelli had a field day, continually beating the offensive lineman across from him. Defensive

Coordinator Euart, defensive line coach Matt Romano and defensive end coach Stephens stayed active in the drill, shouting encouragement and instruction. After the drill, the coaches beamed and congratulated their charges.

Coach Stephens had heard good things from coaches in the lower programs about the freshman standout Kendall Baker. Normally, freshmen do not participate in varsity drills. Stephens pulled Kendall aside after the first practice and said, "Listen, number 52. If you decide you want to jump in and participate in any drill the varsity is involved in at defensive end, go ahead and do it. If any coach says anything to you, tell 'em to come see me."

During the fast-paced, hard-hitting one-on-one session, Kendall stepped up opposite offensive tackle Olderman, pointed his finger at the best lineman on the team and took his stance. They went one-on-one repeatedly, and the freshman fared better than most others versus Olderman.

At the end of practice, Chadwick looked behind him where members of the scout team had gathered behind the huddle. He noticed that some of the yellow jerseys of the junior varsity players were not mesh but were thick cotton. He instructed Jessica Perez, a student manager, to ensure that all players would have mesh jerseys by the next morning. It had become insufferably hot, and the coach wanted his players to have every advantage possible while battling the wretched humid Georgia heat.

After practice, Chadwick again advised his young men to continually hydrate and get rest for their legs. "Also be warned you will be more tired tomorrow morning than you were this morning."

He looked at a couple of younger players and said, "I think y'all may become the kind of football players I'm looking for."

Coach Perez admonished a player who said, "Hey, you!" to a girl manager carrying water bottles. "Her name is Emily," corrected the coach. "Respect that."

Attention to every detail is part of the formula for success in every industry in America, including high school football. Under Chadwick's watchful eyes, looking under every stone has become an art form for the Marist coaching staff.

At Marist, there is a pre-practice before the regular practice even begins. On Tuesday morning, with the rising summer sun already roasting the

practice field, Chadwick conducted a drill to fine-tune his quarterbacks, all five of them. There were two lines of halfbacks five yards on either side of him facing the same direction as the coach. The quarterback started running directly at the coach, who pointed either to his left or his right. The quarterback then pitched the football to the halfback first in line, simulating the pitch to a trailing back in the triple option. Each time the coach instructed, "Plant...pitch...softly." He wanted the ball to be tossed softly and float to the halfback. The exchange had to be errorless or a disastrous turnover might happen. Each quarterback ran ten repetitions of the drill, fifty times in all, *before* practice.

As practice began, Coach Romano trotted his squad of defensive linemen to a far corner of the practice field to engage in a gruesome drill in the rising cauldron of summer heat. A defensive lineman lined up across from two of his teammates who were bent on driving him into the ground. His mission was to burrow under the onslaught of the pair opposite him, keeping his feet driving even as his torso was almost flat on the ground. He had to keep enough leverage to finally burst through the two opposite him and flatten the upright dummy that lay ten yards behind the offensive linemen. The thrashing and wallowing on the ground was enough to strip away all available oxygen. Players gasped for breath.

The drill had a purpose—to allow a player to prove to himself that he could prevail under the worst of circumstances. It was an exhaustive drill, and the group took turns, over and over, even when tongues hung out. Finally, the drill ended, and the weary players dropped to their knees and took a break for a few precious minutes before the next drill began.

At Tuesday's afternoon practice, the offense squared off against the first-string defense and ran twenty quick plays. After each play, each of the nine coaches addressed his specific position players quickly with a combination of instruction, correction and praise in a matter of seconds. The players were all ears. Without reservation, they had bought into the program. They believed in the process.

Wednesday morning, the sun turned the early morning air into a furnace. After six straight blue-collar, intense, hard-nosed practices, the team would be in shorts. However, they would still wear their shoulder pads and headgear. The Georgia High School Association had ruled that teams must dress out in shorts every third day in summer practice.

A new coach stood next to Coach Stephens and offered, "I bet they feel like today will be a holiday compared to the past two days."

Stephens chuckled and said, "Just you watch. Marist hits harder in shorts at practice than other teams do in full pads!"

Sure enough, ten minutes later, linebacker coach Miller conducted full-speed, head-on tackling drills with his linebackers in the end zone.

Keller Carlock, senior middle linebacker, said, "It's just Marist football. We always hit. That's why in games sometimes I see in the second half the other team's running backs start to show doubt. They don't want the ball anymore; they've been hit hard every play and they've had enough."

Near the conclusion of the afternoon practice, the football was placed on the ten-yard line. It was time for the two-minute drill. The object was to cover the ninety yards and record a touchdown against a stout scout-team defense. The offense would be allowed to utilize three timeouts.

It was hectic, nonstop work in the cloak of Georgia heat. Quarterback Perez mixed up quick sideline passes with handoffs to his fullback and pitchouts to his halfbacks. The players were running on empty, but the march was steady. With seven seconds left, Perez completed a strike to his swift split end, Jordan Snellings, who climbed a ladder to make a circus catch for the touchdown.

The coaches eyed one another and gave little smiles. Perhaps this team would have that special trait great Marist teams in the past have had: character.

At the conclusion of practice, the players flopped to the ground in a circle around their head coach. He congratulated them on the spirited practice but reminded them they would have three rigid practices in full pads in store the next day.

> *Get rest, eat all your meals, get medical treatment if you need it and hydrate continuously. You are doing a good job keeping your rooms neat. Keep it up. And don't wear your cleats into the locker room. These are very nice floors. We've got to respect this place.*
>
> *Now, on a very serious matter—be very careful about texting and sending e-mails. When you press "send," it is out there forever, so always use your best judgment.*

Alan Chadwick addresses the smallest issues that might affect the outcome of a game. Before the 8:30 a.m. Thursday practice, he worked with his incredibly gifted kicker/punter, Austin Hardin, on the art of getting his high, booming punts to come to rest inside the receiving team's ten-yard line.

At the same time, the small bus that ferried the female managers from the dormitory, laden with water and equipment, developed mechanical difficulties and balked. The young women had boarded the bus at 8:00 a.m. Promptly at 8:30 a.m., Coach Chadwick blew his high-pitched coach's whistle, signifying the official start of practice. Simultaneously, the managers' bus pulled up, and the seven young girls started offloading vats of water. They had toiled like dogs for days under the searing sun, filling water bottles, skipping from huddle to huddle with squeeze bottles of Gatorade, hoisting heavy boxes of supplies and climbing up and down four flights of stairs several times a day before they could finally shut it down at night, share experiences and relax.

The coach yelled over to the young women next to the bleachers under a full-leafed red oak tree where their makeshift base camp was. "Ladies, you are late for practice! You, too, are part of this team. Since you are late, you will run, just like my players when they are late. Report to me right here as soon as this practice ends."

His words were delivered at high volume. Everyone in earshot could hear his rebuke. The girls explained that the bus had failed to start so they had to get the school mechanic on duty to get it going. Even a few assistant coaches tried to explain away the girls' tardiness. Chadwick turned away, impassively. They had been late, period—end of story.

The summer camp experience isn't just about blocking and tackling. It is about boys becoming men. It is a torturous process that ultimately writes the recipe for the specific chemistry that will define the team. So it is also about bonding, not just when the players bond into a team but also the bonding that transpires among the coaches. A code of respect exists among the coaches because of common intangibles—character, professionalism, football knowledge and work ethic. And because of their mutual respect, no one will be outworked. The coaches at Marist perform their passion unblinkingly through dedicated hard work. They also share a love for their players.

After evening practice and a quick shower, the coaches boarded a school mini-bus and drove into Gainesville to a sports pub named the Monkey Barrel. Together, they enjoyed a flow of pitchers of icy draft beer, spicy buffalo wings, pizza and TVs showing the Atlanta Braves' nightly hunt for a playoff berth. The coaches razzed, educated, teased and toasted one another for a couple of hours. Then they piled into the bus and headed to the dormitory for some shut-eye. Early the next morning would bring another in a string of arduous, exhausting days.

For those young players at summer camp for the first time, it was a boot camp test to see if they had what it takes physically and mentally to be Marist football players. For the seniors, it was the beginning of their last hoorah. For the most part, they had played next to one another and learned to trust one another since the seventh grade. Now it was their turn to see how far they could lead the team through the state playoffs. Marist last won the state in 2003. Another championship ring would become the goal of the seniors on this team.

Finally, Friday arrived. A game scrimmage was held in the morning, capping the most grueling of weeks. It provided the coaches with clues about the current state of the team and helped isolate the areas of weakness that needed the most attention.

Then the team struck camp, motored to Marist and unloaded blocking dummies, bags of footballs, shoulder pads and helmets. The players had earned the most pleasurable of gifts, a two-day respite from practice, a weekend off in Shangri-La, to rest weary limbs and strained muscles.

Two-a-day practices would begin Monday and extend for two weeks. It was time to start focusing on the upcoming season. Soon, the agony of the summer practices, the cramps and the nausea suffered in the madness of the Georgia heat, the bumps and bruises incurred during countless hours spent scrimmaging under an unrelenting sun would be rewarded.

Soon the team, wearing the same warrior blue helmets worn for decades by previous Marist teams, would trot from the locker room to the delight of several thousand fans, join together in the end zone for one final Lord's Prayer, race through the goalposts and smack through the banner in front of a frenzied home crowd.

The greatest reward now would be at hand—testing an enemy on a glorious Friday night.

Chapter 5
The Community Coaches

The linchpin of the success of the Marist football program begins with coaching. The commitment demanded is unswerving for the coach—a total dedication to the job of preparing young football players to sacrifice for one another, to adhere to discipline and to play hard and fair. The coach is rewarded with the knowledge that his players will be prepared to face life as better men because of the experience.

The community coaches who volunteer do it out of passion for Marist football. They have full-time jobs away from the school, but during football season they have another full-time job—that of football coach. They get by on little sleep, juggling two jobs and duties as husbands and fathers. It is an exhausting, demanding avocation, but they are devoted to it. Each of the community coaches has his own life story inside the main story, Marist football.

THE HOMICIDE DETECTIVE

October 28, 2009
6:45 a.m.
City of Atlanta Police Headquarters
Homicide Division

Danny Stephens flashed his credentials, successfully passed the fingerprint security test and entered the elevator. He was dressed in a navy blue suit

with a gray tie under a smartly starched white collar. He wore a gray homburg, and a tan trench coat was folded over his left arm.

Danny is the lead City of Atlanta homicide detective and is passionate about his calling. And he always catches the killer. You do not want him on your trail. He has been a policeman for twenty-two years and a detective in the homicide division for over ten years. Danny is an expert in using neurolinguistics, along with body-language signals, to read if a suspect is lying when being questioned. You do not want to play Texas hold 'em poker against Danny.

Danny has another job he is just as passionate about. For the past nine years, from early August and often into December, he has coached the defensive ends for the Marist football team. He is a community coach, basically a volunteer. Community coaches are paid a pittance for their coaching. But they revel in the job. Of the nine Marist varsity coaches, five are community coaches.

Danny leaves police headquarters every afternoon around 3:00 p.m. in football season and heads to the Marist practice field. Even though practice ends around 6:15 p.m., his second job is not finished. Danny collaborates with the other three defensive coaches for hours after practice, studying film, breaking down offensive tendencies of upcoming opponents, creating game plans, writing scouting reports and discussing the physical and psychological statuses of player personnel. Sometimes the coaches don't leave until midnight. Then Danny goes home to his wife, Tracy, and his three children.

The players revere Danny and affectionately call him "Coach Cop." After every session at every practice, and before every game in warm-ups, Danny calls out to his players, "God is good!" And each time his charges resoundingly respond, "All the time!"

October 28, 2009
4:40 p.m.
Marist Practice Field

Danny was teaching his defensive ends how to "swim" past offensive tackles trying to block them. The upcoming opponent had a pass-happy quarterback, so it was imperative that Danny's ends put the heat on

Lithonia High's passing game. It was a must-win game in order to grab a first- or second-place seed for the playoffs. Such a seed ensured at least the first playoff game would be played at home.

Danny organized a full-contact drill, and each of his defensive ends practiced the move seven times against one another. One of the juniors was less than aggressive so Danny called him by a feminine version of his name. All the other players laughed.

"One more time, Geraldine. Do it like you mean it!"

This time, the player exploded through the block of the offensive lineman, knocked him off his feet and, in a jiffy, deflected the pass thrown by the scout-team quarterback. Danny's voice bellowed, "That's the way! Now I'll call you Gerald again!"

"Coach Cop" huddled with his defensive ends after the drill. "Guys, Lithonia is going to come in here and try to intimidate you. They will act like thugs and try to start fights. I want you to teach them a lesson they will never forget. You are going to be so physical they will never forget the whipping you are about to give them. Great work today!"

Then Danny dropped to a knee. His players formed a tight circle around him.

He said, "God is good!"

His players chanted in response, "All the time!"

After football practice, he was bone-tired and would get no rest anytime soon. But there was a sparkle in his puppy-dog brown eyes.

"I love everything I do in life."

November 13, 2009
7:20 p.m.
Round One Playoff Game v. Sprayberry High School
Marist Football Locker Room

Alan Chadwick stood in the middle of the locker room looking at his team. Pregame warm-ups had just ended, and a pervasive perfume of sweat-soaked uniforms and equipment clung in the air. Players' legs nervously wiggled, nostrils flared, jaw muscles worked overtime behind clenched teeth. The head coach spoke.

"Coach Stephens?"

Danny briskly paced to the center of the room.

It's Friday the thirteenth, and Sprayberry is playing at Marist. May God have mercy on them. Guys, you have been waiting for this moment ever since you played peewee football—the chance to be in a playoff football game. All you need to do now is turn it up and get nasty. It's Friday night in Hughes Spalding Stadium, and the whole state wants us to lose. The playoffs are starting. It's time for Marist to take charge again. It's time to get mean!

November 17, 2009
2:00 p.m.
Marist Eighth-Grade Health Class

"Coach Cop" strolled into Coach Dan Perez's classroom as eighteen eighth-grade students sat as still as pillars of salt. Danny Stephens had volunteered to give a presentation about making the right decisions in life. The boys in gray slacks, white shirts and blue ties and the girls in their Catholic schoolgirl plaid skirts and white blouses sat at rapt attention.

Danny marched directly to the whiteboard and wrote a phone number in the upper right corner with a red magic marker. Danny is six feet, one inch, 230 pounds, with a barrel chest, heavily muscled legs and a perpetual smile on his face. He turned around and addressed the students. "How many of you don't like cops?"

No one raised a hand.

"Come on, now. Be honest with me."

Again, not a hand was raised.

"Well, I don't!" Danny said. And he raised his hand. Behind his desk, Coach Perez slowly raised his hand. Suddenly, a few students raised their hands, and then over half the students admitted they didn't like cops.

Danny opened with both barrels: "God forbid, but if someone came into this school right now and tried to pull a Columbine, I would die for you. They would have to kill me first. You'd be running in one direction, and I'd be running in the other, right at the bad guys."

The detective paused and continued:

> *I'm here for you. If the worst imaginable thing happens to you or your family—whether someone gets raped or robbed or shot—you call me. Think about it. At the worst moment in your life, you will call somebody you don't even like: a policeman. Think about that.*
>
> *Policemen are people, too. And my kids could grow up without a father because I made a commitment to you. I've lost seventy-three police officers in my twenty-two years on the force. I love each and every one of you. So the next time you see a cop, walk up to him and say hello.*

All the students were leaning forward in their desks. Fourteen-year-old girls shifted uneasily in their seats. The boys gave one another quick glances with wide eyes.

He continued: "Look, nobody likes responsibility, but everybody is responsible for his actions, whether it is running a red light or not wearing your tie to school. Everybody is responsible."

The homicide detective turned away, walked to the whiteboard on the classroom's front wall and wrote:

GOD
FAMILY
FRIENDS

"That's what counts. In exactly that order."
Then he wrote the words:

CRACK
HEROIN
METH

"That is the devil's triangle. You do any of these three just *one time* and you will be addicted. One time! Addicted forever! That's what we are talking about right now—decisions."

Danny unloosened the stiff-starched collar on his white dress shirt. "You are the lucky few, the chosen ones, selected to be students at Marist.

Everybody out there," he said pointing out the window, "wants to be in here. You are here for a reason. Be proud of that. You make a bad decision and somebody out there is going to take your seat. It's all about decisions!"

Danny took his right foot and, with his heel, drew an imaginary line fifteen feet long. "There is a line right here, ladies and gentlemen. This side is **Good** and **God**."

He stepped across the line, which the students felt was burning a swath across the classroom floor.

"And this side is **Bad** and **Devil**. That side is the **Jedi**; this side is the **Dark Force**. Life is that simple. All you have to do is say *no*. *No* is the easiest word to speak in the English language."

Danny smiled to break the tension. "Listen to me. In your lifetime, there will be some things that will happen. You won't know what to do, and you'll be afraid to go to your momma or daddy. But you will never be alone. I will be there for you. I don't just mean here at Marist but later on in life. Whatever the situation is, you call me. We'll get you through."

The detective walked over to the ten digits written in red on the whiteboard. "This phone number is my cellphone. Call me, no matter what the problem."

Danny looked at the class for a final time. "Remember, I love each and every one of you."

Then he walked to the football field.

THE COACH'S WIDOW

Jef Euart is up before 6:00 a.m. most mornings communicating with the foremen who lead his landscaping crews. Soon they will head out to beautify the grounds of office parks, apartment communities and shopping centers that dot the north side of Atlanta. Via his hard work through the years, and his delivering a prize-winning, dependable product, his business provides a comfortable income for his young family. Jef devotes 100-percent effort to all his endeavors through his unyielding work ethic. He is also a square shooter. If Jef makes you a promise, it's a done deal.

Jef excelled in sports at Marist and later played baseball at the College of Charleston. He graduated from Marist in 1989, two years before his future wife, Tamsin, graduated from the same school. After college, he came home to Atlanta to start a business. In 1994, he applied to be a community coach at Marist. In 2012, he was still at it, as defensive coordinator.

So Jef truly has two full-time jobs. In football season, he arrives at the assistant coaches' office by 1:00 p.m., engages the DVD projector and breaks down the upcoming opponent's recent games. Each day at 3:50 p.m., the team lines up for stretching and calisthenics under the watchful eye of Jef. He is, in essence, the drill instructor, leading the team through a series of movements and cheers. After twenty minutes of stretching, the team closes in a tight circle around him. He tosses a football in the air, and when he catches it, the team roars, "War Damn Eagle!"

Then the rigors of full-speed practice begin. But after practice, Jef and his defensive coaching staff have more tasks—analyzing tendencies and personnel of the next team on the schedule. The coaches often work late into the darkness of the night. Sometimes Jef doesn't get home before midnight. And early the next morning he is at it again, dedicated to the duties that will compose his waking hours. And even though bone tired once at home, he relishes his duties with the children.

The Marist community is a close-knit family. Meaningful life relationships are the norm, not the exception among Marist graduates. Friendships are joined for a lifetime, and sometimes love happens.

Tamsin Euart was a cheerleader at Marist in 1989 and 1990 when the War Eagles raced to a twenty-eight-game winning streak and won Alan Chadwick's first state championship. She graduated from Georgetown University in 1995. During her senior year in college, she was introduced to Jef. They dated for four years and were married in June 1999. She knew she was not only marrying a man committed to excellence with a growing business in the private sector. She also knew she was marrying a high school football coach.

Tamsin explained:

> *Jef lives his life true to three entities: God, his family and Marist football, in that order. Sure, it's tough when Daddy isn't around the*

family much in football season. It's hard when the young ones ask, "Why isn't Daddy here?"

I understood it would take a major commitment by both of us to make it work, especially with the kids being involved. But Jef absolutely loves coaching Marist football. I knew that full well and completely accepted that as part of our marriage. I would never ask him to give it up. I grew up in that Marist tradition and sense of community that stays with you your whole life. There is uniqueness about the love in the Marist coaching community.

Tamsin reflected, "I'm supportive and wouldn't try to change Jef's choice for the world. Sometimes it's hard, and I tell him to get home, *right now*! But I'm good with it. He shapes kids' lives. We experience together the love of a community. He would be miserable if he didn't coach Marist football."

Tamsin slowly shook her head. "It's difficult for all of us in football season. But the time Jef spends here with his family is always high quality. Jef is the oldest of six children. I am the youngest of five. We both were raised in Irish Catholic families. We've got so much in common, sharing the same values. We work!"

Tamsin smiled:

Jef stands behind everything he says. He's an entrepreneur in the truest sense of the word and a risk-taker. But they are calculated risks, founded on substantial homework and research.

And he's so demanding. Sometimes players hate his guts, but when they graduate, they remember only how fiercely Jef had been committed to their improvement and success. The parents, faculty and alumni have no clue as to what degree the coaches sacrifice for the program.

You always know where you stand with Jef. That's why I love him. He takes a lot of pride in his reputation. He doesn't ask his boys to do anything he doesn't do. His dedication is boundless. When you are as passionate about things like Jef is, you have to love those things. Jef really loves doing Club Marist after the games on Friday nights.

Club Marist is a ritual, by invitation only. All nine varsity coaches congregate in the assistant coaches' office and rehash the game while

watching the high school scores roll across the TV screen at the front of the room. They also devour juicy slices of pizza, tell lies, shoot the bull and bond. They listen to scouting reports about the upcoming opponent. Ex-coaches and ex-players drop by to enjoy the camaraderie, the teasing and the unwinding after a pressure-packed week. Sometimes it lasts into the wee hours of a Saturday morning.

Rest assured Jef will be in his coaching cubicle on Sunday morning by 8:00 a.m., already breaking down film of the next opponent's offense, looking for weaknesses, seeking an edge, in what will be a ten-hour workday.

Tamsin smiled at the pictures of her two beautiful children. Tamsin was also nine months pregnant with her third child, due in October. "Kate was born in 2003. We won State that year. Jack was born in 2006. We went to State and played in the championship game."

Ever the confident football coach's wife, she smiled, patted her belly and simply said, "And now this…maybe a lucky omen?"

Chapter 6
A Ghost from the Past Reports In

S ome men enter adulthood unprepared, never having been taught how to succeed as youths. Their parents never stressed the importance of developing character through sacrifice. And they were never introduced to coming-of-age competition in the classroom or on the athletic field. Somehow they missed out on valuable life lessons that lead to discipline— the understanding and the pursuit of moral courage. The term "moral courage" simply means always doing the right thing.

When an adolescent faces adversity and responds positively, his confidence is fueled. He strives even harder as a result and becomes a winner. He enters adulthood prepared to face and conquer hurdles as he chases and confronts challenges. His parents and mentors led him to the realization that through courage, character, sacrifice and discipline, all his dreams could be fulfilled.

There is a special place with a special disciplined program that has been a paragon of success in developing character in young men. For one hundred years it has molded pubescent, rudderless boys into proud adolescent leaders, ready to face the world. The venue is the Marist School, and the discipline is football.

Marist football has produced decorated war heroes, successful lawyers, corporate chief executive officers and pillars of society. Award-winning authors, learned academicians, whiz-kid scientists and a legion of responsible husbands and fathers also wore the Marist blue helmet.

The line of succession, from the past to the present to the future, exists in the embodiment of the one-hundred-year-old Long Blue Line, the litany of all who have worn the blue and gold. Often they are referred to as the Ghosts of Marist Football. These are real Ghosts, and the coaches and players believe in them.

Players from the past visit today's players before games in the locker room, giving encouragement, and stand like sentinels on the sidelines during games. The tradition is handed down from team to team each year. Often, the Ghosts share their wisdom with current players. They tell the coaches how much the Marist experience meant to them and how they learned so much more about love and respect than they ever knew. Some develop character out of disappointment, just as the coaches turn defeat into a challenge to work hard to improve and grow.

In December 2006, Marist was preparing to head to Warner Robbins. The team had a date to meet superpower Northside High School for the AAAA State Championship. Northside was ranked Number 7 in the *USA Today* Top 25 High School Poll in America. Marist would be a considerable underdog.

Coach Chadwick received this letter as he was preparing his team for the battle:

Harvard Business School
December 8, 2006
Joe Gomes
MBA Class of 2008

Coach Chadwick,
Technology is an amazing thing. As I sit here in Boston, over a thousand miles away, I just finished watching you guys beat East Paulding High in convincing fashion in the State Semi-Finals. You've got to love the internet and Georgia Public Television.

I'm in the middle of my first year of graduate school and I should be studying for finals. Instead, it was more important to me that I spent a few hours tonight checking in on something I still care very much about. It is hard to believe that it has been over ten years since I wore the blue hat for Marist. Some things haven't changed at all; we still run the wishbone (although I

almost choked when I saw your quarterback line up in the shotgun tonight—that must be new), and many faces on the sideline are familiar.

But all in all, what I saw tonight was the same thing I've seen in Marist since I started watching games almost twenty years ago: a well-coached, methodical team executing the game plan and defeating their competition. As I'm learning here in business school, that kind of success doesn't come very easy.

Applying to grad school is a long, intense process. One of the more difficult aspects of the applications are the essays, and a common essay question is "What matters to you most and why?" For my Harvard application, I selected three important aspects of my life to discuss: family, impact on others, and winning.

I thought you might appreciate reading what I shared with the admissions committee in respect to how Marist Football taught me to win. Whether you realize it or not, you make a significant difference in the lives of your players. One that lasts long beyond their playing days, and for this, I simply wanted to say thanks.

Mike Parker (18) smells the end zone in a contest versus Woodward Academy, 1991. *Marist High School Photo Corps.*

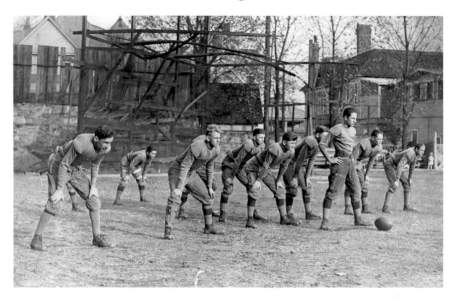

An early 1920s Marist team lines up in the single wing formation on the Ivy Street practice field. *Marist High School Photo Corps.*

On a side note, thought you'd like to know that my wife and I are expecting our first child in March—a boy—so make sure the school leaves a little room in the class of 2025 for him.

Best of luck next week against Northside to win State. I never got around to sending you a congratulatory note for the 2003 championship, so I figured I'd preemptively send one this year instead. I know this has got to be an incredibly exciting time for the team and I hope you guys can bring a championship home.

Sincerely,

Joey Gomes

He included the following essay that was part of his application to Harvard Business School:

Winning

"It's Friday night in the state of Georgia, and you know what that means."

—Alan Chadwick, Head Football Coach, the Marist School.

Every time Alan Chadwick ended a pep rally with those words, the student body exploded. Some say that football is religion in Georgia, and church services are held under bright lights on Friday nights. I spent five years learning to run the Wishbone Offense as a quarterback for the Marist School in Atlanta, Georgia, and I can still call those plays in my sleep. Although I was never the most gifted athlete, I was always the kid who would get the "hustle" award—not the kid who basked in the glory, but the kid that fought and tried like hell.

Although Marist is the size of a class AA school under state classification rules, we have always played on the AAAA level. Despite competing against schools twice our size, we have managed to win every Directors Cup, given to the best all around sports program in the state, since the award's inception. In fact, Sports Illustrated *recently named Marist as the 15th best high school sports program in the country.*

When I was 17, becoming the starting quarterback at Marist was the most important thing in my young life. I spent the majority of the summer of 1995 either on the track or in the weight room. By August, it was clear that our starting quarterback would be someone other than me.

I was crushed, bitter, angry, disappointed—for the first time in my life I viewed myself as a failure. I had a decision to make. I could pout and make excuses, or I could try to make the best out of a bad situation. I went to our head coach and explained that I was disappointed but I wanted to help the team, even if that meant changing positions. He respected my honesty and appreciated my unselfishness. I ended up playing my senior year as a back up tight end and scout team quarterback. Every week in practice, I would run the opposing team's offense and emulate their quarterback in an effort to prepare our first-string defense for the upcoming game.

Scout team quarterback is not a glamorous position, and your supporting cast doesn't always prove to be a worthy test for the first team defense. I spent much of that autumn bruised and beaten, but I never quit.

This was not quite how I had envisioned my senior year unfolding, but looking back on it, I wouldn't have traded this learning experience for the world. At our end of the season awards banquet, after telling the story of an anonymous player who as a leader did as much to contribute

to our successful season as any starter, assistant coach Geoff Lewis closed his award introduction by saying, "I got into coaching to coach players like Joey Gomes."

As I walked up to the podium to accept the Sportsman of the Year Award, I received a standing ovation from my teammates; it is the only standing ovation I have ever received in my life, and it was a moment I will never forget.

Losing the starting quarterback position changed me in two very significant ways. First, it put a fire inside me that has yet to go out. In fact, it sparks up and grows with every new challenge I face. I have always considered myself a competitive person. Like most people, I enjoy winning. But liking to win and hating to lose are two very different things. I am inclined towards the latter. Second, it taught me that you don't have to be the superstar to contribute to a winning team.

After that season was over, I made a few promises to myself. I decided that never again would I ask myself the question, "Did I do everything I could do? Did I prepare in every way? Did I give it my all?" I had known for a long time that I hated losing, but if I did lose, could I walk away and know that I had given it my best?

High school football in Georgia taught me loyalty, passion, excellence, and what it means to truly be a team player. I have carried these traits with me through four years of college and five years with Eli Lilly—and they have never let me down. And in those years since I left Marist—I have never questioned myself again.

Respectfully,
Joey Gomes

Chapter 7
One Family Together

A championship football program isn't built on just coaches, players and tradition. There are many other ingredients that contribute to the success of Marist football. It is the devotion and participation of the support groups that create the package that galvanizes the Marist community and campus.

The 3:00 p.m. school bell announced the close of another day. Students briskly filed out of classrooms, laughing at jokes and texting on cellphones. They headed to athletic fields and the library.

Alexandra Viers giggled at the question, "Are the football players different from the other boys at Marist?"

The AAAA Georgia High School Breaststroke Champion answered, "Well, almost all the boys *do* play football. Last year only two boys in the seventh grade didn't go out for football. It's the thing to do. Football is the king of sports for the boys here."

She sat in her desk in Coach Matt Romano's macroeconomics classroom wearing her blue Marist varsity letter jacket. On her desk was a handout with questions about "Changes in the Short-Run Equilibrium Price Level and Output." She expected to make an A in the difficult Advanced Placement course.

She had been swimming since she was four. For years she practiced each day and twice on Tuesdays, when her first practice began at the uncivilized hour of 5:00 a.m.

She had been accepted to Washington and Lee University, where she would study political science and swim. Alexandra intended to pursue a career as a political consultant for the U.S. Senate.

"Our swim team goes to the football games together. We love them. We go to dinner at the Mellow Mushroom for pizza after swim practice and then head to the game.

"Coach Romano has helped me relate to economic theory. He has actually made it fun. We're happy here at Marist because we are fortunate to have teachers like him. He cares."

Over 90 percent of the student body participates in at least one extracurricular activity. The school administration learned long ago that a busy student is a happy student. And happy students perform better academically.

In the athletic building, the cheerleaders were lined up outside a long hallway. They were enduring another rigorous workout. Football players passed them and entered the weight room. The girls' workouts consisted of exercises at fifteen stations, including pushups, squats, box jumps, squat thrusts, dead lifts, wall sits, abdominal rollers, band curls, band chest presses and mountain climbing. The nineteen well-conditioned and acrobatic young women executed four sets of each exercise before Mrs. Heather Nichols, the squad's coach, dismissed them.

Micaela Luckovich and Brittany Opraseuth, the varsity cheerleader co-captains, recalled that both were in the fifth grade when they saw their first Marist football game. The experience had a lasting impact on both of them.

Micaela related, "Actually, peer pressure made me go out for cheering originally. I have worked hard at it over the years, and that work has paid off."

Brittany agreed, "It is such an honor to be selected a captain. It's a lot of work, but it's so much fun. We do so much more behind the scenes than just doing the cheers and routines during the games."

Micaela, whose father is nationally acclaimed cartoonist Mike Luckovich with the *Atlanta Journal-Constitution*, was in charge of creating the banner the football team crashes through just before each game's kickoff. She planned to enter the University of Georgia to prepare for a graphic design career.

Micaela explained:

All the cheerleaders join together and brainstorm about the game at hand. We consider the opponent and our past relationship with that team. We create our art to be in good taste but also on the cutting edge of humor. We collaborate and create a theme. But we always include two things on the banner. The first is some sort of pest, like a roach or a nasty-looking wasp—something that should be destroyed. It represents the enemy. We also include a War Eagle on the banner in a prominent position in full attacking flight.

It takes us two or three hours to come to a conclusion about how the banner will look. Then we have to make it. It takes us another five hours to create the banner we would hope Leonardo da Vinci would be proud of.

Brittany said, "We have a weeklong camp in the summer just like the football team, as well as the conditioning program. It is a demanding job, but the Friday night games make it all worthwhile. The football players are our best friends. They treat us with respect. We are all in this together."

Brittany planned on enrolling at Georgia Tech with her sights set on medical school.

Out on the practice field, Coach Chadwick's whistle shrieked as his special teams practiced kickoff coverage and kickoff returns. Returners met tacklers in full flight, and the sound of leather popping was audible. The coach gave a small sign of approval. "Break!"

The players flocked to the sideline, where Katie Neel and Margaret Sikes, the football team managers, had stacked scores of paper cups with red Gatorade on a table. They sat contentedly in the managers' golf cart watching the thirsty players slurp down the contents. The two seniors were as much a part of the team as the defensive ends. The young women had been at this job since they were ninth graders. They performed their duties in the same manner the rest of the football program operated, with passion and successful execution.

Katie intended to pursue a career in broadcast journalism. She turned her head to the rear of the cart looking for some tape and said:

The Program

It's demanding work, but we love it. We get on the job at 3:30 in the afternoon and spend three hours doing this after school every day. On game days we are on the job from 3:00 in the afternoon til 11:00 p.m. Before practice we have to sanitize all the water bottles and Gatorade containers. We have to load the ice buckets and set up the tables where we fill up the cups with water and Gatorade. We take the baskets of red scout team jerseys down to where Bone Drill will take place behind the twenty-yard line.

Margaret added:

And the toolbox. We have to make sure it is always on the cart at practice and on the sideline at the games. It has every conceivable tool in it to fix things that go wrong. If a facemask breaks, we've got a tool that helps remove the broken one quickly so we can get a new one on as fast as possible. It's got extra pairs of cleats in it. We even put an extra helmet in it. Would you believe a guy forgot his helmet at a road game recently?

Margaret's green eyes lit up in the warm sunshine bathing the practice field. She would matriculate to the University of Georgia and pursue a degree in early education. "We love the coaches. If we have any problems, not just problems about football, but *any* problems, they are there for us, to help us through."

The coaches demand the same discipline from the female managers they do from the players. Once before a key region game, Coach Etheridge detected something amiss as he watched the pregame warm-ups. The female team managers were wearing camo, tie-dyed T-shirts. He ordered, "Go inside right now and go put on Marist football shirts. You are part of this team. We are fighting down here in the trenches, and this is a distraction. It's not about you. It's all about the team."

Five minutes later, the girls were back on the field, dressed properly. Katie said:

By being a football manager, I became close to not only the team and fellow managers but also the coaches. And because of their attitude and ethics these coaches are now some of the most respected role models in

my life. They have shown me what "tough love" truly is. They push the boys hard because they want the boys to do their best and be their best. Humility is stressed because once you are on top there is no place to go but down.

The unique mission of Marist School is to form the whole person in the image of Christ. It is created by blending three distinct traditions: the pursuit of academic excellence, the heritage of Catholic education and the spirit of the Society of Mary. Athletics, including football, is just part of the equation.

Jordan Barrs enrolled at Marist in the ninth grade. His family had moved to Atlanta from Savannah, where he made excellent grades at a highly regarded private school. In describing the adjustment, he said, "Boy, was I in for a surprise to see how hard Marist was. It was so competitive.

"I've really worked hard to maintain a 3.3 GPA average. Some of my classes are Advanced Placement courses. I do my best schoolwork during football season, when everything is structured. Football made me a better student."

The class of 2011 with 175 students included five National Merit Finalists. In addition, 12 percent of the class finished with a GPA of more than 3.99, while 46 percent finished with a GPA between 3.500 and 3.999. Recent graduates entered a who's who list of top academic universities, including Yale University, University of Pennsylvania, Princeton University, University of California, University of Notre Dame and Stanford University. Others headed to University of Michigan, University of Virginia, University of Southern California, University of North Carolina, Georgia Institute of Technology, United States Air Force Academy, United States Naval Academy and United States Military Academy. The University of Georgia claimed the biggest haul with forty-one graduates.

Marist athletics is an important component of the school's mission to "form the whole person." Since the school's founding in 1901, thousands of Marist athletes have learned sportsmanship, teamwork, personal responsibility and leadership. More than 80 percent of the school's students participate in at least one of the school's seventy interscholastic athletic teams.

The Program

Tommy Marshall, director of athletics, has shined in his role at Marist for fourteen years. Under his management, Marist has won the prestigious State AAAA Director's Cup thirteen consecutive years. The trophy is awarded to the school with the best overall performance in athletics in the state.

Part II

Victory and Defeat

Chapter 8
Ecstasy

W e prepare for the future by experiencing both victory and defeat. The lessons learned forge character. Games are an integral part of all societies. In ancient times, young boys were prepared for war by playing formal games.

There is nothing finer than the sweet ecstasy of winning. There is nothing more anguishing than suffering a bitter defeat. And learning how to deal with both teaches young men about character. Marist football is a training ground for success later in life, whether in battle or business, law or medicine.

Champions with great tradition have signature moments, victories for the ages, which provide inspiration for future teams. Alabama, Notre Dame, the Green Bay Packers and the Pittsburgh Steelers watch film of their triumphal predecessors for motivation before championship games.

The Marist War Eagles have had more than their share of memorable wins for almost one hundred years. The teams of the present and future draw inspiration from players of the past and refer to them as the Ghosts of Marist Football.

DECEMBER 18, 1989, SYLVESTER, GEORGIA

A few on the bus, which streaked through the darkening December afternoon, had traveled down this same road two years before, heading to Sylvester to play powerhouse Worth County High for the Georgia AAA

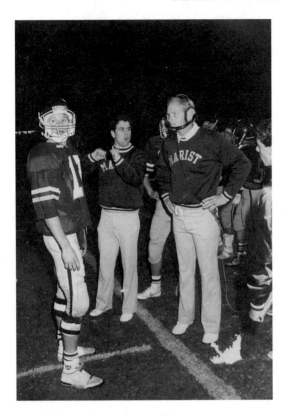

Coach Alan Chadwick discusses
strategy with quarterback Rob
Perez, 1987. *Marist High School
Photo Corps.*

State Football Championship. They had been sophomores then, part
of a Marist team with high expectations, sporting a 14-0 record. At the
end of that night, however, all the dreams had unraveled. The opponent
continually made one more key tackle or gained one more precious yard,
and Marist's championship dreams perished in south Georgia, 26–15.

But on this evening, the sophomores of two years ago would be the
senior leaders of this team, which was deep in resources led by quarterback
Sean Cotter, whose quick feet had propelled Alan Chadwick's triple-
option attack to roll up record-setting yardage during the season. Once
again, an undefeated 14-0 Marist squad headed to its destiny, deep in
south Georgia, where the top-ranked team in the state waited in ambush.
Nerves were on fire, and a number of the Marist players leaned against
the bus just before getting aboard, losing their pregame meals.

Two Georgia Highway Patrol cars eased out of the parking lot
and onto U.S. Highway 82, providing escort. The bus took dead aim

for hostile Worth County Stadium, twenty-two miles to the west. The blacktop artery sliced through piney woods, swamps and farm fields that stretched to the horizon.

The setting sun hung like a red plum in the center of the windshield, sending a blood-red glow down the inside walls of the bus and across the players' faces. Dusk descended, and the patrol cars' whirling blue strobe lights cast an eerie glow through a fog mist that hovered just a few feet above the road. Tires slapped against the asphalt, and windshield wipers played a tick-tock dirge like a clock nearing a final countdown: *whish-tick, swish-tock.* Players stared straight ahead, jaws clenched, nerves jangled, transfixed with thoughts of what lay ahead. *Dear God, please help me be stronger than my foe...please help me fulfill my dream.*

Nary a word was spoken. The mist lifted. All daylight departed. Not a sound could be heard but the humming of the silver bus's powerful motor.

It would be the fifth time in the past nine years that the team from the Catholic private high school in Atlanta had traveled to south Georgia for the state championship. Yet somehow things seemed different this time. There was plenty of talent, enhanced by a blue-collar approach that squeezed the will and life out of a succession of good opponents. This team developed a winning credo created by some inspirational seniors: all-state lineman Boyd Andrews, relentless linebacker Stewart Williams and hard-nosed halfback Lance McCormick. A talented junior class was led by shifty pony-back Mike MacLane and blue-chip lineman David Weeks.

Worth County's offense was led by sensational all-state halfback Robert Toomer, who later would star for LSU. He had already smashed the all-time Georgia schoolboy record for most career carries. The Rams' defense was anchored by a pair of six-foot, two-inch, 225-pound aggressive defensive ends, a corps of ferocious linebackers, and quick-as-mercury cornerbacks. The team was playing with ultimate confidence and swagger, having throttled most opponents for the past three seasons.

It was clear to the Marist coaches that they would have to play so tough that Worth County would be taken out of its normal game. The coaching staff burned the midnight oil during the week leading up to the game, endlessly scouring Worth County films. All season, their players had bought into the discipline and sacrifice required to gain the right to engage in a fifteenth game. The team was one organism.

The bus pulled adjacent to the stadium two hours before kickoff. The players followed the head coach single file into the visitors' dressing room, a cramped, musty rectangle.

Local grade-school youngsters loomed over the entrance to the locker room from the stands and derisively yelled insults: "You fish eaters are dead meat!" and "You city-slickers are gonna wish you never left Atlanta!"

Coach Chadwick gathered his team in a circle around him:

> *We will start our regular pregame routine in thirty minutes. Right now I want you to walk out to that field and observe a scene that you will never forget. Because tonight that field is yours. Go stand under one goalpost and look down the length of that field, which is your field tonight, to the other goalpost. Look at the lights gleaming down and look at the stands filling up. Behold the scene of a championship football game, then come back in here and put on those blue hats and get ready to grab the ring.*

An hour later, the eleven-thousand-seat stadium was teeming. As the Marist team trotted out of the locker room, belligerent local fans threw pennies, spat at and cursed the players.

"Hey, little rich boy! Yo mama drive you down here in her fancy Mer-Say-Dees Bends? You boys will be needin' a hearse after tonight."

"The Blessed Virgin herself ain't gonna be able to help y'all tonight."

In the end zone, the Crisp County athletic director was answering questions from a small circle of south Georgia football coaches. The only question was how bad would Marist be beaten. After all, they pointed out, "Looks like just a bunch of slow white boys. They ain't got a chance in hell against these fast athletes we got down here."

The athletic director had been in attendance for the Marist practice the evening before at the Crisp County football field. "I wouldn't be so sure if I were you, boys," he responded to the coaches. "They were in sweats at my place last night, and I have never seen a team go full speed without pads like that. They were banging the hell out of each other. Why, I saw number 54 haul off and hit number 65 square in the jaw! I guarantee they ain't afraid and will come to play. Don't count 'em out."

The other coaches appeared shocked.

Meanwhile, Alan Chadwick had crafted a special play after watching tapes of Worth County games. Their defensive ends and outside linebackers pinned their ears back and charged hell-bent-for-leather into the opponent backfield, wrecking running plays while putting constant heat on the quarterback. Meanwhile, the Worth County cornerbacks played it honest, patrolling out on the perimeter in case the other team tried reverses or toss sweeps. The coach marveled at the aggressiveness and effectiveness of the talented defense.

No wonder they rarely give up any points, he mulled.

And then it struck him. He would turn their aggressiveness into his ally. During practice that week, Sean Cotter worked on the quarterback counter-play with countless repetitions. Taking the snap from center with the backfield lined up in a pure vanilla wishbone formation, Sean would step and turn smartly to his right, faking the ball to his fullback heading off his right guard's left hip. The two halfbacks also sprinted to the right and the linemen veer-blocked to the right. Marist was showing its classic triple option play, 42 Triple, the staple bread-and-butter play. It was the very same play Worth County would concentrate on at practice. Their coaches declared if Marist's triple option was stalled, the state championship would be theirs again.

But it was all a setup by Chadwick. After the fake to his fullback, after the whole defense crashed in and angled to its left, Sean would quickly pivot the opposite way and stutter step toward the gap between his center and left guard. The whole defense would head one way, and Sean would go against the grain. Taking quick steps, he would cut behind a seal block by his left tackle, find daylight and hopefully set sail for big yardage.

It worked. The first time the play was called, Sean cut back on the counter-play and scampered for thirty-one yards, the key play in a seventy-six-yard touchdown drive. Chadwick kept the defense honest, calling traditional fullback plunges and halfback sweeps. Again in the second quarter, the quarterback counter-play was called. Sean wheeled after faking to his fullback, cut back and burst downfield for a twenty-eight-yard gain. Marist jumped ahead 14–0. The Worth County defense looked disoriented and began to play with less intensity.

Just before halftime, Chadwick reached into his bag of tricks and pulled out the ultimate gadget play. Just seconds remained on the clock,

and Marist was nearing field-goal range. As Sean Cotter readied his team for the next play, his split end raced into the huddle from the bench and whispered, "Fumblerooskie!"

Sean took the quick snap from his center and, with sleight of hand, quickly placed the football next to his center's left foot and rolled out to his right, following all three of the other backs. The right guard, Matt Post, slowly counted to three and then moved to his left, picked up the football and sprinted unnoticed by the Worth County defense and the packed stadium. He sprinted like he never had before until he crossed the goal line and fell to the turf. The noise in the Marist stands was tumultuous. It was halftime, and Marist was shocking the state of Georgia, 21–0.

Worth County scored a touchdown in the third quarter to narrow the gap. But then the rigid Marist defense took over, denying any more first downs. Marist middle linebacker Stewart Williams, a five-foot, eleven-inch, 225-pound tackling machine, was in on a score of tackles. The swarming defense put three hats on each ball carrier and receiver, throwing a lasso around the high-octane Worth County offense, which meekly just slunk away. In the fourth quarter, Marist iced the game when Cotter engineered another touchdown drive, highlighted by his seventeen-yard dash employing the same quarterback counter-play.

As the final ticks took the game clock to zero, pandemonium swept across the Marist sideline and through the stands behind the bench. Marist had won the state championship, 30–6, in the most hostile of environments. The Marist wishbone attack had rolled for almost four hundred yards rushing, and the defense had played as if possessed. And they won it the way Alan Chadwick drew it up, pounding the football relentlessly without throwing a single pass.

The perfect season, a 15-0 run, once a dream by the coaches and players in the punishing August heat of three-a-day practices at summer camp, had been achieved. And bedlam and joy filled the team bus on its four-hour trek back to Atlanta.

The spirit of that 1989 team would join the top of the roll call of the history of the Ghosts of Marist Football past.

The following year, Marist reeled off thirteen wins in a row. The seniors were now 28-0 since moving up to the varsity as juniors. Finally, on another road trip to deep south Georgia, they experienced for the first

time the gut-wrenching agony of defeat, losing to Cairo High School in the 1990 semifinals.

Oh, but what a fabulous ride it had been!

AUTHOR'S NOTE: The author's son, Franklin Cox III, was a reserve halfback on the 1989 and '90 teams. He never forgot one second of the miraculous day his teammates won the state championship. He savored the moment as he looked around the stadium just before the game ended and promised himself, "What a wonderful film I'm going to make from this experience." He majored in drama at the University of Georgia and attended NYU film school. He has been Alan Chadwick's videographer for the past eleven years.

Chapter 9
Improbable Victories

There are times when a Marist team must do the impossible, against all odds. In the huddle, the players suddenly sense a twelfth man they cannot see. But they believe in the Ghosts of Marist Football, and they know the powerful spirit of the past is with them. They cannot dishonor the spirit by faltering. Nor can they let their teammates down. There is a job to be done.

THE DRIVE

December 5, 2003
Hughes Spalding Stadium

Except for one bump in the road, the 2003 Marist regular season had been near perfect. The team crushed its first two playoff opponents and then prepared to face Number 2–ranked Shaw High, an undefeated team out of Columbus, in the AAAA quarterfinals. The good news was that the War Eagles had earned the right to face Shaw at home, where Marist had not lost a playoff game in ten years. The bad news was that Shaw would be packing its buses for the two-hour trip up to Atlanta with a squadron of powerful, heavily muscled, swift athletes.

Victory and Defeat

Both defenses played with rigid determination in the first half, and Marist took a 12–10 halftime lead. Late in the third quarter, Shaw mounted a forty-six-yard touchdown drive that resulted in a 17–12 edge. After the kickoff, Marist took over on its own twenty-yard line with 11:43 left in the game. On first down, halfback Chris Davis burst for eleven yards and a first down up to the Marist thirty-one. All-state quarterback Sean McVay then gained four yards on the speed option play. On second and six, fullback Michael Ashkouti bulled for four more yards. On third down, the powerful fullback ripped for ten more yards, and Marist now had a first down on its forty-nine-yard line.

The clock wound down as Marist kept to its ground game. The excitement in the Marist stands morphed into a clamor. Marist would have to go the distance for a touchdown or fold tent for the season. The thick Shaw linemen took their defensive stances and dug their heels into the soil.

Chadwick went back to the same play—42 Triple. Ashkouti burrowed for three more valuable yards behind blocks by Kyle Murphy and Matt Rumsey. On second down, McVay chanted the count at the line of scrimmage while looking downfield. He rolled out to his right, noted the near cornerback backpedaled with the split end and raced around the corner for an eight-yard gain. Marist now was forty yards away from paydirt.

On first down, Marist ran the triple option to the left side—43 Triple. Ashkouti kept the handoff and powered for four tough yards. On second down, McVay faded back for a play action pass and then darted for two yards. Shaw burned its second timeout. McVay and his offense trotted to the sidelines. The coaches had to shout to be heard while giving instructions to the offense. The din from the Marist stands was earsplitting. Marist had a third down on the Shaw thirty-four. Four yards were needed for a first down. The team was now in four-down territory. It was quickly decided there would be no pass play. The Marist linemen would have to get lower and surge for a push to make room for the ball carrier. Marist chose the "veer" play, and Ashkouti followed his left guard, Alex Salzillo, for a seven-yard gain down to the twenty-seven and another vital first down.

There was no panic in the Marist huddle. There were just over five minutes left in the game. Marist needed not only to score the touchdown but also to bleed as much time off the clock as possible to deprive Shaw

the luxury of having ample time to respond. The chorus rippling out of the Marist stands became a cacophony of cheers and mad screams. Grown men stared wide-eyed down at the field, yelling until their faces became scarlet. An uneasy pall of silence wafted through the Shaw sidelines and stands.

Marist repeated the same play. Ashkouti rambled off left guard for nine more bruising yards to the Shaw eighteen-yard line. Halfback Anderson Russell, who later would become a four-year starter for Ohio State, slashed for nine yards on a counter-play for a first down on the Shaw nine-yard line.

The Marist fans could sense the kill now. There was blood in the air. The Shaw faithful became raucous, begging the defense to stiffen and thwart the long Marist drive.

Hold that line, hold that line! Dee-fense, dee-fense, dee-fense!

It was crunch time for the Marist ground game. On first down, they went to their bread-and butter-play, 42 Triple, and Ashkouti bulled for three yards to the Shaw six. On second down, Marist went to the well again. Ashkouti carried again on the same play and gained a meager yard to Shaw's five-yard line.

McVay called timeout. Marist had two downs to gain five yards and the lead. There was just over 2:40 remaining. It was all down to this. Could Chadwick pull a rabbit out of his hat with clever play calling? Would the powerhouse Shaw defense shut down the Marist quest?

"Let's go veer again," Offensive Coordinator Etheridge suggested to Chadwick, who agreed. But McVay had spotted something. He got word to Etheridge up in the booth. He knew *the* play that would work. It was "there!" he said. Etheridge, at the last instant, changed the play that could decide the season. He said, "OK. Let's run it!"

McVay quickly broke the huddle. He strolled up to the line of scrimmage and checked the Shaw defensive formation. Marist was lined up strong right, and Shaw had shifted accordingly.

Perfect! McVay thought, as a swarm of butterflies danced inside him. He took one last deep breath and called the signals as the whole stadium rose to its feet.

The Marist linemen blocked to the right, and the other three backs ran the "wham" play to the "2" hole, between center and right guard.

Four Shaw defenders took Ashkouti down at the two-yard line. Four more defenders drifted to their left to safeguard against a reverse or misdirection. It seemed the play had been blunted.

But McVay had completely turned his back to the defense and faked to the last back heading for the hole with his left hand while hiding the ball in his stomach with his right hand. He calmly turned his head for two full seconds and watched his backs attack the line of scrimmage.

The whole world fell for the fake as McVay bolted to the left on a naked bootleg play. No Shaw defender saw him waltz into the end zone, and no defender was within ten yards when the official raised his hands to the heavens. *Touchdown!*

Finally, the fans spotted McVay handing the football to the official. The roar of approval echoed around the concrete stands. Grandfathers cheered, and schoolchildren did little jigs. Parents hugged each other, and cheerleaders burst into tears of joy.

It had been the grandest of drives.

Shaw got the kickoff, went nowhere and the game ended.

The following week, the Georgia Dome was the venue for the 2003 AAAA semifinal games. Thomas County Central, a south Georgia power and an old Marist nemesis, was the opponent. The teams had done battle with each other four times in the Georgia Dome in a running feud stretching over the previous decade. And Alan Chadwick had come up just short at the end of each game.

The teams met in the 1996 state semifinals in what was fast becoming a smoldering rivalry. Marist led 21–14 when the top-ranked running back in the state, Joe Burns, broke loose for a late touchdown with just seconds left in the game. Eschewing an almost certain extra-point attempt that would tie the game, Ed Pilcher, the veteran Thomas County coach, decided to throw caution to the wind and go for 2 points then and there. The quarterback faked to his fullback and tossed back to Burns, who broke to his right. But Marist had sniffed out the play and braced against the run with an eight-man front.

Burns took the ball and sprinted to his right, turned upfield toward the goal line and then raised his right arm and launched the ball to the back of the end zone. The pass was perfect, good for the 2-point play and a 22–21 win. Dismayed, the Marist defenders fell to the turf.

Coach Pilcher said after the game, "We had to gamble on fourth down. We hadn't stopped Marist all night long, so I decided against going for the tie. I figured we might not get another chance as good as right then to win the game. We guessed right."

So in 2003, once again, Thomas County Central and Ed Pilcher stood as a roadblock in the way of Marist's state title aspirations. There were so many black-and-gold-clad Yellow Jacket fans in the huge indoor facility that it appeared the whole county had driven the 215 miles north to Atlanta from Thomasville.

But on this night, the jinx was to be broken. Marist quarterback McVay's quick feet and accurate arm led Marist to a convincing 35–21 semifinal victory. Marist's stingy defense clamped down on the potent Thomas County offense in the second half, paving the way for a state title game at home for the first time since 1979.

The looming 2003 AAAA State Championship game seemed like an anticlimax after the joy of the Thomas County Central victory. Alan Chadwick sensed it the first thing Sunday morning while viewing a game DVD of Statesboro High School, a rugged south Georgia foe that would travel to Marist for the fifteenth and final game of the year. His team had deliriously celebrated on the green carpet of the Georgia Dome and on the bus back to the locker room after the semifinal win. Somehow, he would have to bring the team back to earth to focus on the job at hand.

As the coaches gathered for a meeting early Sunday afternoon, he addressed the issue. "I'm afraid we think we won the state championship last night. These players will have a hangover, a letdown, after they finally beat Thomas County. We've got a real challenge in front of us this week to motivate this group."

He looked around the table at his assistants: "Think about it. A state championship game—right out there on our field! We've got to get their attention. If we challenge this bunch of ours, they'll respond positively."

His team had averaged 364 yards rushing for the previous fourteen games. The coach had a plan. "Statesboro hasn't faced a true triple-option team like us this year. We will run it, and run it, and run it some more. And that's how we'll win."

On a frigid December evening, Marist took care of business at home in a swollen Hughes Spalding Stadium. The Marist running game controlled the clock, and the War Eagles dismantled Statesboro 20–6, to claim Alan Chadwick's second state championship.

The key to the state championship was the eventful fourth-quarter drive on the same field two weeks before against Shaw High, when a coaching staff and team resolutely joined as one to fashion a courageous drive for the ages, a successful drive against the clock and a determined enemy, an implausible, plucky drive that ultimately produced the Georgia AAAA 2003 State Championship.

THE PLAY

December 5, 2008
Hughes Spalding Stadium

It was frigid on the Marist sidelines in the state semifinal football game. And so was the Marist offense in the first half against the visiting Rome Wolves. The winner would move on to play for the AAAA State Championship the following week in the Georgia Dome. Rome is sixty miles northwest of Atlanta. It is small-town, proud and as American as a Norman Rockwell illustration. And a great portion of the town had traveled to the Marist campus to support its boys.

Marist sputtered with the football in a mistake-riddled first half. And Marist's defense had no answer for Rome's wing-t offense, which had its way with quick sweeps. Late in the second quarter, Marist quarterback Kyle Farmer hit wideout Penn Davenport on a slant pattern that went the distance. Down 14–7 at intermission, the Marist coaching staff made major halftime adjustments.

Rome High ran a quick sweep to the right to open its first possession of the third quarter. The Marist defense smacked the halfback down for a two-yard loss. Rome came back with the same play on third down. The result was the same.

After a Rome field goal midway through the third quarter, Marist eked out a couple of first downs on runs by junior backs Matt Connors and

Patrick Sullivan. Connors rambled for fourteen more yards on a fullback quick trap for another first down. Then fleet halfback Sam McNearney went the distance from the thirty-one-yard line. Marist missed the extra point and trailed, 17–13.

Minutes later, Rome recovered a blocked Marist punt within the shadows of the Marist goal line. A touchdown would seal Marist's doom. But on second down, Rome was called for holding after a halfback carried down to the Marist two-yard line. The Marist defense held, and Rome missed a field goal attempt.

With 5:18 left in the game, Marist took possession of the football on its own twenty-yard line. Marist needed a touchdown or the season was over. In the huddle, quarterback Farmer asked the split end who had just brought in the first play to repeat himself. The racket in the stadium was earsplitting. Farmer took the snap and followed fullback Conners for twelve yards on a midline power play.

Farmer then hit McNearney with a flat pass for five yards. On second down, Farmer ran the midline play to the left for three yards. On third and two, Farmer called for a speed option play to the left. At the last possible second, he pitched to halfback Sullivan, who converted for fourteen vital yards. McNearney helped spring his halfback partner loose with a concussive block at the corner.

The clock ticked inside the three-minute mark as Marist stared at the goal line forty-six yards away. The Marist bench players turned toward the stands behind them, motioning with their extended arms, begging the fans to stop roaring. The players on the field were having a tough time hearing the quarterback's signals.

Then Farmer went back to the well with the midline play to the right again. His linemen, Trey Nordone and Hugh Williams, flattened a couple of Rome defenders, and the quarterback slithered for twenty yards down to the Rome twenty-six-yard line.

On first down, Farmer kept for a single yard. On second down, McNearney took a toss and gained three yards. On third and six, fullback Connors smashed for five yards on the belly play.

Marist went to a double tight end set on fourth and one. It was do-or-die for both teams. Connors angled off tackle on the belly play again, got hit at the line of scrimmage, kept his legs churning and gained three yards.

Marist had new life with a first down on the fourteen-yard line. The clock raced inside two minutes. Both teams' timeouts had been spent.

On first down, Marist went to the belly play again and lost two yards. Farmer dropped back on second down and threw incomplete. On third and twelve, Farmer drilled a slant pass to split end Kevin Allman, who was blasted by the Rome safety but hung on for a thirteen-yard gain and a first down on the Rome three-yard line.

The official spotted the ball and wound the clock again. Less than sixty seconds remained.

On first down, Marist ran the triple option to the right, the short side of the field, for no gain. It was the very play the seniors had practiced for countless repetitions the past six years. It was the integral driver of the offense. The opponents knew it was the heart and soul of the Marist system. And it could be stopped, *if* each defensive player stuck to his responsibilities. It only took one miscue by one opponent on the other side of the ball for the triple option to work.

On second down, Offensive Coordinator Paul Etheridge called for the next play to be run in the same direction, to the short side of the field. Farmer took the snap and pitched to swift Sullivan on the speed option play. But the Rome defense nailed the Marist halfback for a one-yard loss.

The clock was inside thirty seconds, and Marist had a third down on the Rome four-yard line. Pandemonium, hope and fear swept through both sides of the rollicking stadium, which had a life of its own. The noise was maddening, the tension almost unendurable.

The ball was snapped, and the Marist backfield headed right again. But this time Sullivan took the pitch, planted his feet and threw a halfback pass. It fluttered to the ground in the end zone, incomplete, with three seconds left. Enough time for one more play.

Etheridge instantly sent in the play, the one that would decide the season for both teams.

Twenty-two players lined up on the stage. It became the center of the universe. Marist moved up to the line of scrimmage and got set. Rome dug in. The movements seemed to be in slow motion, and all the noise went away just before the snap.

Marist lined up in a pure vanilla wishbone formation. It signaled run, with power, was on the way. The play started, once again, to the right,

and the Rome defenders angled that way. Farmer took two steps to the right and stuffed the ball into fullback Connors's midsection. They had gone to the belly play again, it appeared. But in an instant, Farmer yanked the football back and, in one motion, pitched to his right. Split end Allman had lined up far to the right side of the formation, just yards from the right sideline. The instant the ball was snapped, he was in full stride, sprinting to the left, the opposite way Farmer was moving. He caught the pitch from Farmer on the nine-yard line and turned on his speed.

Time had expired, but the play would continue. A Rome cornerback headed in the same direction. Allman set dead aim on the far orange pylon in the left corner of the field at the goal line. He locked onto his target like an Exocet missile. The two met at the three-yard line, just a few feet inside the sideline. Allman lunged forward and stretched his six-foot, three-inch frame, cradling the ball with his outstretched right arm, and fell to the earth. The official four yards away raised his arms to the black sky. *Touchdown!*

The event occurred with such finality that a surreal calm descended on the players. They all just stared at the referee, the football inside the goal line and the clock for two, maybe three long seconds. And then both teams understood.

The stands emptied onto the field. A throbbing, hysterical, human mass enveloped the players. Rome players knelt and smashed their helmets into the turf. Marist players did pirouettes and hugged moms, girlfriends and one another.

Then the players shook hands. The Rome players silently walked to their bus in shock. And Marist was heading to the Georgia Dome. They had a date to play their bitter rival, Tucker High School, again, this time for the state championship,

The team knew that somehow the Ghosts had played an integral part in the miracle. There was no doubt there had been a twelfth man in the huddle. You just couldn't see him.

THE KICK

September 17, 2010
Hallford Stadium

Southwest DeKalb High School would be the foe in a must-win game
for each team. Since 1972, SWD had won sixteen region titles and two
state championships. And for this big game, it would have the luxury
of playing at home. The game would also be broadcast on TV as the
Comcast Game of the Week.

The winner would have a chance to land a playoff berth at home. The
loser could be staring at no playoff spot at all.

Coach Paul Etheridge spoke to the team in the classroom before
boarding the buses Friday afternoon: "I don't care if it rains. I don't care
if the game starts at nine o'clock tonight. I don't care what happens. We
go down there and smack them and come away with a win! We will take
it to them and come away victorious."

Friday afternoon rush-hour Atlanta traffic in the fall is a challenge,
testing the wits and patience of all motorists. It is especially stressful for
Coach Chadwick when his team heads south to play Southwest DeKalb
in Halford Stadium, located way down in the southern part of mammoth
DeKalb County. The trip must be endured on one of the most congested
roadways in the country, infamous I-285.

The route takes the team through the tangle of Spaghetti Junction
and past the exit for Stone Mountain, whose mammoth granite majesty
is to the east. The trip to Panthersville, Southwest DeKalb's home, is
forty-five minutes according to MapQuest. But Alan Chadwick could not
count on that during a Friday afternoon rush hour when the motorway's
sometimes ten lanes of traffic become clogged.

The coach has an inflexible pregame routine on gameday. Elements
of the team will leave the locker room for warm-ups at intervals. The
designated times are written in bright blue characters on the whiteboard.
The routine does not change; Marist football does not change.

So the head coach planned ahead for the traffic. God forbid his team
might be denied his unbending time sequence ritual of pregame warm-

ups. He ordered the traveling party to board the buses for a 5:00 p.m. departure, three hours ahead of kickoff.

The early fall sun slanted through the tinted bus windows. To the west, the panorama of the downtown Atlanta skyline thrust into the blue sky. Young men's heads drooped when some fell into fitful catnaps. Others drummed fingers against windows, mimicking the rhythms and lyrics of Eminem. The head coach, riding shotgun in row one, right side, stared rigidly ahead. Finally, the bus crept off the final exit and pulled up to the stadium, directly on schedule.

Before warm-ups, Coach Chadwick gathered his team around him just outside the south end zone. The 250-member Southwest DeKalb marching band—one of the most dynamic in the country, with six drum majors decked in white bell-bottom pants and flowing blue capes, high-stepping to the beat of snare drums, traced by a score of bronze dancing girls in sleek, skintight gold outfits, shimmying in step to the blasts of tubas—stormed past. The packed stadium throbbed with an electric racket.

"Look around you. You're in a hostile place. But I am not leaving here tonight without a win. You put that blue helmet on and go hit somebody like you've never done before. Then do it again. There are hundreds of past players that wore that blue helmet that will be watching you tonight. They expect nothing less than you to play as passionately as possible."

In the first half, both defenses controlled the tempo, and at halftime, the score was 7–7.

At halftime, Coach Jef Euart spoke to the team: "This is your whole season. You will be measured by this second half. You can either win and go forward or lose and pack it in for the rest of the season and fail to make the playoffs."

In the fourth quarter, Marist trailed 14–7. The defense held and the offense drove to the one-yard line. With less than five minutes to play, on fourth down, halfback Gray King glided across the goal line to tie the game, 14–14.

Defensive tackle Justin Olderman led a stiff defensive effort and forced a quick punt. Marist got the ball back with just under a minute remaining on its own thirty-one-yard line.

A quick trap play for four yards followed by a completed eleven-yard pass by Perez gave Marist a vital first down. On second down, the

quarterback connected for another eleven-yard gain to move the chains. Marist rushed for five yards on a midline play down to the Southwest DeKalb forty-two-yard line and called time with only fifteen ticks left on the clock.

After two pass incompletions, and with only three seconds remaining, Marist called its final timeout. Chadwick chose to eschew a last-gasp Hail Mary pass effort and sent kicker Austin Hardin in to attempt a fifty-nine-yard field goal.

No way, Jose. Everyone in the stadium thought it an impossible task—except for two people, Alan Chadwick and his young kicker with a powerful leg.

The ball was snapped, and Hardin strode forward, his foot delivering a powerful blow. The football took an incredibly high arc, fluttering for one, then two, then three seconds toward its destination. At the last possible instant, it curled just inside the right upright and tumbled over the crossbar.

Disbelief engulfed Southwest DeKalb as their coaches fell to their knees, burying their faces in their hands in frustration. The scoreboard told the final story—Marist 17, Southwest DeKalb 14.

A few wondered…how did it twist to the left at the goalpost just at the right instant? Were there some Ghosts at work?

Chapter 10
Agony

Disaster

August 28, 2009
Friday, 1:30 p.m.
Kuhrt Gymnasium, Marist School, Atlanta, Georgia

Mike Coveny became the first Marist player in school history to rush for more than one thousand yards in a single season. He was named all-state halfback and played in the state championship games in 1979 and 1980. Mike earned three letters playing football for Princeton University. He then gained his law degree from Emory University Law School and practiced law for ten years. But his heart was in coaching, and his love was for his alma mater. So he returned to Marist in 2006 to coach football and to teach.

He dismissed his American history class at noon and joined the Marist coaching staff in the gym to witness the year's first pep rally. Tonight's opening game would be as important as any playoff game. The opponent had been Marist's biggest rival for fifty years.

Over seven hundred students screaming at the top of their lungs could not diffuse the ear-piercing, amped-up music pouring from the public-address speakers in the gymnasium. AC/DC was gunning out guitar riffs and bellicose vocals from its heavy metal masterpiece "Thunderstruck." The audio accompanied a four-minute video montage dancing across the large screen in the middle of the auditorium showing the most riveting

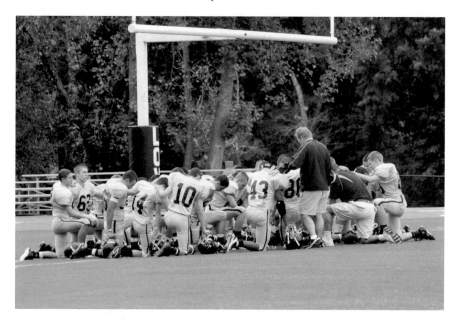

Coach Mike Coveny leads the pregame prayer for a Marist junior varsity game on the road at Lovett. *Marist High School Photo Corps.*

plays the Marist football team had delivered during the past four years against its most hated rival, Saint Pius X High School, whose team was coming to pay a visit.

Cheerleaders danced, yelled and performed somersaults in front of the jammed stands. Sixty varsity football players, in jeans and blue jerseys, exchanged high-fives after each bone-crushing tackle floored an enemy running back and after each long-yardage Marist touchdown gallop appeared on the screen. Teachers howled, coaches threw fists in the air, mothers and fathers clapped until their hands were crimson. Gameday had finally arrived.

August 28, 2009
Friday, 4:00 p.m.
Marist School Chapel

The players took seats on the benches arranged on three sides around the altar in the Marist Chapel. It was time for the pregame Mass, part

of the Marist experience for the school's football team for nearly one hundred years.

Coach Chadwick was the last to enter the chapel. On cue, the priest and his altar boys made a quick entrance, and the Mass began. Father Ralph Olek, in a cream chasuble trimmed in crimson, stood behind the waist-high altar and blessed the team.

Coach Chadwick gave his prayer responses in a clear, distinct voice. Many players just mumbled responses. The head coach stood, glared at his team and then raised his outstretched arms, ordering his team to increase the volume with meaning. They did.

At the moment the bread and wine were consecrated, there was no sound whatsoever in the chapel, now lit by slanting, yellow afternoon rays from a late summer sun. Just before communion, a ritual of love and togetherness transpired. The players rose, formed lines and gave one another hugs and soft words. There was a steady rhythm of backs being slapped mixed with soft words about brotherhood.

After communion, the players slumped in seats, heads bowed, hands knitted together. The only audible sounds were of breathing—quick, nervous pulls of oxygen followed by long exhalations, the sound of stress being relieved.

Father Ralph instructed, "Go, the Mass is ended. But remember to not only give it all you have but, more importantly, show your best sportsmanship during the game and after."

August 28, 2009
Friday, 10:05 p.m.
Hughes Spalding Stadium, Marist School, Atlanta, Georgia

The stadium lights beamed into Coach Coveny's cobalt blue, bloodshot eyes. The coach blinked repeatedly at midfield while looking at the blasphemous scene unfolding on his sacred field.

This can't be happening, he considered, clinging to the last vestiges of denial. But the searing pain ravaging his soul told him otherwise. *Oh, it's real*, he thought. *It's as real as a heart attack.*

His bitter rival was dancing up and down on his ten-yard line, and its players held their golden helmets aloft like spoils earned in combat.

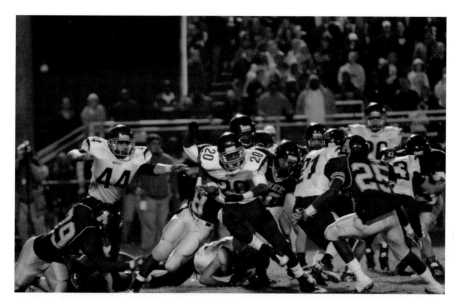

Marist's Jordan Snellings (20) bursts through the Apalachee line for positive yardage in a key playoff game as Jonah Cashdan (44) provides assistance, November 20, 2009. *Toni James.*

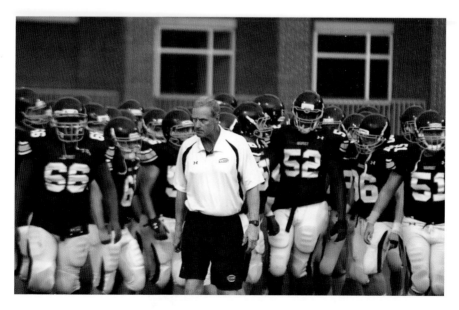

Marist head coach Alan Chadwick leads his squad onto the field for a preseason scrimmage. War Eagles Steven Wallace (66), Kendall Baker (52) and Matt Orr (51) follow, August 19, 2011. *Toni James.*

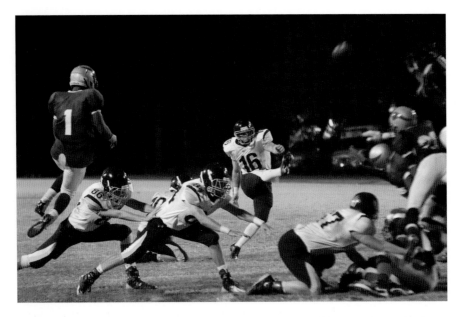

Bill Young (86), David Phelps (84) and Tyler Whitehead (67) provide protection as Austin Hardin (16) launches a booming punt in a Marist rout of Lakeside 53–0, October 8, 2010. *Toni James.*

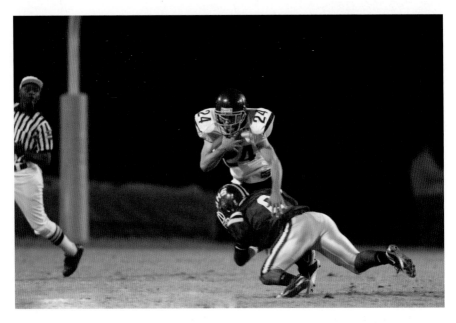

Halfback Jack Mohan (24) fights for Marist first down yardage against Dunwoody, October 15, 2010. *Toni James.*

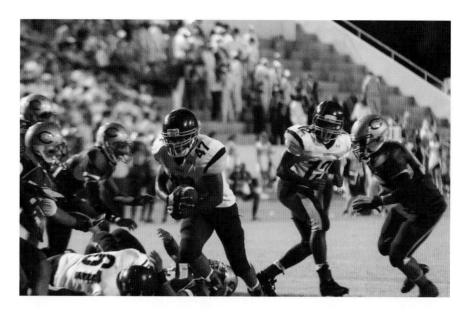

Fullback Jason Morris gouges the Chamblee defense for yardage behind a block by Thomas Wilson (61) as quarterback Myles Willis (12) watches in the 28–3 Marist victory, September 9, 2011. *Toni James.*

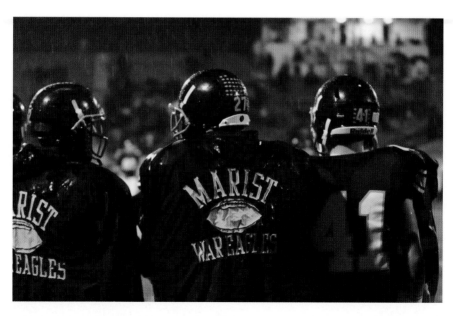

Marist juniors Seth Stokes (27) and Patrick Anhut (41) watch the action from the sideline in a downpour against Mays, October 28, 2011. *Toni James.*

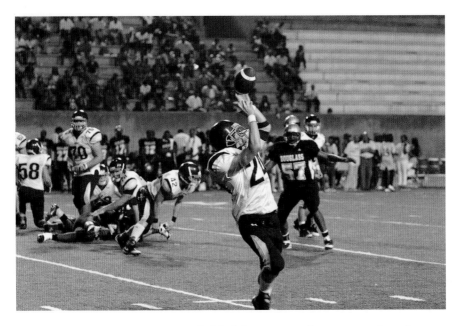

Halfback Jack Mohan (24) snags a pass in Marist's season-opening runaway win against Douglass, August 27, 2010. *Marist High School Photo Corps*.

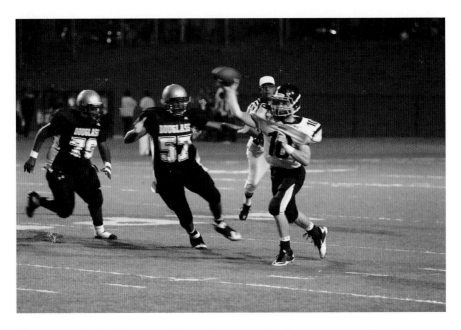

Marist quarterback Andy Perez (10) completes a pass despite pressure from Douglass linemen, August 27, 2010. *Marist High School Photo Corps*.

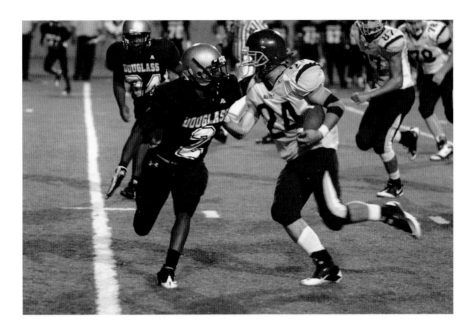

Halfback Jack Mohan (24) bolts for sixteen yards and a Marist first down versus Douglass, August 27, 2010. *Marist High School Photo Corps*.

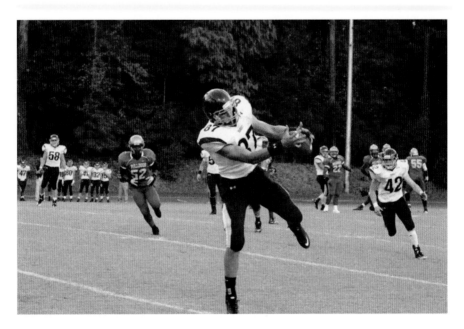

All-state tight end Greg Taboada (87) hauls in an Andy Perez pass for a first down in the Marist win over Chamblee, 28–3, September 9, 2011. *Marist High School Photo Corps*.

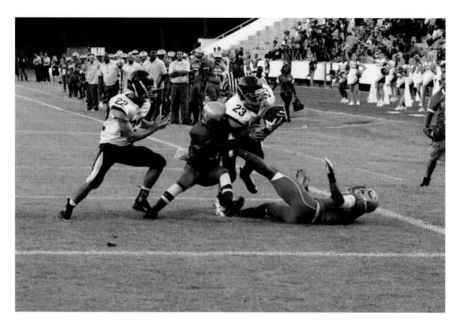

William Curran (23) splits Chamblee Bulldog defenders for a first down as mate Gray King (22) assists, September 9, 2011. *Marist High School Photo Corps.*

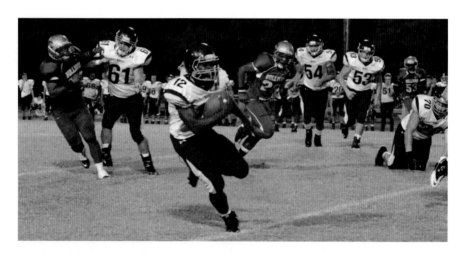

Marist linemen Thomas Wilson (61), Preston Furry (54), Connor Cote (53) and Nick Brigham (70) gash a hole in the defense, allowing Myles Willis (12) to break free, September 9, 2011. *Marist High School Photo Corps.*

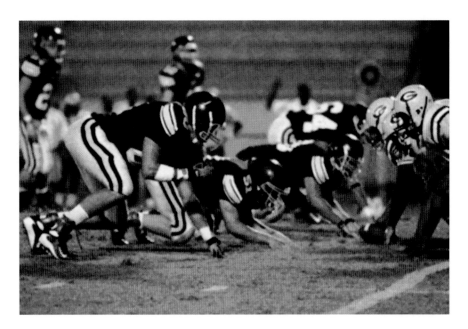

The Marist defensive line hunkers down in a Griffin 2008 preseason scrimmage. *Marist High School Photo Corps.*

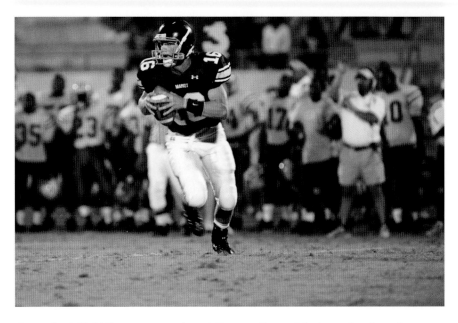

Quarterback Todd Farmer gets ready to deliver a strike to a Marist receiver in a win over the Griffin Bears, 2008. *Marist High School Photo Corps.*

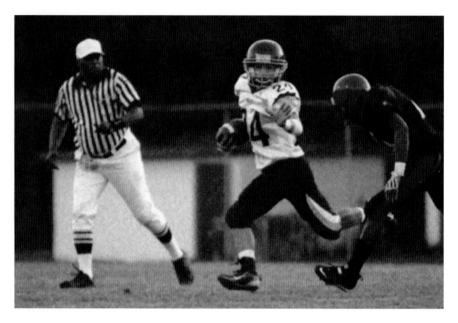

Halfback John Crochet (24) stiff-arms a Stone Mountain defender in a road win, September 5, 2008. *Marist High School Photo Corps.*

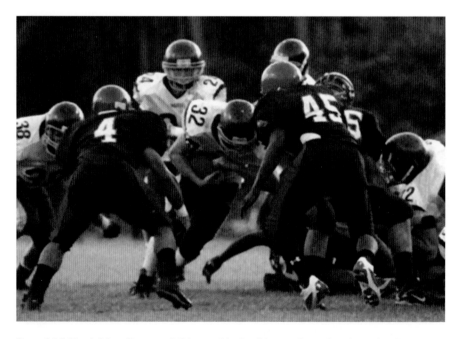

Powerful fullback Matt Connors (32) lowers his shoulders and smashes through a Stone Mountain defensive wall for a twelve-yard gain, September 5, 2008. *Marist High School Photo Corps.*

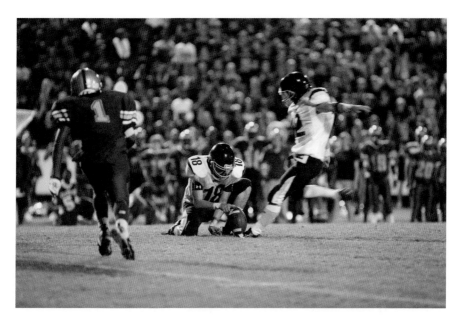

Jimbo Haneklau (18) holds as Justin Moore (12), elite Marist kicker, drills a forty-one-yard field goal in a win over Chamblee, September 12, 2008. *Marist High School Photo Corps.*

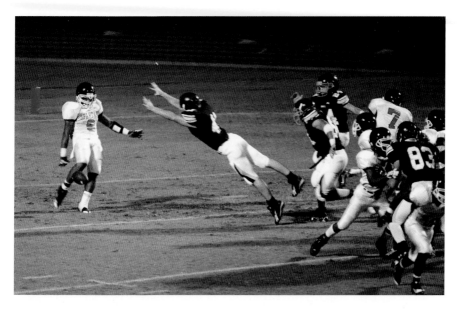

Keller Carlock (41) launches himself, blocks a North Springs punt and helps Marist to a rousing home victory, September 19, 2010. *Marist High School Photo Corps.*

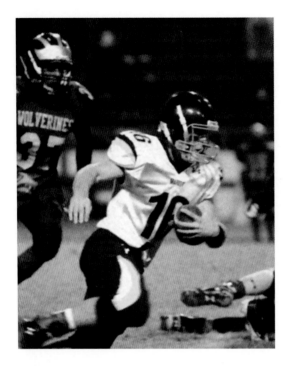

Signal-caller Kyle Farmer (16) keeps the ball on an option in a Marist win over Miller Grove, October 7, 2008. *Marist High School Photo Corps.*

Matt Connors (32) rips off a thirty-two-yard gain as Marist defeats region rival Southwest DeKalb, October 28, 2008. *Marist High School Photo Corps.*

Danny Stephens, the beloved Atlanta Police homicide detective affectionately called "Coach Cop" by Marist players, gives pregame pointers to the junior varsity, 2011. *Marist High School Photo Corps.*

Middle school players assemble to draw equipment for a new Marist season. *Marist High School Photo Corps.*

Above: The 2008 starting Marist offense waits for the next play call in huddle: Patrick Sullivan (21), Jimbo Haneklau (18), Randy Carroll (64), Jeff Ducote (60), Phillip Wood (51) and Jeff Ervin (80). *Marist High School Photo Corps.*

Left: Marist lineman Joe Pfeffer leads the team onto the field for the second half against Rome, December 5, 2008. *Marist High School Photo Corps.*

Marist game captains Cole Becker (23), Trey Nordone (54), Randy Carroll (64) and Sam McNearney (13) prepare to go to midfield for the coin toss, September 11, 2009. *Marist High School Photo Corps.*

Marist coaches explain strategy to Cole Sutter (63), Mitchell Anderson (75) and Blake Secret (88) during the Lakeside game, November 6, 2009. *Marist High School Photo Corps.*

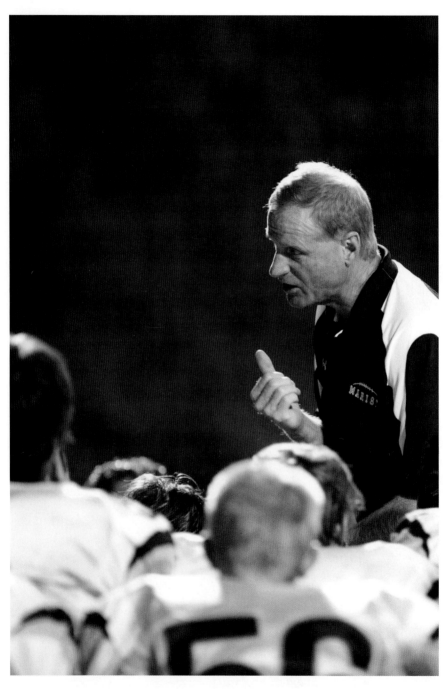

Head Coach Alan Chadwick challenges his Marist team in a pregame speech before a must-win game against Southwest DeKalb, September 17, 2010. *Marist High School Photo Corps.*

The War Eagle victory banner unfurls in front of the student section in a win over Southwest DeKalb, September 16, 2011. *Marist High School Photo Corps.*

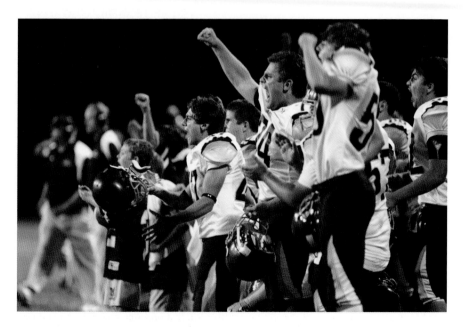

Richie Stirne (47) and Jay Eichelberger (74) erupt on the sideline as Marist pulls ahead of Lithonia, October 31, 2008. *Marist High School Photo Corps.*

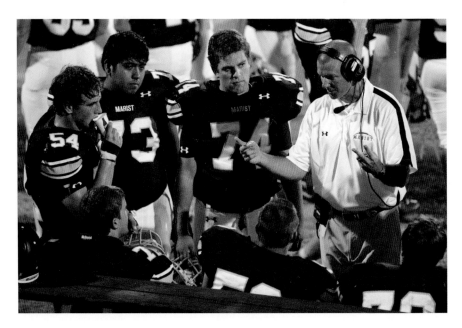

Trey Nordone (54), Wollinskey Mendez (73), Jay Eichelberger (74) and the rest of the Marist offensive line listen intently to Coach Dan Perez explain a new blocking scheme, September 26, 2008. *Marist High School Photo Corps.*

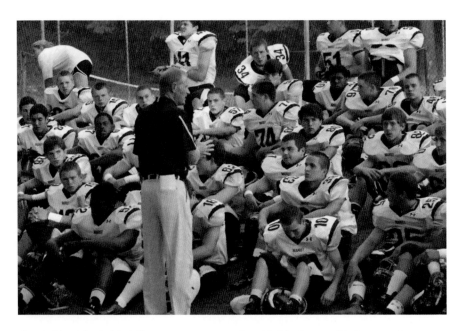

Coach Alan Chadwick delivers a pregame speech to his Marist squad before a region game with Lithonia, October 21, 2011. *Marist High School Photo Corps.*

Victory and Defeat

Every centimeter of their begrimed white jerseys was sweat-soaked from the terribly humid Georgia air. He glanced to the sideline and saw scores and then hundreds of their fans stream onto the field to dance and celebrate with their beloved victors.

It was a scene from the apocalypse. The foe danced madly, desecrating the home field on which he had played for a state championship thirty years before. His team, *playing on its own field*, had just been thrashed by the other big Catholic football program in Atlanta. This was the very home field that had furnished the best home record the past ten years of all 393 high schools in Georgia schoolboy football. Saint Pius X had just upset Number 3–ranked Marist 28–3. It was the first time in thirty-five years they had won at Marist.

The beating was complete. Marist's effort included four wretched turnovers, missed tackles and a meager thirty-six-yard output by the offense in the second half. The disrespectful din of celebration was a violation. Coveny cast one last bewildered glance downfield and then walked off the field.

He stumbled into the players' locker room. He slipped off his Under Armor black cleats, slid to the floor, leaned back against the wall and stared vacantly as the players silently entered the locker room. Almost zombie-like, they shed their torn game jerseys, filthy white pants and blue helmets and slowly strode to the showers. It was only the third loss at home in the previous thirty-seven games.

How had it happened? he wondered. *Why did it happen?*

Coach Chadwick paced slowly back and forth in front of the stands in the basketball gym as his players took seats to be addressed by the coaching staff before being dismissed. After the team was seated, the coach continued to pace the gleaming wooden floor, occasionally looking up into the stands. There was no sound whatsoever. The hush was like that of a large church filled with mourners just before the funeral begins—a silence so pervasive it almost takes on life.

Finally, he came to rest. His fierce blue eyes swept across his players seated in front of him. "This was my fault. I let you down. I did not have us ready to play Marist football. Now we'll see what this team is made

of. Our opponent whipped us physically. We're not used to that around here. At practice Monday, we will go back to square one, working on fundamentals. We will get after each other."

The coach raised his pitch an octave higher. "Your coaching staff will find a way to straighten this out. I assure you of that. Each of you must recommit yourself to be 100 percent dedicated to practice and to play Marist football. You must create team chemistry and fight together to become a decent football team. Be here at 2:00 p.m. sharp Sunday for weight training and film sessions with your coaches."

The head coach dismissed the team and headed for the coaches' bullpen. It is in this room where the nine-man coaching staff enjoys victories, dissects painful losses, checks out high school football results on TV, gossips, playfully teases each other and bonds past midnight in a weekly postgame assembly.

Pizza laden with pepperoni and spicy jalapeños had arrived, but the food containers remained unopened. The head coach had not endured many losses in his twenty-five-year career at Marist.

"Is this the worst loss ever?" Chadwick asked his coaches.

A few grunted in quiet voices, "Yes."

It wasn't just a loss. It was an embarrassment for the coach and his team, and it had been on TV for the whole Metro Atlanta area to witness. It was also played in front of one of the largest audiences at Marist in several years with nearly 8,800 spectators in attendance.

"What the hell are we going to do?" he asked.

There was no answer.

"Do I have to call up the *Atlanta Journal-Constitution* and tell 'em we're going to be 0-10 and miss the playoffs for the first time in my twenty-five years as head coach here? Because that's what's going to happen if we don't turn this runaway train around."

There was no response.

"Damn, I can't believe how unphysical we were tonight. They kicked our butts."

He shook his head, stared out the window into the blackness that shrouded the stadium and shook his head again.

Victory and Defeat

August 30, 2009
Sunday, 11:50 a.m.
Conference Room, Centennial Center Athletic Complex

The nine varsity coaches occupied positions at the conference room table in the athletic complex. Each position coach felt none of his players had stepped up and made a significant play.

Alan Chadwick pursed his lips and glanced around the table. "We're not physical. We. Are. Just. Not. Physical. That seems to be the nature of this team."

His assistant coaches stared back at him, shaking their heads in consternation.

In 2008, the school had reached another milestone in its pursuit of gridiron excellence when it rang up victory number six hundred. And since Alan Chadwick has been head coach, the success of his program has been predicated on a basic premise. "We *must* be tougher than our opponent," he reminded his staff. "I promise you, we *will* get more physical."

Marist School is a demanding academic preparatory school with rigid entrance requirements. Dumb jocks need not apply. Marist does not lower the admission academic requirements for anyone. Consequently, many top athletes are turned away—the kind of athletes who would make Chadwick's job a lot easier.

Alan Chadwick instills toughness in his squad. "We are not as athletic as most of our opponents. We are not as strong and not as fast. So for us to compete at the championship level, we must be tougher. We must be more physical and hit harder than the players on the other sideline. We want to be so physical that at some point the other team simply quits."

The lights in the conference room were switched off, and the head coach activated the digital-video projector. On the seven-foot-tall screen, an offensive lineman made an ineffective block, and the Marist halfback was slammed to the turf like a rag doll for a two-yard loss.

The coach stared wide-eyed at the screen. "Look at that—we're slow and soft!"

Paul Etheridge, the position coach for the quarterbacks, shook his head when a fullback hit the wrong hole. He had been the captain of the team for the state championship game in 1987. Later, he would

play tight end for the Georgia Bulldogs and catch Eric Zeier's first pass completion. He volunteered as a community coach out of love for his alma mater.

The Marist offense is painstakingly built around the wishbone triple-option attack. It is a precise offense, and the quarterback is asked to make split-second decisions. It has been the offense of choice for Marist since 1974 because it is particularly suited for the type of student athlete who attends Marist. The offense requires unfailing discipline. And it takes intelligent football players to understand it and execute it. It matches the profile of the Marist male student—intelligent, disciplined and tough.

Starting in the seventh grade, the players are schooled in the wishbone. By the time they are seniors, they have run the triple option thousands of repetitions. In Coach Chadwick's offense, the players execute plays ad lib. It takes intelligent players to be able to check through a list of options and then make decisions quickly and correctly.

The quarterback position is the hardest position to learn and execute in the triple-option offense. It is even more of a challenge when the quarterback has had no varsity game experience.

Andy Perez had just made his debut as the starting quarterback Friday night. It was a long and unfruitful night for the junior. It was nothing like his preparation against the scout team in summer practice or his experience as quarterback for the junior varsity team the year earlier. He certainly had the pedigree. His uncle Rob Perez had guided the Marist wishbone offense to the state championship game in 1987. Rob later starred as quarterback at the Air Force Academy, a team that also utilized the triple option. Another of Andy's uncles, Marist assistant head coach Dan Perez, threw for 1,238 yards in the 1984 Marist season.

Andy first stood on the Marist sideline on Friday nights when he was three years old. And after every game, when he said his prayers and pulled the covers up, he dreamed about someday wearing a blue Marist game jersey with number 10 on it as the Marist starting varsity quarterback. He considered it his ancestral duty.

Alan Chadwick glanced around the table and asked, "What do we do about Andy's decision making?"

His coaching staff stared back at him and then at one another.

The head coach answered his own question. "Everybody on the staff is giving advice to Andy. There are too many coaches doing it. Going forward, only two people are going to coach number 10: me and Coach Etheridge. We cannot miss this about our quarterback."

Coach Perez said, "After the game, their head coach told me about Andy, 'Until it really becomes clear, it's like running in sand.'"

Chadwick asked his coaches, "What does this team have to do to be successful? We are not making any plays like we need to. We are jumping offsides, not blocking, starting out too high. We played so bad we didn't give ourselves the chance to compete and win. We didn't finish our execution, *in our own house*, Friday night."

Coach Euart hit the nail on the head: "We need leaders. The problem is we don't have the type of leaders the team gravitates to. We don't have any alpha-male, blue-collar leaders with swagger."

Coach Perez reminded the others, "Last year's team took us to the fifteenth game, in the Georgia Dome for the state championship game, and made it a point to prove that the people in this very room were wrong. Nobody thought they were good."

Chadwick changed the focus:

> *Stone Mountain comes here next week with a lot of great athletes and a new head coach. We have to get our boys ready. There is no way I'm letting Stone Mountain come in here and beat us. Our team has to understand this game will be their Super Bowl.*
>
> *I've noticed we've gotten away from punishing mistakes. That will change with tomorrow's practice. I don't care that we have no depth. We will go after each other for the rest of the season as hard as we can. We can't worry about injuries just because we have no depth. We must step it up.*

After an intense week of practice, Alan Chadwick addressed his team before the Stone Mountain game kickoff: "We got too comfortable going into this season. We are changing that. Get up off the mat! Do you want to be a part of the Marist tradition? Then prove it! There's no hype here tonight for this game. There's no TV. There won't be over eight thousand people in the stands like last week. But tonight is your Super

Bowl. If you want to have a successful season, you better play like there's no tomorrow."

During the first half, quarterback Andy Perez showed great improvement directing the Marist wishbone offense. His confidence was bolstered after a fruitful week of practice. His decisions were flawless while directing the triple option, and Marist took a 42–12 lead into the locker room at halftime.

The Marist coaching staff had seen a marked improvement in just one week. After the game, they wondered, which is the real team: the one so outplayed the week before or the one so dominant tonight? They prayed it was the latter because Number 1–ranked Tucker High loomed ahead in three weeks. The staff knew they had to work overtime to be ready to face what would be the biggest test of the year.

September 25, 2009
Tucker High School

For the past decade, the road to the state championship has passed through the annual Marist-Tucker game, one of the most contested rivalries in the country. Just the year before, Marist beat Tucker and made it all the way to the Georgia Dome for the AAAA State Championship game. As fate would have it, the game was a rematch with Tucker. The Tigers had hitched up their pants after the Marist loss and reeled off a string of consecutive victories. In the rematch, Tucker gained revenge for the earlier loss, 15–8, and won the state crown.

In the film room on Sunday, Coach Paul Etheridge spotted how aggressively the Tucker cornerbacks charged up for sweeps. "Let's run 'War Eagle' on our first play of the game," he suggested. The play begins as a split end reverse. But suddenly, the end plants his feet and throws a bomb to the halfback.

"Sounds good," agreed the head coach.

On Monday, September 21, 2009, the Atlanta metro area experienced record flooding from a days-long deluge of heavy rain. The one-hundred-year flood record was broken, and neighborhoods and streets were under water. So Alan Chadwick took his boys into the indoor softball facility

with an artificial turf floor behind the stadium to practice. The offense ran a series of fifteen plays repeatedly. The defense engaged in fierce tackling drills. The head coach blew his whistle to end practice early. The roads were getting dangerous.

But the coaches stayed until midnight. The defensive coaching staff—Jef Euart, Danny Stephens, Matt Miller and Matt Romano—went for a quick dinner at El Torrero restaurant, their ritual on Mondays after practice. After munching on chips slathered with salsa and queso, they downed chicken fajita quesadillas. Back in the coaching office, they began their thorough analysis of Tucker's fluid wing-t offense.

Coach Euart had diagrammed on the whiteboard all 218 plays from the five most recent Tucker games, including the state championship Marist game the previous December. They broke down Tucker's tendencies. For example, if a tight end lines up, where do they run? When the ball is on the right hash, what do they do? Which plays do they run on first down, and which on third and long? The staff discovered that 60 percent of the time they ran to the tight end's side. On first down, 50 percent of the time they ran a sweep. And 82 percent of the time they would run to the slot or the wing. If number 2 and number 5 were in the backfield, they would run their wildcat play.

Tucker ran a fast-tempo offense. Coach Euart stressed that the staff needed to simplify lining up on defense. "We've *got* to be ready before the snap. If not, their speed will kill us."

Before Tuesday's practice, Coach Chadwick informed the team that Coach Danny Stephens ("Coach Cop") had just been named the City of Atlanta's Detective of the Year. And then the coach sent his charges through a rugged two-and-a-half-hour practice at full speed.

At practice on Thursday, Coach Etheridge challenged everyone to give 110 percent effort. "Be tougher than them. Every yard is valuable. Fight for that extra yard. If you gain that extra yard on seventy plays, that will probably win the ballgame."

On Friday night, the United States Marine Corps USA Rivalry Game of the Week featured Marist at Tucker. The televised game was also broadcast around the world via the Internet.

Before the first play from scrimmage, Marist quarterback Andy Perez looked at his teammates holding hands in the huddle.

Coach Alan Chadwick gives encouragement to fullback Matt Connors (32), while Coach
Mike Coveny confers with halfback Hunter Bailey (38) during timeout in a key game against
Tucker, September 25, 2009. *Marist High School Photo Corps.*

"War Eagle, on hut," he ordered.

Perez took the snap, pivoted and faked to fullback Matt Connors.
Split end Penn Davenport streaked past Perez with the handoff and then
stopped and threw a strike to halfback Patrick Sullivan for a forty-five-
yard gain. On the next play, Connors was sprung free on a block by
guard Trey Nordone and waltzed thirty-eight yards for a touchdown.
The Tucker defense looked dazed.

It only got better.

Tucker's offense was held to three straight three and outs. Early in the
second quarter, Marist halfback Sam McNearney turned a toss sweep
into a fifty-two-yard touchdown. And in the third quarter, McNearney
followed Connors off tackle on the belly play and raced eighty yards
unscathed to increase the Marist lead to 29–7.

The Marist defense smothered Tucker's versatile running game while
forcing two crucial second-half turnovers. Meanwhile, Marist's triple-
option offense recorded 469 total yards on the way to the 32–7 upset of
the Number 1 team in the state.

Marist halfback Sam McNearney (13) studies halftime adjustments by coaches Dan Perez (left) and Paul Etheridge during a crucial Tucker game, September 25, 2009. *Marist High School Photo Corps.*

Chadwick praised his team after the win: "I'm thrilled with how you have responded with your hard work since our first game. We have a chance to play ten more games if you continue to sacrifice like you have the past month. I would love to earn the chance to meet Tucker again in the Dome for game number fifteen."

THE SECOND SEASON

November 6, 2009
Friday, 11:00 p.m.
Marist Coaches' Bullpen Office

The second season is what each player and coach has sweated, bled and strived for since the broiling days of summer camp. It is the playoffs. Alan

Chadwick had steered his War Eagles into the playoffs for the twenty-sixth consecutive year.

The last regular-season game had just ended with a victory an hour earlier, and already the intensity was being ratcheted up. Lose one game and the season is over, kaput, as suddenly as brightness becomes blackness, the instant the stadium lights are flicked off. Win four in a row and you earn a fifth playoff game, this one for the grand prize: the Georgia AAAA High School Football Championship. Each week provides one more opportunity to extend the season, to face greater challenges, to grow closer and get better as a team. No one wants the drama to end. It is too exquisite a feeling.

After the final regular-season game, a 41–13 pounding of Lakeside High, the Marist players high-stepped to ear-splitting music blasting from speakers in corners of the locker room. Staccato lyrics from Ludacris added fuel to the adrenaline rush racing through the locker room. War Eagles danced solo, wildly, like Sioux warriors did the night they massacred the U.S. Seventh Cavalry in 1876 in Montana.

The assistant coaches, seated around the table in the bullpen, took turns sitting next to a figure dressed in black, listening to his words of advice tumble forth, soaking up each syllable of each word as if the information was priceless, like gems of wisdom from a Jedi master. The teacher was in his seventies with craggy features and gnarled fingers. Six weeks earlier, he underwent a triple bypass. Complications arose, and his life teetered like a seesaw. The probability of his survival was iffy. Those who knew Doc Spurgeon would have jumped on the odds. That week, clinging precariously to life, he sent a handwritten message to be read to his beloved Marist team just before kickoff. He told them to never quit because he never would. He told them he would be back for the playoffs. And here he was.

This was his eighteenth year working as a volunteer for the Marist football program. A PhD and a college English professor for twenty-five years, Doc was an advance scout. He could scout an upcoming opponent and tell you every player's strengths, weaknesses, speed, size and jersey number from memory. He could come real close to guessing an opposing player's pulse rate, character and family life by watching his conduct and body language on the field. He also scouts for The Ohio State University. On this night, he scouted the Sprayberry-Sequoia game. Marist was to host the winner in the opening round of the playoffs.

Victory and Defeat

Jef Euart, the Marist defensive coordinator, leaned forward, listening intently to Doc's conclusions about Sprayberry, which had just pulled a major upset by defeating Sequoia on the road. Just before the final gun of that game rang out, Doc raced down Georgia Highway 400 to give his scouting report to the Marist coaching staff.

"They are the best offensive team we have faced this year."

Coach Euart slowly raised his eyebrows.

> *Jef, they have the best quarterback we have faced this year. They mainly run the shotgun. We must keep the quarterback contained! If we let him outside it's all over. They run a three-wide receiver set. The best one is number 11. He is about 6-3 and runs real fast. They don't have a great offensive line, but they don't need one with all their great skill players. They go for the big play. They don't go for first downs—they go for touchdowns. If we don't play better than we have the last few games, we will not beat them.*

The nine coaches in the bullpen were all ears now, and silent.

Doc pointed toward Paul Etheridge, the offensive coordinator, across the table. "For us to win we will have to hog the ball on offense with several eight-minute drives and eat the clock. We don't want to get into a race with them. They have too many weapons."

Etheridge opened a pizza box, peeled off a steaming pepperoni-sausage slice and took a swig from his Coca-Cola. Doc continued:

> *Paul, they are not real good on defense. They don't tackle well. Their linebackers are both 6-3 and look beautiful. But they can't tackle anybody. They didn't stop Sequoia all night. Sequoia stopped themselves. They had four turnovers the first half. We need to run our basic offense right at them, especially our fullback Connors.*
>
> *I'll come in tomorrow and put on the chalkboard their entire offensive and defensive sets and each starter's size, speed, jersey number, strengths and weaknesses. You watch the tape, and you will see what I'm telling you is true.*

November 8, 2009
Saturday, 9 a.m.
Marist Athletic Building, Film Room

Click! The offensive line coach reviewed the play, a pitch to the halfback for a twenty-two-yard gain, for the fourth time on the screen in the film room. He was grading the individual efforts of his offensive linemen.

Coach Dan Perez was dissecting the performance of his position players in the game just finished twelve hours ago. The opponent's defense had speed and power. But the versatile triple-option attack by the Marist offense so befuddled its opponent that by halftime, they had been beaten like yard dogs.

Click! The next play appeared on the screen—a dive by the fullback. On a grid sheet, the coach wrote a numerical grade after each play next to his center, his two guards and his two tackles.

Click! He groaned when his left tackle missed a check-off by the quarterback and failed to block the middle linebacker. The halfback counter-play that should have gone for a nice gain only netted one yard.

Click! "All right...super double team, Trey and Hugh!" His right guard and right tackle had just converged into and buried the huge three-hundred-pound nose guard across from them. The swift Marist fullback bounded past the line of scrimmage in a jiffy for a fourteen-yard gain.

Offensive guard Trey Nordone (54) gets instructions from Coach Dan Perez as other offensive linemen listen versus Chamblee, September 11, 2009. *Marist High School Photo Corps.*

Victory and Defeat

This was the coach's twenty-third year serving on the Marist coaching staff. He started at quarterback as a junior at Marist. As a senior, he was the wishbone signal caller on a team that won thirteen of fifteen games. They lost in the state championship game by a narrow margin deep in hostile south Georgia.

Each Saturday morning after a Friday night game, he grades his players' performances. With his tutelage and their effort, they have gotten better.

"They *have* to get better," he stressed. Their opponents in the playoffs are usually bigger, stronger and faster.

"This is the playoffs now—the second season. This is what we live for, this incredible competition. We will outwork our opponent in preparation. We will outhit our opponent on gameday. We will outsmart our opponent. Then we will win."

With that, the coach picked up his cellphone to check in with each of his players, a weekly Saturday ritual, just so they know he is around if they need him.

Offensive line coach Dan Perez stresses assignments with Marist linemen Hugh Williams (72), Trey Nordone (54), Oke Pearson (71) and Patrick Mooney (66) in the Miller Grove game, October 16, 2009. *Marist High School Photo Corps*.

November 8, 2009
Sunday, 11:00 a.m.
Marist Coaches' Bullpen Office

Jef Euart leaned back in his chair and studied his masterpiece. The result of his eighteen-hour project filled up a whiteboard on the wall. Next to the whiteboard was a large window filled with a brilliant blue sky. Seated nearby were his three defensive assistant coaches: Danny Stephens, defensive end coach; Matt Miller, linebacker coach; and Matt Romano, defensive line coach.

Jef spent the greater part of Saturday breaking down three Sprayberry game tapes. He displayed the offensive formations in a color code. The most recent game versus Sequoia High was diagrammed in black magic marker. Jef displayed the Hiram High game in red and the Hillgrove High game in green.

Jef said, "Their quarterback is a game breaker. If we contain him, we win. It's that simple. Danny, our ends must keep containment. But at the same time, we will play downhill on every play."

Suddenly, the Marist trainer in charge of general health matters for the team entered into the defensive coaches' war room. "Jef," he started. "Do you want the bad stuff first or not?"

Euart twirled his chair away from the screen and greeted the trainer with an inquisitive gaze. His pupils were needle points from the stress of the past forty-eight hours.

"Speak to me," the defensive coordinator said.

"It doesn't look promising about Keller Carlock. He left the game in the second quarter last Friday night with a knee injury. His MCL [medial collateral ligament] has been pulled from the bone. It may or may not be torn. We will proceed with an MRI tomorrow. He is definitely out this week and maybe for the rest of the playoffs."

It was devastating news. The best guess by Dr. Marvin Royster, the team orthopedist, during halftime Friday night was that the injury was a strained ligament. Carlock was to sit out the second half. But upon further evaluation on Saturday, the doctor ruled him out for the next game at a minimum.

Keller Carlock was the stud middle linebacker, the heart and soul of the Marist defense. He closed swiftly with opposition running backs

and made them pay. His smile was genuine, and his passion to win was contagious. He was a leader on the field with his bravado and in the locker room with his charisma.

Euart eyed the trainer. "Oh, that's just great. Anymore good news?"

"I'm afraid I don't have any good news. Our halfbacks McNearney and Sullivan have bone bruises just below the knee. It is very painful, but as you know, they are tough as nails. We are working in the training room to get the soreness and swelling reduced. They'll be at full speed for practice tomorrow."

Both halfbacks were five feet, seven inches and 150 pounds and were senior leaders. They also played both ways. Despite their size, they were the best blockers on offense and the surest tacklers on defense. The coaches affectionately call them "the midgets."

On Monday evening, the coaches brainstormed about the tendencies Sprayberry showed in each formation. Then they decided how to defend each situation. They stayed until midnight, finally satisfied they had it nailed down.

November 10, 2009
Tuesday, 3:00 p.m.
Marist Athletic Building

Players on the defensive team bolted to the coaches' bullpen at the sound of the final school bell. Coach Euart had thirty precious minutes to instruct them about the game plan the defensive coaches had installed the previous night. Immediately after the classroom work, they were to conduct on-the-job-training on the practice field.

The team was told the fate of Carlock. The team would be facing a challenge of the highest order without its defensive leader. Indeed, the "mike" linebacker was irreplaceable.

The War Eagles' base defense was a 4-3 front consisting of four down linemen. Two outside linebackers and a middle linebacker stood a few yards behind them. Positioned behind the linebackers were two safeties and two cornerbacks forming the secondary. But with no real middle linebacker, Euart had to improvise.

"Guys, necessity is the mother of invention. We won't have Keller on the field with us this week. We will have to overcome this adversity if we are to beat a very fine football team coming to our house Friday night. We are not going to be able to stick to our base defense."

He turned from his players sprawled throughout the room and pointed to the whiteboard:

So we will be running everything we usually do, but we will be doing so out of different fronts. The key to our victory is how well we recognize their formations and personnel.

If number 36 comes in, we know they have two tight ends. Recognize that. When the quarterback audibles and changes plays, he flicks his hands and the ball is immediately snapped. Linebackers and corners, you must look for that.

The defensive coach pointed to Sprayberry's passing plays on the whiteboard:

They love to throw to the middle of the field to number 11, their possession guy, especially on third and long. The quarterback is quite accurate with a strong arm. Therefore, when the ball is snapped, we will roll to a three-deep secondary and settle in the middle looking for that route. We can and will cheat to the inside. The second the quarterback gets the ball, he looks directly at the man he wants to throw the ball to. We must read his eyes!

In one corner of the crowded office were defensive backs Patrick Sullivan, Sam McNearney and Penn Davenport. "Guys, we have a chance for some 'pick sixes' Friday night."

The three defensive backs grinned and flexed their biceps. They all wanted to add to their interception totals.

"We must control this quarterback, so we will 'spy' him with our linebackers. Linebackers, do not go back in your usual coverage. You just read the quarterback."

The coach stressed the importance of formation recognition:

They usually line up in the shotgun with one back next to the quarterback. If we see an empty backfield with no one back there but the quarterback, it is a pass 95 percent of the time.

When they put a guy in motion and number 35 is in the game, we know it will be him on a jet sweep. He is over two hundred pounds and will get up in there with power. When they run that, we need to make a big play and make a tackle for a loss. Come up hard and Bam!...cause a fumble in the backfield.

Jef spoke slowly and clearly: "Gentlemen, we *must* take advantage of this information. We must play at a quick tempo. We must be in our positions and ready before number 4 starts calling signals."

He raised his voice:

Don't you dare listen to anyone other than your coaches. People outside this building know nothing about our opponent. Sprayberry is extremely dangerous. You better believe me. We have a lot to improvise and learn in a very short period of time. That's why I'm glad I've got smart players. At practice today and tomorrow, we will go full speed and hit as hard as we will Friday night. We will play attacking, downhill defense. Gentlemen, if we are more physical than they are, we will win.

Coach Euart conducted an intense tackling drill for his defensive backs in a driving rainstorm. Fundamentals are stressed at every practice. Linemen need to play low, defensive backs need to tackle by keeping their balance without diving at the ball carrier, fullbacks must hit the hole at the exact centimeter called for or the timing of the play will be disrupted and wide receivers must run perfect routes. It is at practice, not in Friday night games, that players and the team improve.

The success of Marist football begins with an ethos that is three-pronged, based on intelligence, discipline and physicality. Since usually the other team has better skilled athletes, Marist must be tougher. Marist must be more physical. Marist must whip the other team physically in order to control the game. Therefore, Marist football practices are physical, tough affairs, especially Tuesday practices.

When a player gets hurt, he walks it off for a few seconds, trying not to show pain. His teammates look away. The player shakes it off. It is part of his job to play through pain, and he is back in the huddle after missing a play or two.

Euart's crisp voice bellowed, "That's the way to get after each other! If we don't do it here and now we sure as hell won't do it when it counts Friday night. This is Tuesday, boys. Bloody Tuesday...you can't go home until you bleed!"

In attendance were several coaches from some other high schools who were allowed to observe the practice. Their teams had not made the playoffs.

One of them asked Coach Stephens, "Coach, do you always hit like this? This is full-speed contact. We don't hit like this after September."

Stephens smiled. "We always go at it with this intensity. It doesn't matter if it's during three-a-days at August camp or in December two days before the state championship. It's Marist football."

Tropical Storm Ida dropped torrents of wind-driven rain on the practice field. Players were soaked to the bone and shivered from the chill. But they exulted and pranced through the practice like young colts, reveling in the playoff chase. Six inches of rain had fallen in the past forty-eight hours. The coaches said the rain was a reminder they had to be ready to face unexpected challenges and battle any adversity.

Sprayberry had a formidable front seven, so Marist prepared to pass more than usual to be effective. Andy Perez, the Marist quarterback, was hitting his receivers with accurate passes. The receivers were in top form, hauling in curl routes and snagging deep, skinny post passes.

The Bone Drill was executed at a frenzied pace. Fifteen plays selected to be the fulcrum of the offensive game plan were run against the scout team repeatedly until there were no mistakes. After each play, each coach shouted words of applause or correction to his position players. And as soon as each play ended, the offense raced back to the huddle to call the next play. Each time the head coach yelled, "C'mon. Hurry up. Hurry up! Get the ball off, get the ball off!"

Andy Perez called the final play of the drill in the huddle that offensive coordinator Etheridge whispered in his ear. It was the bread-and-butter staple play of the Marist triple option. "R 42 Triple on hike."

Victory and Defeat

The junior quarterback pulled the ball from fullback Connors's belly and tossed it back to halfback Patrick Sullivan, who swept wide to the right. The ball carrier cut inside his lead blocker, halfback Sam McNearney, who collapsed the outside linebacker moving in for the tackle. At the moment of impact, Sam unleashed a bloodcurdling war cry.

The defender was leveled by the collision, and Sullivan danced all the way to the end zone for the score. The team roared its approval of the perfect block. The two halfbacks leapt and high-fived each other. Confidence brimmed in the eyes of the players. There was a satisfied smile on each coach's face. The team had jelled.

Finally, the long, piercing sound that signals the end of practice piped from Alan Chadwick's whistle. The team rushed to midfield and formed a circle around the head coach. Breathing came in gasps. Winded players took short pulls of oxygen. Despite the chill and wetness, players continued to sweat after just running arduous wind sprints.

The head coach stood on the fifty-yard line. His blue eyes darted quickly from player to player for a millisecond at a time. He spoke with raindrops falling from the brim of his soaked blue Marist baseball cap:

> *My men, this today was the best practice any team had in the state of Georgia in AAAA football. I salute your passion. We are going to win Friday night. I know you will be disciplined. Take care of your assignments and play physical Marist football. But also you must think about making plays—making plays that mean the difference in the ballgame. Imagine it in your sleep. The play that came your way and then you took care of business.*

November 11, 2009
Wednesday, 5:30 p.m.
Marist Practice Field

The storm scuttled northeast overnight, up past the Carolinas, and the sky was blue and cloudless.

Coach James conducted a bare-knuckles drill to get his receivers open. His players lined up in two lines facing one another. The first job of the receiver was to get past his opponent across the line of scrimmage who

tried to knock him off balance. The receiver's second job was to run the preordained route perfectly, as if he had a GPS connecting his brain to his feet. The problem at this practice, however, was that Coach James allowed the scout team defenders to create mayhem in order to distract the receiver. No holds were barred. Pass interference and illegal holding were fair game. The coach figured if his ends could fight through the illegality they faced at practice, they would surely be able to break free in a real game with officials keeping order.

Wednesday's practice carried through with the same intensity as the day before. There was a swagger in the collective body language of the squad. Team chemistry was off the charts. Coaches challenged players, and the players responded zestfully. Something very special was happening. More than at any time in the season, there was something different in the coaches' smiles. There was something different in the players' eyes. They wanted to bury Sprayberry High.

November 12, 2009
Thursday, 4:45 p.m.
Marist Practice Field

Justin Moore was in red shorts and wore no pads. He placed himself in position precisely one and a half steps behind and two steps to the left of the kicking tee. He approached his forty-two-yard attempt with a side-winding soccer-style leg action. The sun hung like a brilliant yellow lamp just above the crossbar, casting its blinding, autumnal slants of light from a sky that was only that pure cobalt color of blue that appears a few days a year in north Georgia. The pigskin soared and plumb-bobbed the twin vertical bars of the goalpost.

Perfect!

The attempt would have been good from fifty-two yards. The assistant coaches, even the members of the scout team who tried to block the field goal, smiled. Justin was one of the best kickers in the state. But he had put a scare into the Marist football program by recently turning his right ankle. He received icing and heat treatments and just the day before was given a cortisone injection. He was a key weapon for the War Eagles.

Eleven months earlier, he had nailed a fifty-yard field goal in the AAAA State Championship game in the Georgia Dome.

The ball was moved back five more yards. The ball was snapped, and Justin drilled the forty-seven-yard effort flawlessly. All hands on the practice field breathed a sigh of relief.

Except for one. Head Coach Alan Chadwick looked at his stopwatch and barked at Justin.

"Damnit, Justin. It has to be gone in 1.3 seconds, not 1.6 seconds!"

The perfectionist was not being trivial. The coach knew that three-tenths of a second delay in a field goal attempt could result in disaster—a blocked field goal resulting in a championship game loss.

In twenty-five seasons as Marist head coach, his teams had just missed out in punching the biggest high school sports ticket there is, the state championship game, by losing six times in the semifinals. But on five other occasions, he did guide Marist to the AAAA State Championship final game. And twice he experienced the exultation of victory. But he cannot forget the three times his team fell just short of championships. Defeat-adverse, he would leave nothing to chance.

In twenty-four hours, his young warriors would don their battle garb. If they weren't ready now, they never would be. The head coach blew the final whistle of the week, and his players congregated in a 360-degree circle around him.

His players lay back on the green field like they had a long time ago as second graders at summer camps up in the forested mountains. Some realized it might be the last time they ever performed in this most holy of places.

The head coach spoke urgently: "Seniors. Back in the seventh grade, you went undefeated. In the eighth grade, you went undefeated again, correct? And as ninth graders, you won every game. Your junior varsity team then went undefeated. Last year, as juniors, you did a real good job, and we made it all the way to the state championship final game."

With that, the head coach walked a few paces and placed a hand on Matt Connors's shoulder. "You seniors know what Marist football has meant to you—the friends you have made, the challenges you have conquered and all the sweat, blood and tears you have endured. You may

only have one day left of the purest of trips you will ever take in your life. It all comes down to tomorrow."

Small glints of sunlight illuminated the beads of sweat dripping down the foreheads of his engrossed players. "Everything you have accomplished the last six years together, everything you have done, worked for, dreamed of, sacrificed for and shared together could continue for at least one more week. But tomorrow night there is one more journey to ensure our progression. The biggest step we have to make for the rest of this journey takes place tomorrow night—right here."

Coach Chadwick beckoned to Dan Perez. His hearty voice explained:

> There is one thing I want you to think about the next twenty-four hours. And that is to continue to have the trust and confidence you have placed with the coaches. We know what we are doing this time of the year. Here is the key to tomorrow night. If we can execute the way we are capable of for forty-eight minutes, there is not one doubt in my mind what will happen. Sprayberry High School will be in deep trouble. Remember, the coaches believe in you. If we didn't, we wouldn't work as hard as we do. Good luck to you.

The head coach called for Coach Euart to speak. The usually vocal coach parsed his words: "We had a great week of practice, and that makes me feel very good about where we are. I've been thinking about what I was going to say right now. And you know what? To hell with what I might say. Because it's all about this." With that, he pointed three times to his heart.

Next to address the team was Coach Etheridge:

> We will face adversity tomorrow night. The question is how do we respond. Great teams grow from it, get strong because of it. We have the potential to be a great football team. But you have to understand something, and you will when you get older: the responsibility lies with you. You can't pass the buck. There is nowhere to go. That's why football is a great life lesson.
>
> Every man here has to pay his bills. It is his responsibility. Every man here has a family he must take care of. It is his responsibility. This

is a small microcosm of what life is. The hay is in the barn, boys. It is now your responsibility. So man up!

Later that night, as exhausted halfback Patrick Sullivan entered his bedroom, he found a letter on his pillow. He opened the envelope and began reading:

November 12, 2009

Dear Patrick,

By the time you read this you will have completed your Thursday's practice in preparation for your game tomorrow against Sprayberry. I can't tell you how exciting this week has been for me personally not to mention all the dads, moms, coaches, and fans.

Over the last few years during football season there have been countless numbers of people who have stopped me just to tell me how much they enjoy watching you play and how important you are to your teammates and the fans. They didn't have to tell because I already knew. I've seen you perform with passion and exuberance in everything you did since you were very young both on and off the field.

This is your last go-around with Marist football in your final drive to the Championship. This is your time to take the field full of passion and show the leadership you have exemplified for so many years. Don't be afraid to grab a teammate's facemask and tell him to dig deep and leave it all on the field. Try to engage the crowd and tell your teammates on the sideline to show excitement and energy every play. This is your team; take control and lead them to victory. This team has talent but needs leadership! The big guys are great but they are quiet. Tonight we need passion and excitement! You and Sam McNearney are the two leaders. You two may be the smallest players on the field but have the largest hearts and most determination! You are truly one of the toughest kids I know. It's not only your toughness, passion and heart that make you a leader it's also the compassion and caring you show for others. Remember what Doc Spurgeon told me recently, "pound for pound Patrick is one of the best players I have ever coached in sixty years."

I've told you this many times before but I will tell you again...you have made me very proud. Not just for your success on the field but your development as a person and a man. I know you have great things that lie ahead for you.

Go out tomorrow night and have fun. Enjoy the spirit, the camaraderie and the competition. Play hard and come off the field knowing you did everything you could do. No matter the outcome, I want you to know how proud of you I am and I love you very much.
Terry (AKA "daddy")

November 13, 2009
Game Day, Marist v. Sprayberry, AAAA Georgia High School Playoffs—Round One
Friday, 2:45 p.m., Pregame Meal

Alan Chadwick pulled out from the faculty parking and drove to the same restaurant that had provided the pregame meal for his team before every game since 1986. Riding shotgun was his assistant coach, John James. In the rear were halfback coach Mike Coveny and video production coordinator Franklin Cox III.

The head coach cruised down the ribbon of a driveway that is the principal road on the campus. He passed the new state-of-the-art athletic building complex that houses a large, sparkling gymnasium with highly polished wooden floors, classrooms, a weight room the likes of which are found at NCAA Division 1 schools, conference rooms, locker rooms and athletic department offices. Cupboards line the halls, bulging with hundreds of trophies captured by Marist athletic teams over the past century. He passed the twenty-thousand-volume library, the still-muddy soccer fields and the alumni office building, behind which the school chapel rests.

He waited for the interminably slow traffic light to turn green so he could take a left turn onto Ashford-Dunwoody Road. His eyes flicked from his watch to the signal and then to the rearview mirror. Then he went through the same routine again. With the kickoff of the biggest game of the year just hours away, Chadwick was visibly wired. He looked both ways and licked his lips. Then the light turned green and he took a hard, aggressive left turn.

On the way to the restaurant, not a single word was spoken. He drove for ten minutes with fingers gripped tightly on the steering wheel. His tensile movements revealed a man in complete concentration. He entered the Mad Italian restaurant, took an immediate left and took his customary seat with his back to the wall. From this position, he could view the entire restaurant.

The entrée choices were chicken penne pasta, spaghetti with red meat sauce or Philly cheese steak sandwiches, served with hunks of Italian bread and iceberg lettuce salad. The head coach, a creature of habit, had brought his team to partake in pregame meals here for the past twenty-three years.

The restaurant was filled with seven-foot-tall pieces of art, mostly in blue and gold, the team's colors. Cartoon/caricature posters of current seniors and coaches hung in rows from the ceiling, acrylic paintings of members of the War Eagle football community.

The head coach looked at John James. "Are we ready?"

"You bet we are," James responded.

Comcast television was filming a special on the game, and a camera team showed up at the restaurant. The reporter introduced himself to the head coach and asked for permission to interview a few of the players who would be selected by the coach. Chadwick nodded absentmindedly and grunted his permission, even though it would depart from the team's normal routine. He appeared highly agitated. He wanted no distractions for himself or his players. He delivered a list of a few seniors' names to the reporter.

The players piled into the restaurant at 3:15 p.m. after school dismissal. Fullback Matt Connors sat at his customary table diagonally across from his head coach. Seated at the same table were fellow seniors, kicker Justin Moore, tight end Michael Crawford and split end William Costabile.

Connors ordered his favorite, a huge Philly cheese steak sandwich. The room bubbled with youthful enthusiasm. Baskets of Italian bread and miniature bars of Snickers and Butterfingers scattered on tabletops were gobbled up while the players waited for their entrées.

Chadwick smiled wryly when he saw a player in a T-shirt with a rhetorical question written across the front: "Who is John Galt?"

The Comcast reporter, holding his microphone, walked up to halfback Sam McNearney, one of the players selected to be interviewed. Chadwick blurted out, "No! Not now. This is not the time or place. Later."

He glanced around the large room at his energized players razzing one another. He glanced down at his plate and quickly jabbed his fork into a spool of spaghetti. He bolted his food down, his eyes darting from player to player, sizing up their behavior.

Are we really ready? he wondered.

There were question marks in his piercing blue eyes.

November 13, 2009
Friday, 5: 00 p.m.
Team Classroom, Athletic Building

Immediately after the pregame Mass, the offensive team members took seats in a classroom in the athletic building, still in jeans and T-shirts. The players were wide-eyed, like young U.S. Marines crouched in the belly of the chopper heading for the landing zone. Alan Chadwick and Paul Etheridge began a pregame skull session.

The soft-spoken head coach spoke with urgency: "Are we ready to go? Last week, these guys came out on the opening kickoff like wild bandits. They had their first-string fastest players on kickoff coverage. They run fast. Number 10, block him! Number 35, number 46, number 11, we must block them, too."

Etheridge added, "That's what they do—haul butt. We cannot be intimidated by their kickoff coverage."

Alan Chadwick continued, "We have to take the ball up field. We have to keep the ball tonight. We are not going to give the ball to them and let them get up by seven points early and let them get all fired up. So on kickoff returns we have to go!"

With that, he scanned the classroom and then asked, "You men on our wedge. I want you going hard. I want you attacking somebody!"

His assistant coach added, "And knock the crap out of them. They will be coming at full speed, so you've got to be going full speed—right at them!"

Coach Chadwick chimed in, "I have a pizza and a milkshake for anybody that puts one of them on the ground."

The players roared their approval. Those who played only offense left the classroom. Other players, those who only played defense, entered and took seats.

Victory and Defeat

Defensive coordinator Euart knew he had coached his side of the ball up as well as he could. After a few reminders about responsibilities, he kept it short and simple: "I feel so happy about our practices this week. I feel great about our schemes. I feel good about the way we are going to take it to them. Execute with a reckless abandon. There's no tomorrow, guys. Leave it all out there."

Daylight was all but gone from the darkening Georgia fall sky. Daylight saving time had elapsed, and the natural clock was in play, bringing nightfall quicker each day as winter approached.

The percussion sounds from snare drums snapped across the campus from one hundred yards away, and lilting notes from a flute bounced off the back of the stadium's south wall. An electronic screech announced that the PA system has just been engaged.

Hundreds of students, some dressed in costumes, others in school colors of blue and gold, drifted through the campus. Some young male students were shirtless, their torsos and faces splashed with blue and gold war paint.

Sam McNearney stood on the portico just outside the locker room. He gazed just beyond the fence that circled the track surrounding the gridiron inside Hughes Spalding Stadium. Brilliant beams from stadium lights highlighted the green football field. In twenty-five more minutes, he and the rest of the offensive backs would take to the field for pregame warm-ups. All the seniors knew this could well be the final home game they would ever play on Marist soil. There was no guarantee of a future. There was only this night.

He knew he would be called upon for every play in the game. He and the other halfback, Patrick Sullivan, were the vocal, physical and inspirational leaders of the team, though both were five feet, seven inches and weighed but 150 pounds each. They played without fear, blocking ferociously for each other against defenders weighing 50 to 75 pounds more than them. On defense, they brought the wood against opposing ball carriers, tackling surely and crisply in the open field. Both had great leaping ability and had led the team the past two years in interceptions.

Sam shook his head at the sight of the field, and his words poured out in a whisper:

I've been waiting for this day my whole life. Last night, I dreamed about the first touchdown I scored. It was against Tucker last year, and it was a toss sweep. I broke wide and had this vision the whole world was closing in on me. Suddenly I saw a tunnel, and I knew if I could just get to the front door of that tunnel I was gone. And it happened. So maybe it'll happen again tonight, if not by me then by one of the other backs.

His eyes drifted back to the door leading into the locker room, and he raised his voice. "We will win tonight."

It was exam week at Marist. Scholastics are as tough as it gets at this high school. Thankfully, Matt Connors, the starting Marist fullback, only had one final exam on game day. He wanted to maintain his 3.3 GPA. Georgia Tech was interested in him, and he was dedicated to his schoolwork. He pulled into the students' parking lot in his Chevy Sierra at 10:30 a.m. and studied for his exam for over an hour. After he aced the statistics exam, he went to the Chick-Fil-A restaurant up the street with a few pals for some comfort food. Back at school in the training room, he immersed his body in an ice bath to jettison the soreness out of his bumps and bruises that resulted from a demanding season.

After the pregame Mass, he shared his feelings with a soft smile: "I feel very special. It's a spiritual, calm feeling. I don't get butterflies nearly as much as before. I played in fifteen games last year and eleven so far this year. I am ready."

At his locker, Matt pulled his skintight Under Armor T-shirt over his strapping upper body. Then he cinched the shoulder brace he wore to stabilize his A/C shoulder joint, which for the past month had presented chronic problems. The powerful fullback knew he would be summoned to be a major force on both sides of the ball if his team was to advance to the second round.

"This is big," Matt began again, "and I've never been more excited. It is probably the last time I step out onto Hughes Spalding Field. After we win tonight, we will probably play a one-seed on the road next week." His friend, linebacker Cole Becker, helped him pull his blue game jersey over his shoulder pads. The bruising fullback continued:

Victory and Defeat

I just want to put on a good show for forty-eight minutes. We've got two things going for us: we just put in a great week of practice, and we've got genuine enthusiasm running high. It's a great environment. It will already be dark when we go out there for warm-ups. I'm looking forward to the challenge. This is special. I've been playing for six years here, since the seventh grade. The atmosphere today is just great. I'm really looking forward to the coaches' speeches.

Patrick Sullivan laced up his football cleats after just having his ankles taped. Black paint lines crossed the tops of his cheekbones just below his green eyes. When Sully talked, it was always with a smile and a shake of his shiny thatch of brown hair: "I'm so excited! I usually lie in bed the night before a game thinking about making a great run down the sideline, or intercepting a pass, or making a big tackle. Last year against Tucker, I visualized what I would do. I dreamed about it and thought about it all night, and then it happened."

Yellow Cobb County school buses forged down a concrete lane behind the stadium carrying the Sprayberry High School football team to the visitors' locker room.

Andy Perez, the Marist quarterback, standing just outside the locker room entrance soaking in the pregame activities, followed the passage of the buses. The aroma of chili dogs wafted from the world-famous Varsity drive-in restaurant's catering truck. A golf cart driven by the cheerleader captains streaked past carrying a huge poster they had constructed, through which the team would burst just before kickoff.

Suddenly, Guns N' Roses blared out a warning to the visitors over the stadium sound system. "Welcome to the Jungle" lyrics assaulted the ears of all within hearing distance, increasing the edginess. The song has been a mainstay of the pregame music at the Marist stadium for twenty years.

The quarterback spoke calmly:

I am relaxed and confident. This is what I've been waiting for my entire life. Each night this week in bed I have gone over the defenses they will present and what schemes we will come up with as answers. But it's Friday night now, and I'll go by instinct and not over-think.

This is what I've dreamed about since I was three years old on the sidelines. I always wanted to be the starting quarterback for Marist in the playoffs. It has really helped me that my own blood, my uncles, were successful doing the same thing. This is a new season beginning right now. We must take care of this team coming here tonight and move on to the next playoff game.

Parents tailgated on the practice field. Picnic tables overflowed with plates of deviled eggs, baskets of chips and salsa, buckets of chicken tenders, a bin of barbecue sandwiches and to-die-for chocolate brownies. The moms wore badges pinned to their sweaters bearing images of their sons in blue game jerseys.

Eileen Moore, the mother of kicker Justin Moore, asked about her son. There was a special pressure that always weighed on him. He must be ready, if called upon, to decide the outcome of a do-or-die game with a long field goal attempt. So far this year, he had been deadly accurate but had not faced a pressure situation.

She asked, "How is Justin doing in the locker room? Is he smiling? If he is, that's a good thing. He wants to be in the position to make the difference."

One of the coaches who had attended the pregame Mass saw her, came over to her and told her a special story about her son. It happened just after communion in the Marist Chapel. Justin was wearing jeans and a red T-shirt. He sat forward in his seat, his head bowed, his eyes closed and his arms dangling in front of him with his hands clasped in prayer. He was motionless, and his breathing came and went slowly.

The coach said it looked like Justin was thanking his God for giving him the grace to believe in Him. At the same time, the kicker couldn't help but visualize he was on the left hash mark behind the football, which was on the thirty-three-yard line. There were three seconds left, and the score was tied. He was being called upon to win tonight's game with a fifty-yard field goal, just like the one he had made in the state championship game last season. The ball was snapped, Justin's right foot thundered into the pigskin and it climbed in the dark sky heading for the goal post. Then Justin raised his head from deep prayer, opened his eyes and smiled.

Traces of tears spilled down Eileen Moore's cheeks. She nodded her head up and down, smiled and said, "How wonderful."

Trucks passed the practice field loaded with TV reporters with digital voice recorders and cameramen with broadcast-quality equipment. The Comcast Cable crew had been on campus for hours and interviewed the head coach and certain seniors he selected. Their high-tech cameras were on the roll in the locker room, capturing footage for a special they were producing about Marist football.

At 6:00 p.m., Alan Chadwick and his coaching staff entered the highly charged atmosphere of the players' locker room. The tension was palpable. The odor was the musky perfume of adrenaline-produced perspiration. Hearts pounded at the red-line level.

Players who were standing shifted from one foot to the other, like heavyweight prizefighters do in the middle of the ring just before the opening bell. Players sitting in front of their lockers with lips compressed stared into their blue helmets held in their laps. It was a "thousand-yard" stare. Players sitting on the floor adjusted teammates' equipment next to them.

The head coach, dressed in khakis, a white Marist coaching staff shirt and Under Armor football shoes, glanced around the packed room and asked, "What do you play for? Who do you play for?" as he pointed at individual players.

"Juniors, do you play for your seniors?"

"Justin Olderman, do you play for your grandfather?"

"Sam, do you play for your cousin?"

"Do you play for your school?"

"Do you play for the traditions of Marist football?"

"Do you play for your coaches?"

"Do you play for your pride?"

The head coach shook his head, placed his hands in his back pockets, paced restlessly and continued: "It doesn't matter. Whatever reason you play for tonight, I'm only going to ask you to give it everything you've got. That's what it's going to take—eleven bodies out there with blue hats on playing as hard as they can."

The tall, blond, charismatic coach raised his right arm to the ceiling with outstretched fingers. "It's about effort! Don't leave any regrets in your mind that you didn't give all your effort to tip that pass."

With that, he bent over and jabbed his forefinger at four players seated just in front of him. Their heads bobbed up and down, throat muscles constricted and eyes glazed over.

He turned and paced again. He pointed to the corner where Patrick Sullivan and Cole Becker, two of his senior leaders, were sitting in their lockers. "Make plays, don't be afraid to make plays, make it happen."

The coach gently kicked the shoe of a player in front of him. "It's just about determination. The only thing we ask is give it everything you've got out on that field."

Chadwick slowly walked to the right side of the room, locking eyes with player after player as a general does when he inspects his troops. "There will be swings in this ballgame. Understand that. Expect that. Be challenged by that and rise to the challenge. If you miss a tackle, don't miss it the next time. If you miss a block on a misdirection play, don't miss it the second time, and [he pointed to Paul Etheridge, his offensive coordinator] don't be afraid to call that play a second time, coach."

He stepped to the center of the room and lowered his voice. "Have some fun. We're at home. It's a great atmosphere. Cherish it. Relish in it. Be brave; don't be afraid of anything. Play hard with all the determination you have, and we'll be fine. If we call your number, go get the job done. With everything there is to play for, go give it all you got."

At 6:25 p.m., halfbacks McNearney and Sullivan led the backs onto the field for warm-ups. Rhythmic drumbeats matched the sounds of their cleats on the cement of the runway to the field. A lone trumpet squealed jazz notes.

Eight minutes later, seniors Penn Davenport and Michael Crawford locked arms and led the receivers onto the field. Marist was expecting to be more active in the passing game than usual to have a more balanced attack.

At 6:40 p.m., senior guard Trey Nordone led his fellow linemen onto the gridiron to loosen up as their opponents trotted onto their side of the fifty-yard line. The Sprayberry linemen were huge, much larger than they appeared on film. Trey gathered his cohorts in a tight huddle and said, "We have to make them pay. We must leave it all out here on the field on every play. This is our foxhole, and they are not going to overrun us."

The routine does not change. Marist football does not change. No one on the coaching staff can recall when the times to hit the field were any

different. Alan Chadwick is a creature of habit, clinging to the same routines and rituals that have been part of his success at Marist. He is immutable.

Both coaching staffs walked up and down the lines of players stretching and loosening up. Occasionally, several coaches turned around with arms folded and observed the other squad. Players stretched hamstrings, torsos, quadriceps, necks and calves for twenty minutes. Coach Euart's whistle chirped, and sixty-five teammates dashed to form one tight circle around the coach. Then a lusty cry of "War Damn Eagle!" rang out, and the team broke into position groups for short drills.

The head official met Chadwick at midfield, and pleasantries were exchanged. The coach advised the referee that Marist might employ a fake field goal play, forewarning how the formation would be legal.

Katie Neel and Margaret Sikes, the Marist team managers, with their younger assistant managers Jessica Perez and Eliza Gipson, had been working feverishly for several hours. Behind the Marist bench, they filled scores of paper cups with water and yellow Gatorade, unloaded buckets of ice and filled sixteen twenty-four-ounce water bottles to be carried out to the team during timeouts. They placed the headsets for the coaches to communicate with each other during the game at one end of the bench. They unloaded a couple of industrial-sized containers filled with multi-gallons of more water.

An official bent over to talk to the four ball boys wearing their seventh-grade Marist game jerseys. He instructed them how and when to get footballs from the sideline to the proper official on the field. An hour and a half earlier, Coach Perez had huddled with the youths in a corner of the locker room and explained their mission to them.

The boys were thrilled to have been selected for such an important game. They stared wide-eyed at varsity players strapping on their battle gear. Someday, they imagined, they, too, might be standing in this room, suiting up, just like their larger-than-life heroes were.

The Marist backfield ran repetitions at the thirty-yard line heading to the end zone. The plays were part of the bread-and-butter triple-option repertoire—the dive, the read, the pitch, the speed option. Offensive coaches stood across the line of scrimmage, acting like defenders, trying to slap the ball out of ball carriers' hands. There were never too many repetitions of basic fundamental plays, according to Alan Chadwick's philosophy.

The dry-run plays were executed flawlessly. Quarterback Perez seemed surer and quicker than he had all year. Mike Coveny, the backfield coach, shoved his players, trying to knock them off stride, making them concentrate on keeping their balance.

Coach Jef Euart directed his defensive backs through reaction drills. With each movement of his raised arm holding a football, his young men reacted with quick stutter steps to the left, then the right, then back, then forward.

Coach Danny Stephens instructed his defensive ends to cut-block the pulling guards heading their way from the other side of the line of scrimmage. "I want you launching yourself so you hit him just above the knees with your helmet. You will sacrifice yourself so their runner will not have any blocking. "

After a few repetitions, he took a knee and gathered his players in a close circle around him. Beads of perspiration dripped slowly from their chins onto the forest green Sprinturf field. He said, "I'm counting on each and every one of you to lay it on the line for each other tonight, okay? We are all brothers out here."

He stuck his hand in the middle of the circle, and it was immediately covered by a hand from each of his players. All the hands touched, and it became one hand. The coach smiled and said, "God is good!"

His players answered, "All the time!"

The atmosphere was electric with a buildup of tension. A surreal mixture of sweetness, urgency and adrenaline flowed through the soul of each player and coach. If you could capture the essence of that special feeling, you could bottle it and sell it by the ounce for more than the price of gold.

At 7:10 p.m., the team and coaches shuffled off the field to the locker room for final adjustments and speeches by the coaching staff.

Alan Chadwick stood in the middle of the locker room. The coach called John James, his receivers coach, front and center. Eighty sets of eyeballs followed as he bolted to the center of the locker room. His words tumbled out with gravity: "This is how you will win. You will win if you fight your butts off. If you get beat you get up and you do it again…and again…and again. And you keep coming, and coming, and coming until that final gun goes off. This is a game of controlled fury. Are you meaner, are you tougher, do you want it more than the guy wearing black across from you? We'll find out tonight. Let's get after them!"

Victory and Defeat

The players' voices erupted in thunderous volume.

The head coach waited for several suspenseful seconds and then called up the next assistant coach to address the squad: "Coach Miller."

Matt Miller's robust voice, charged with emotion and zeal, rang out: "Guys, did you feel those butterflies out there, the emotion out there on that field, the enthusiasm out there? I'll tell you what that is. It's Marist football! It's the love we have for everyone within these doors. For the first time this year, I've seen it all week long. I just saw it in your eyes a few minutes ago out there on our field. It's that emotion, that passion, that love for all the hard work you've done."

The ruggedly handsome coach folded his arms while peering around the locker room, smiled and continued:

> *There will come a time when you grow up and you'll be an old guy like me and you'll look back on moments like this. And sometimes, guys, there might be a "what if?" What if I'd taken that one more step that coach talked about? What if I'd reached just one inch farther and knocked that ball down? What if I'd finished my block a little bit harder?*
>
> *What if?*
>
> *Guys, this is one of those moments in your life. The regular season is over. It's the playoffs. It's time to start getting after somebody. So here tonight, don't let there be any "what ifs." Leave no doubt out there. Do you hear me?*

The locker room became kinetic, boiling over with youthful exuberance.

Coach Coveny was next on stage, and he charged to the front of the locker room, bellowing, "No more doubt! Drive that dark shadow of doubt away. Let there be no doubt in any Marist football player on this football team. There is no tomorrow. There is only tonight. Go get after them!"

Coach Romano waded through the room teeming with roars of applause from the team. He said, "It's hard to follow that, Coach Coveny."

His measured voice delivered impassioned words: "I want you to do one thing for me. One thing. For five more minutes I want you to bottle it up. It's going to be tough out there. They are a good opponent, a proud opponent. We're going to need that energy, that passion, for forty-eight

minutes. So bottle it up for five more minutes, because when the time comes, and you will know when it comes, you let it erupt! You got that?"

Coach Dan Perez spoke next:

Here's a couple of hints about playoff football. Don't make it more than it is. It's still a football game. And football games in November on Friday nights are won by the simple things of blocking and tackling. It's really that simple. The second thing about playoff football is what play will be the play? Last year it happened to fall our way on the last play of the state semifinal game. Forty-eight minutes, and the very last play of the game decided it. Tonight it might be the first play. You never know.

We're going to have them outnumbered tonight. We're not going to have eleven players out there; we're going to have at least twelve on every snap. Marist has been playing football for almost one hundred years. If you don't believe in Ghosts, you better start. Because those Ghosts are going to rise off Nancy Creek right behind the stadium and ride the fog into the stadium and through the goalposts. The Ghosts will be out there with you. You better believe in the Ghosts of Marist Football.

A member of the officiating crew stuck his head in the locker room and asked for the team captains to come to the field for the coin toss. Kickoff was six minutes away.

Coach Stephens had an insistent message: "I'm talking about good old-fashioned hatred. It's time to get mean. It's time to get nasty. Most of you were accepted to Marist when you were in the sixth grade. Your mom was very happy because it's a great academic school. But your father smirked because of why he really wanted you here—to wear that blue helmet!"

Defensive coordinator Euart leaped up and stood on the long bench that runs down the length of the locker room. The team swarmed in and crowded around him in a scene that resembled a mosh pit. He spoke passionately: "There has been many a team that sat in this locker room right where you are. Some were decent, some were good, some were great. But the one common characteristic they all shared, and share with you, is that come playoff time they became a mean, tough band of brothers. We're sitting in a foxhole, men. Right here. You do whatever you have to do to protect this foxhole. Let's go win this thing!"

The last person to leave the locker room was Alan Chadwick. He saw a former player, a Ghost of Marist Football, next to the exit door. His blue eyes showed recognition. As he passed, he smiled like he was savoring something and whispered, "Pretty special, isn't it?"

Early in the first quarter, safety Patrick Sullivan's interception of a Sprayberry pass gave the ball to the Marist offense. Andy Perez hit speedster split end Jordan Snellings with a thirteen-yard pass inside Sprayberry territory. Sullivan took a Perez pitch on the triple-option play, swerved inside the containment and bolted for twenty-one more yards. Sam McNearney wriggled out of the grasp of a defensive tackle and squirmed for seven more yards down to the four-yard line. Perez ran a quarterback bootleg into the end zone, and Marist led 7–0 with a minute and a half left in the first quarter.

Jerick McKinnon, the swift Sprayberry quarterback, scored two minutes later to cap a seven-play, eighty-yard drive. The Marist sideline became subdued by the suddenness of the opponent's response.

After the kickoff, the War Eagles took over on their own twenty-yard line. Fullback Matt Connors powered up the middle with three consecutive carries for twenty-three yards. Perez kept the ball on the triple-option play, turned inside and picked up another first down, gaining ten yards down to the Sprayberry forty-seven-yard line. Perez took the next snap, faked to Connors, read the pitch man angling in toward him and pitched out to Sullivan, who was smacked down for a three-yard loss by a blitzing free safety. In the press box, offensive coordinator Paul Etheridge's headset was besieged with negative chatter from the other offensive coaches. "Listen guys, just relax. We're gonna be just fine."

Etheridge called four consecutive plays resulting in fullback Connors accounting for another twenty-one yards. Marist had run twelve plays and consumed six minutes and twenty seconds on the current drive, hogging the ball and chewing up the clock, just like Doc Spurgeon had scripted in his scouting report.

With the ball on the Sprayberry twenty-four-yard line, Etheridge calmly sent the next play down to John James's headset. The coach whispered the selection to senior split end Penn Davenport, who dashed out to his huddling teammates with the call. Perez calmly repeated the

play in the huddle: "L91 and up." At the snap, Davenport sprinted down the right sideline and gave a head fake to the inside, causing the cornerback covering him to hesitate an instant and lose a step. Davenport poured on the jets and streaked past the ten-yard line with the cornerback on his heels. Perez lofted a deep, tightly spiraling rainbow pass. Coach Etheridge stood and screamed, "Go up and get it, Penn!"

At that moment, Penn Davenport looked back, arched his back and leaped like a deer nearing the back corner of the end zone. The ball fluttered just past the outstretched fingers of the Sprayberry defender into the hands of Davenport, who cradled the ball while falling to the turf at the back of the end zone. *Touchdown!* It was an electric moment, and the stadium was awash in a din of riotous noise. Marist trotted into the locker room with a 14–7 halftime lead.

The offensive coaches conferred in the coaches' locker room about problems the Sprayberry defense had presented. Etheridge decided it best to bring in his halfbacks who were out on wings and put them in the full house wishbone formation. He wanted to run 42 and 43 Triple, the staple of the Marist running game, to the tight end side. The coaches decided unanimously to stick to a smash-mouth running game in the second half.

In the locker room, Etheridge turned away from the whiteboard and told the team, "You are guaranteed one more half this season. You are guaranteed nothing more than that. You must play harder than you did in the first half. You understand? I'm real proud of how hard you played, but you have to do it for one more half. We need two more touchdowns. Go do it!"

Sprayberry received the second-half kickoff, but the Marist defense led by linebacker Cole Becker's aggressive tackling forced a punt. Marist took possession on its own forty-three-yard line. Connors banged for eight yards on two trap plays, and Perez gained thirteen more on a couple of keepers. Then Perez dropped back and connected with McNearney circling out of the backfield, who dashed for twenty-five yards to put Marist inside Sprayberry's fifteen-yard line.

Coach Etheridge had the defense reeling. On third down and eleven to go, he spoke confidently into his microphone: "L to Left Power, 42 Triple Lead, SE Reverse." The offensive coordinator knew Sprayberry would be expecting a pass. Instead, he opted for trickery.

At the snap, the Marist offensive linemen fired to the right in their normal blocking schemes when the triple option is employed. Perez cradled the football in Connors's midsection and then yanked the ball back while running parallel to the line of scrimmage. McNearney was running ahead of him, leading interference, and Sullivan was trailing behind him should he choose to pitch. But suddenly, out of nowhere, split end Penn Davenport, who had been flanked wide to the right, took the toss behind Perez while running in the opposite direction. Mercury-heeled Davenport employed high gear, locked on to the orange pylon at the left corner of the goal line and outsprinted the defensive back who had the angle on him. Bedlam erupted on the sideline, and the War Eagles took a 21–7 advantage late in the third period.

But there was no quit in Sprayberry. Propelled by the strong legs and accurate arm of McKinnon, the Yellow Jackets covered seventy-four yards in eight plays, and Sprayberry pulled within seven points again.

After a Sprayberry punt, Marist took possession with eight minutes left in the game on its thirty-yard line. If Sprayberry scored again, it could mean overtime, a situation to be avoided. Any kind of bad luck at all in overtime could bring the curtain down for the season. To lose at home in the first round of the playoffs, to be the team that had the Long Blue Line's twenty-six straight home playoff victory skein snapped, was unthinkable.

Chadwick gathered his offense around him on the sideline and instructed them insistently: "Let's take control of this thing right now and run it down their throats. Let's play Marist football the way it's supposed to be played!"

Fullback Connors bulled for four, four and eight yards on three straight plunges. McNearney followed left tackle Justin Olderman and gained nine more yards. Etheridge went back to the triple option again. Connors pounded for five yards, and Perez kept for three more. On third and two, Sullivan ran the belly play for five yards and a first down on Sprayberry's thirty-seven-yard line. On the next play, Perez pitched off to McNearney, who swept the left end for five more yards.

Coach Dan Perez's face was a mask of emotion. His linemen had taken control of the bigger Sprayberry defense. "Let's put 'em away!" he yelled out to his linemen.

Etheridge barked the next play down to Coach James: "L Trade, 46 Veer." Matt Connors exploded from his stance just seven feet behind his quarterback, took the handoff, hit the hole on the right side of the line, cut to the middle and took it to the house, a thrilling twenty-seven-yard burst. The score—Marist 29, Sprayberry 14—became final a few minutes later.

For the evening, workhorse Connors gained 124 yards on nineteen carries and also sacked the Sprayberry quarterback from his defensive end position. Quarterback Perez directed a flawless running game and was five of nine for 74 yards through the air. Davenport, McNearney and Sullivan also played sterling defense and were instrumental in throwing a blanket over the Yellow Jacket receivers. Marist defensive linemen Philip Wood and Burke McCarty kept relentless pressure on the Sprayberry quarterback, who was harried all evening long. Hulking 240-pound sophomore offensive guard Nick Brigham, affectionately called "Porkchop" by his line coach, was a road-grader, clearing a path for the Marist stable of running backs all night long.

The teams formed two lines in opposite directions and exchanged greetings of good sportsmanship. Many of the Sprayberry players had tears flowing down their cheeks. They appeared bewildered and stunned that the game they thought could be theirs had turned against them with such finality. The Sprayberry coaches shook the hands of their Marist counterparts, and each said, "Great job, coach. Good luck next week."

The visiting players slowly walked to their buses in a dirge-like shuffle, their helmets dangling by their sides, steam rising from their sweat-soaked heads. There was to be no week ahead for them. There were to be no more Friday nights in store. Senior players cried openly, realizing they had just had their last hurrah. For them it was over—all over.

As the final gun sounded, frenzied Marist fans swamped the field. Moms and dads danced with their sons, girlfriends hugged players, eight-year-old boys begged for chinstraps and autographs, cheerleaders pranced to the drumbeats of the band. Then the players, coaches and cheerleaders stood together and sung as one the Marist alma mater. The victory had ensured the magic of the second season would continue. The Ghosts of Marist Football would have more work to do.

Victory and Defeat

November 15, 2009
Sunday, 1:00 p.m.
Marist Coaches' Conference Room

Marist would have to travel forty miles to Winder for the second playoff game. It was expected to be quite a nerve-racking journey on buses traveling on a couple of the most maddening, congested arteries in the nation. Apalachee High School, 11-0 and ranked Number 6 in the state, would be waiting in its new stadium with half of Barrow County in attendance.

"We need to square away our travel schedule for Friday right now," began the head coach. "I'll err on the side of leaving early because no way do I want to be late for our pregame activities."

Jef Euart and Paul Etheridge gave quick, nervous glances to each other. "Well," responded Etheridge, "we don't want to get there too early and have our guys lollygagging around and getting nervous watching all the hoopla out there. We want to get off the buses and head straight for the pregame routine."

"I second that, coach," said Euart.

Chadwick considered them for a minute. Then he said, "Okay. But we will still leave early, just to be safe. We'll have Mass at 2:00 p.m. and our classroom meetings at 2:40. We'll dress here, not there. We'll eat the pregame meal at 3:30 and hit I-285 at four o'clock."

Ace middle linebacker Keller Carlock had been declared out for the season with a torn medial collateral ligament. And films proved that Apalachee's offense ran the football 70 percent of the time with its two fast wingbacks. Somehow, Marist would have to adjust its defense to overcome the key player's absence. Fullback Matt Connors, who had played little on defense, was informed at Monday's practice that he would be required to take a number of reps in Carlock's stead. His teammates smiled when he jumped into the defensive huddle during a lively scrimmage, called the play and yelled at the offense breaking the huddle, "Bring it!"

November 17, 2009
Tuesday, 5:04 p.m.
Marist Practice Field

Jef Euart conducted a live scrimmage as his starting defense faced the scout team running scripted Apalachee plays. The plays came rapidly, and after each, the coach screamed, "Way to go! Hustle back, huddle, huddle, get ready! Here we go."

Outstanding junior varsity athlete Myles Willis imitated the excellent Apalachee quarterback, Mike Norman.

Buck Sweep—stopped for no gain. "Way to play downhill," yelled Euart.

Wham Play—stopped for a yard loss. "That's the way to stay low!" said defensive line coach Matt Romano.

Cross Buck—another loss with five defenders in on the tackle.

Jet Sweep—halfback hit behind line of scrimmage.

Coach Chadwick blew his whistle for the next practice rotation.

Euart said, "Just one more play, Coach, okay?"

Chadwick turned away, shook his head and glanced at his watch. He treasured his timetable, down to the last second.

At 5:24 p.m., the team was granted a water break.

At 5:26 p.m., it was time for daily fundamental drills for each position.

Even though it was the twelfth game of the year, Chadwick placed a seven-foot-long ruler from the quarterback's feet to the front knuckles of the fullback in his four-point stance behind him. For the timing to work, the fundamentals had to be *precise*, the coach insisted.

Coach Romano reminded his defensive linemen to push the blocking sleds with tiny steps, staying low and keeping their balance.

The tight ends and wide receivers executed scores of precise pass routes as Coach John James delivered the ball on target to them.

Coach Etheridge slammed down his cap when the offensive huddle took too long to head to the line of scrimmage. "If you want to regret something for the rest of your lives, get on that bus Friday and go up Highway 316 and get beat! It all starts right here at practice."

At 6: 05 p.m., a full scrimmage for the offense unfolded at an up-tempo pace.

At 6:20 p.m., the players ran fifty-five-yard wind sprints across the width of the field and back again and again.

At 6:30 p.m., Coach Chadwick thanked his players for giving such an inspiring effort and dismissed them.

As Wednesday's practice got underway, Chadwick challenged his staff, "Come on, coaches, and turn up the intensity! Get on their butts on every play."

The nine-man coaching staff burned the midnight oil each night, clocking in for the most grueling week of the year. They painstakingly scoured Apalachee films, seeking weaknesses that may have been overlooked.

By game day, the coaching staff was confident the team was ready to go. Coach Euart said, "If we play our best game, we can beat anybody." They respected the fact that Apalachee, called the "Cardiac Cats," had won two overtime games and another by one point.

On Friday afternoon, the players walked out of the locker room in blue game britches and T-shirts into a cool autumn breeze. Team moms distributed bottles of Gatorade. The players loaded their equipment into the bus bins and quietly boarded.

The buses slowly pulled out of the Mad Italian restaurant at 4:00 p.m. after a hearty pregame meal and motored onto the clogged I-285 freeway to begin the tedious journey. After a few minutes of fitful stop-and-go traffic, many players drifted into a light slumber. A couple of female team managers giggled while exchanging texts, drawing a stare of rebuke from a nearby coach. The head coach stared straight ahead, occasionally glancing at his watch.

It took forty minutes just to get past the multi layers of Spaghetti Junction, where the buses headed north up I-85. But Chadwick's timeline had accounted for the sluggish pace. The buses turned onto State Highway 316, where a series of red lights had traffic backed up considerably. But on schedule, the vehicles entered Barrow County. The bus driver overshot the exit to the stadium and had to retrace his path, causing a delay. Chadwick just shook his head.

The love affair for its home team by the locals was visible immediately after the buses exited the highway. Banners, roadside homemade signs, scrawlings on back windows of pickup trucks all carried the same message: "Beware! This is Apalachee Wildcat country!"

Suddenly, a yellowish gleam lit up the sky dead ahead, brilliant candlelight created by the powerful four-hundred-watt lights of the R. Harold Harrison Stadium in the middle of the sprawling Apalachee High School campus.

Children raced alongside the bus, reveling in an atmosphere of ten county fairs. Local civic groups huddled next to industrial-sized barbecue grills bellowing clouds of charcoal smoke, strewn with chicken, ribs and burgers sizzling. The parking lot slots and the home stadium seats were jammed two hours before kickoff. Anyone tardy would face standing room only.

The bus driver didn't see the traffic coordinator signaling him with a flashlight and drove past the new, gleaming athletic building housing locker rooms. A few blocks later, the head coach leaped to the front of the bus and instructed the driver to head back the other way

But the bus pulled up to the athletic building at 5:45 p.m., exactly on schedule. The players filed into the locker room, dressed and walked out into the sparkling new field house, taking seats on the glistening gym floor while Chadwick made final preparations, quietly conferring with coaches and team leaders. Team doctors checked braces, and trainers began taping players who needed it. Noise from the frenzied activity of a whole county celebrating just outside the doors of the building turbocharged the butterflies at work in the bellies of the visiting team.

Finally, the head coach gave his team its final marching orders, suggesting that they relish the whole spectacle, urging them to stay confident in the midst of hostility and reminding them of the sacred duty they had to the litany of the Ghosts of Marist Football.

Matt Connors later remembered the preparations in the locker room: "Just before warm-ups, they gave me an IV in the back of the locker room so I wouldn't become dehydrated since I would be going both ways. The coaches' speeches helped us get focused and got our blood flowing. They made us believe we could go out and do it."

He noticed how friendly many of the Apalachee fans were before the game:

> *Some of the local fans held the big doors open for us when we left the field house and walked to the stadium for the warm-ups. They clapped for us when we walked through the parking lot where they were tailgating. Of course, there were a few boos. It was so exciting. The pregame routine was electric. The place was packed.*
>
> *We had a lot of fans show up, but the noise from the Apalachee side just before kickoff was real loud. I just tried to block it out. Their players looked bigger to me than in the films, but it didn't make me nervous. As*

a sophomore, I would have been worried if there was a three-hundred-pound guy across from me, but not now. We had beaten a lot of teams with size like that.

Both teams conducted high-charged warm-ups. Both teams were ready to rumble. Both teams roared cadence while stretching, as if one.

As the game began, the fans wrapped themselves in blankets against the cold.

Andy Perez scored a quick touchdown on a keeper, and Patrick Sullivan added another on a sweep. Marist led 14–0 with just a minute left before halftime. But on fourth down on the Marist five-yard line, Apalachee halfback Jon Lee stretched the field and then reversed course and scored. The huge home crowd roared as the Wildcats trotted confidently to the sanctuary of their locker room for halftime.

The Marist coaches knew the late score had created a major negative momentum shift. In the locker room, the coaches reemphasized the necessity of playing with confidence and pride.

After a third-quarter Apalachee touchdown, Sullivan once again scored, this time on a seventy-one-yard gallop, outrunning both safeties. Marist now had a 21–14 lead.

But the Apalachee running game was starting to gouge chunks of yardage against the Marist defense, sorely missing its brilliant middle linebacker. Wildcat running back John Ansley broke off tackle and took it to the house for a fifty-six-yard touchdown, knotting the score at 21–21.

The tension became constricting on both sidelines. There would only be one winner, and the game was becoming a duel to the death.

Connors and Sullivan quickly teamed together for a couple of long gainers, and Marist yet again took a touchdown lead.

Midway through the fourth quarter, Apalachee gambled. The Wildcats converted on a trick hook-and-ladder play on fourth and ten on the Marist thirty-four-yard line. The quarterback threw a quick pass to a receiver who lateraled the football back to the trailing Ansley, who bolted to the Marist eleven-yard line. In two plays, Apalachee scored and made it 28–28. And then regulation play ended.

The overtime period followed. The whole season now depended on two series of plays for each team, one on offense and one on defense.

Marist got the first possession and lined up on the Apalachee fifteen-yard line. Connors delivered, once again, with a burst over two defenders. Marist led 35–28.

Apalachee took over and went solely to its power running game. On third down, powerful fullback Christian Hoard, five feet, eleven inches, 240 pounds, blasted off his right tackle from the five-yard line and tumbled into the end zone, making the score Marist 35, Apalachee 34. The Apalachee Nation was ecstatic, and their stands writhed in bedlam. The Marist fans were almost mute.

Apalachee coach Shane Davis told his team before the game that they would pull out all the stops and play to win. After the touchdown, he called timeout, and his team raced over to the sideline and huddled around him. Should they kick the extra point, tie the game and undergo another overtime period? Or should they go for all the marbles at this moment, right now, and seize victory?

The coach later said, "I just asked the kids what they wanted to do. Did they want to put the season on the line with a two-point play, and they all said yes."

Marist defensive back Sam McNearney's first thought after the touchdown was, "Okay. They scored that touchdown. That's all right, we'll just have to score again."

Then he watched the Apalachee offense trot from the sidelines after the timeout. "They decided to go for two, and I said, 'Wow!'—here it comes! I knew without a doubt we would stop them."

Marist lined up in its goal line defense with the ball spotted on the three-yard line. Just before Apalachee broke the huddle, safety Patrick Sullivan yelled to his teammates, "Everybody go 100 percent and we win!"

Apalachee's fullback Hoard broke from his stance at the snap of the ball, took the handoff and slashed into the end zone. It was the same play he had just executed to score the touchdown.

And, *presto!* It was over. The scoreboard lights flashed the final tally.

APALACHEE	36
VISITORS	35

Victory and Defeat

McNearney recounted:

I knew they would run the same play they scored the touchdown with, the fullback wham. I was close in at the right corner. They sent motion my way. My first responsibility was sweep, so I had to honor that. He took the handoff and had no trouble scoring on the left side.

Then I heard their crowd roar. It was the worst. I couldn't believe what just happened, but with each second, it sunk in more and more. I would still be laying on that field if someone hadn't picked me up.

Connors had just entered the game at middle linebacker. "Their right guard got on me real quick, and their halfback blocked our left cornerback. The fullback scored. It was the worst feeling I've ever had."

The defeated team made its way through the jubilant home crowd that swamped the field. Back in the locker room, the seniors slumped in lockers and on the floor, sobbing, realizing the dream of the past six years was over. There would be no more football for most of them again, ever. The body language of the bloodied, exhausted players portrayed the deep, visceral pain swimming in their souls. Their breath came in spurts between sobs. Tears flowed down cheeks and dropped one by one onto their muddied white jerseys. The room was awash in agony. No one spoke; no one gave orders. The only exchanged glances were those of helplessness and sorrow, as if there had been a death in the family.

And, indeed, there had been.

There is nothing like the exquisite feeling upon winning a championship game. But the flip side can be one of angst, fueled by a calamitous ending to what promised to be another championship season.

After his last football game ended with surprising suddenness, bringing the searing pain only felt by a disciple fervently committed to a cause just lost, Trey Nordone sat crumpled on the locker room floor. The exhausted senior had lost both his dream and his love on the final play of the playoff game in overtime. He and his senior teammates absorbed the horrible moment in silence, suffering and shock.

Oblivious to the world, he remained motionless, staring into an abyss, his uniform caked with grass stains and traces of Georgia red clay. Time had stopped for him. There was no past and no future, just the now—this

empty vacuum—composed of loathing and loss. And the undeniable truth persisted, the realization that there would be no more Marist football.

After a long while, he slowly reached for the laces of a football shoe, sighed and leaned back against the wall. Finally, his head coach came to him and helped him to his feet, hugged him and told him he loved him. Nordone remembered nothing after that—not the screaming silence of the long bus ride back to school nor the waking hours clogged with despair the following week.

Ten days later, he remembered, "The final scene is blurry…but etched in my memory…and it all melds into one blur of turf and cleats and sweat and blood."

He turned away and took a deep breath. "We let them get in there for two points in overtime. That blocks out everything in my mind, the finality of it. I'll never again step on the football field. At the last second, I was locked up with their tackle. I got off the block and saw the fullback's legs go past as he ran into the end zone. It was the very play we expected, a fullback wham. Then I heard the crowd noise, and I knew. In one split second, I registered realization, denial and despair."

His words came haltingly, like those in the confessional booth. But he had no sin to confess, just black memories to describe.

"Someday it'll stop hurting so bad," he said. "After the game, in that locker room, I refused to accept my football career ended that way. I stayed in my pads. I knew I would never put those smelly pads on again, never ever again. I just could *not* take off that uniform. Finally, Coach Chadwick came up to me and convinced me the bus was getting ready to leave."

He finally smiled, lost in reverie.

In the Southwest DeKalb game, I broke my toe playing defense. My leg was extended with my foot under it when I went to the ground with guys on top of me. Something had to give. Three toes were jammed, one was broken. The pain was terrible, but it was such an important game I hid it. I just bit the bullet and pushed through.

It was the best defensive game I ever played, making tackles, shedding blocks. It was big for me. We were down and struggling, my toe was broken, I was giving all my effort through the pain and my effort was effective.

Trey Nordone put the whole matter in a final thought: "When you play with your full heart in total dedication and you play with all your passion, good things happen."

After the bus finally got back to Marist, after the players showered away the dirt and blood and put on jeans and sweatshirts, the team filed into the gymnasium. The coaches praised their courage and told them to hold their heads high. Then the team surrounded Alan Chadwick, who had knelt to the hardwood floor, in a final circle. He created a personal prayer from his heart, mentioning strength and love. Then all the seniors stood in line to shake his hand and give emotional hugs as tears flooded the floor. The coach told them how he loved them so. Then the players shook all the other coaches' hands.

Then the 2009 team left the building for the last time as one.

Linebacker coach Matt Miller looked back on the long season:

> The great thing about Marist football is the lessons it teaches our young men. They are not always going to win, but what matters most is the effort they put into it. When we get knocked down, we dust ourselves off and get back up to fight the next play. We win with class, and we lose with class. This year's team did a great job representing Marist, not only when we won but also when we lost. They are a great group of young men.

A few days later, a somber Alan Chadwick sat at the entrance to the locker room, checking off items on his clipboard. The players were turning in equipment, and the head coach and his equipment manager were taking an inventory. Each player shuffled by with pads and helmets heading to the equipment room. Voices spoke in soft murmurs, and the head coach remained silent, looking contemplative. The sense of loss hung heavy over the whole program, a burning sore in the soul of the Marist War Eagle.

Wide receiver Penn Davenport stood among a group of a few seniors and said, "When the game ended so suddenly, and we had lost in an unbelievable way, I didn't know what to do."

He shook his head and added, "I still don't know what to do. I wonder how long it will hurt like this?"

The other seniors looked at each other. There was no answer.
A new poster in the locker room shouted out in large blue letters:

Attn: Juniors and Sophomores
If you are not already pushing yourself to be better next year you are
behind the 8-ball!

Victory and defeat, winning and losing, both on the scoreboard and on the practice field are what forge character that lasts a lifetime. How can you battle in a business or a profession if you don't know the difference between success and failure? How can you be successful unless you vow to refuse to lose?

Part III

The End and the Beginning

Chapter 11
Hunting Rhinoceros with BB Guns

August 17, 2010
12:30 p.m.
Hudson's Grill

Senior leaders Justin Olderman, Keller Carlock and Sean Manzelli sat along the wall at a corner table of the restaurant near Marist. They discussed their expectations during lunch about the upcoming 2010 football season. Chicken fingers and cheeseburgers were the entrées du jour.

Olderman, whose father and grandfather had both starred at the University of Virginia and played in the NFL, was a six-foot, three-inch, 230-pound force on both sides of the line of scrimmage. He began, "We're all excited about this senior year. I play Marist football for the camaraderie and fellowship. These are the best friendships I will ever have. I expect the three of us to step up and provide the leadership this team needs and expects."

Carlock, a returning six-foot, one-inch, 210-pound starter at middle linebacker, smiled and said, "We will have a lot better chemistry this year than last, I feel. We did a good job last year educating the sophomores who this year will be a good supporting cast. Justin was right—it's the togetherness that counts so much. That, plus our hard work, is the reason we win. The coaches expect us to step up and lead."

Manzelli had grown into his six-foot, four-inch frame since his junior year. He worked closely with a personal trainer in the off-season. The

grueling workouts Sean religiously attended added 15 pounds of rippled muscle. Now, at 207 pounds, he was quicker and more explosive at defensive end than before.

He shook his head, like shaking cobwebs away: "The way we lost, on the last play of our twelfth game last year, has motivated us ever since. Losing is the worst thing about Marist football. We work so much harder than everybody else, it just kills us when we lose."

Carlock added, "It's our job now to keep the tradition going. In the future, we'll be part of the Ghosts of Marist Football. But right now, our job is to lead this team to a championship."

Olderman reflected about the academics: "Marist is a top academic school. That's one reason we miss out on so many good players who go elsewhere. They simply can't get in here. So we know we have to work harder to make up for the talent gap we suffer against so many top Georgia high schools."

Olderman discussed unwritten rules: "We have one basic rule here. And that is you must play hard each play. If I see a guy take a play off or loaf, I'll say something to him. In fact, I'll yell at him."

August 28, 2010
7:00 a.m.
Waffle House

Alan Chadwick sat at the table scouring the *Atlanta Journal-Constitution* sports section, stunned at how many upsets had occurred on the opening night of Georgia high school football. "It looks like a lot of what used to be average teams we play have gotten a whole lot better. That makes it harder on us." His football team had just concluded a convincing season-opening victory the night before, 48–12 over Douglass High School. He sat at the same table at the same restaurant in Chamblee he has for years on Saturday mornings during football season. He is a man of energy and expects little rest during the almost five-month-long football season. His usual tablemate, Dr. William Hardcastle, team physician for the past thirty-four years, sat across the table. The breakfast was part of another ritual of Chadwick's, a man who rarely varies from his habits.

The End and the Beginning

His breakfast was the same as always: two eggs over-light, hash browns, orange juice and decaf coffee. He always appears hungry when he eats, and when he begins, there is no stop until completion. He eats the way he coaches: orderly and efficiently, until the job is done.

The Waffle House was the first stop of his Saturday morning schedule during football season. Next, he would exchange the previous night's game DVDs with the coach of next week's opponent. After breakfast, he headed north on Peachtree Industrial Boulevard to Olga's restaurant. Franklin Stephens, head coach of Number 1–ranked Tucker High School, was already in the parking lot.

For the past decade, the road to the 6-AAAA Region Championship had gone through Tucker and Marist. Whichever team won the key game against the other usually also won the region championship and was awarded home field advantage in the playoffs. Both teams were perennially rated in the Top 10 in the state. It is one of the most ballyhooed games in Georgia every year. The coaches respected each other and enjoyed nothing better than defeating the other.

Stephens came forward with his large hand extended, and Alan Chadwick shook it and said, "Coach, it'll be crazy Friday night—TV game of the week, the Marine Corps Rivalry Trophy at stake, radio and a huge crowd."

Stephens responded, "Heard you've got a lot of size this year. My offensive linemen are so small I have to look down at them."

Chadwick picked up on that. "Sounds just like our backfield."

They measured each other with mutual respect. Both men are committed to excellence, and both are winners.

This pivotal game would set the pecking order in the region for the rest of the season. The game was essentially the first playoff game of the year even though it was played just before Labor Day.

The two shook hands, and Chadwick raced to the film room at Marist to watch the swarming Tucker defense at work the previous night. "We've got to solve this aggressive, quick defense," he muttered.

The next day, Alan Chadwick chaired the coaching staff's three-hour Sunday meeting. Tucker had opened the season by scoring fifty points against a preseason Top 10 team, Southwest DeKalb—in the first half.

After viewing the first-half tape, offensive coordinator Etheridge allowed, "Their defense is extremely quick to the ball. They explode

through plays. We will have to try to get up quick on them or they will try to run away from us with a big lead."

The head coach asked new assistant Michael Day, who had been a defensive coach at Tucker the past few seasons, "What can you tell us about them?"

Day responded, "When they get off that bus Friday night, they will feel they are down by seven points when they walk in here. So they will try to intimidate us from the very start. They are terrified of our triple option and will play a 4-4 defense. So we need to get up quick."

The head coach added, "We must have hard, physical practices this week. And I want you to handpick the best possible scout teams so we can have real competition when we go one-on-one this week."

The players, having completed their lifting in the weight room, were already seated in the film room when the coaches entered to critique the previous game.

Etheridge set the tone: "I don't care that we won 48–12 Friday night. We did not play as physical against Douglass as Tucker did against Southwest DeKalb. They play violent football."

He slowly let his eyes drift across the room.

"Are you afraid of them?"

The team responded in unison, "No!"

Etheridge whispered, "Are you sure?"

"Yes!" came the cry.

After Monday's practice, the defensive coaches grabbed a quick dinner at their favorite Mexican restaurant and then headed to the assistant coaches' room to plot the defensive game plan. Defensive coordinator Jef Euart had drawn on the blackboard all the formations Tucker had employed in Friday night's game and in the Tucker-Marist game the year before when Number 1–ranked Tucker was upset by the War Eagles. The coaches concluded which plays were run from the different formations. After several hours, they knew the most likely plays Tucker would run based on the formations in which they lined.

After Tuesday's practice, Euart assembled his starting defensive team in the coaches' bullpen and said, "They are fathoms ahead of us in athleticism and speed. Our only chance is to recognize their formations and be in position to make plays. If we don't, we'll get killed."

The End and the Beginning

After the players were sent home, the coaches headed to a classroom for the weekly Tuesday night dinner prepared by the team moms. The fare featured bacon, egg and sausage casserole, hash brown potato casserole, sausage and cheese grits, fruit salad, homemade cinnamon rolls, orange juice and iced tea. A coach could get mighty hungry after a full day of teaching, working on a career and coaching a grueling two-and-a-half-hour football practice.

After dinner, the coaches retired to the conference rooms to construct the scouting reports. Each player would get the reports before Wednesday's practice. Chadwick made sure each mom responsible for the meal would get a handwritten thank-you letter.

Wednesday's practice was spirited and very physical. The defense worked on reacting to formations, and the offense worked on variations of the triple option and a newly installed gadget play.

Just after the Friday night TV Game of the Week began, Marist found itself backed up deep in its territory on fourth down. An errant snap sailed over punter Austin Hardin's head for a safety. And just minutes later, Tucker halfback Lequan Maggett sprinted for a twenty-five-yard score, and Marist trailed 9–0.

In the third quarter, Marist took the lead 10–9, aided by a sixty-seven-yard reverse by swift wide receiver Jordan Snellings. A few minutes later, the Marist defense stiffened and stopped Tucker on fourth and goal at the Marist one.

It took Marist just six plays to cover the ninety-nine yards. Halfback Gray King scored from thirty-three yards out to provide Marist with a 17–9 advantage.

With less than five minutes to play, Tucker scored to narrow the Marist lead to 17–15 and chose to go for a 2-point conversion. A fade pass to the back of the end zone was completed, and the game went to overtime. Both teams scored TDs in the first overtime, and Tucker scored another touchdown in the second overtime period.

Faced with a last-ditch fourth and two situation from the Tucker seven-yard line, Marist was forced to pass. The attempt was deflected. Tucker had just punched a big hole in the heart of Marist, 31–24.

Afterward in the steamy locker room, players sat, some immobilized, all exhausted. Sweat-soaked jerseys and blood-drenched socks lay in sodden

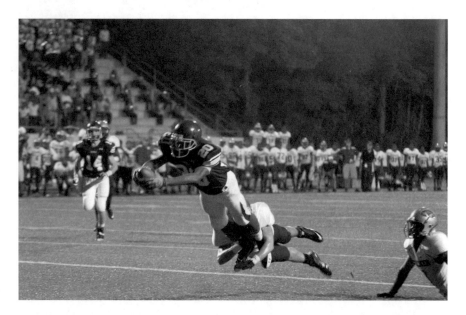

Sure-fingered Marist receiver Jordan Snellings (20) hangs on to a quarterback Andy Perez aerial for a vital first down against arch rival Tucker with Jack Burke (14) ready to help, September 3, 2010. *Toni James.*

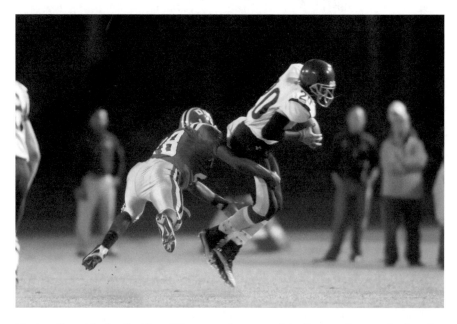

Marist split end Jordan Snellings (20) escapes the grasp of the Dunwoody cornerback and gains a first down, October 15, 2010. *Toni James.*

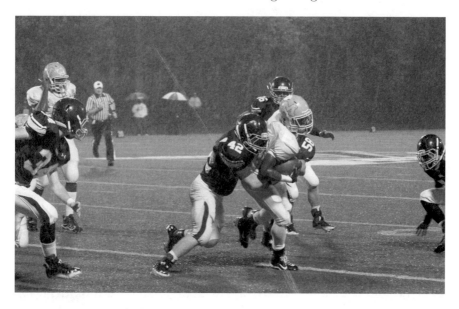

Marist linebacker Austin Hicks (42) applies the brakes to a Mays ball carrier as Bobby Scott (34), Jordan Barrs (58) and Matthew Frassrand (86) assist, October 28, 2011. *Toni James.*

heaps next to stalls. Coach Chadwick let them feel the pain for ten minutes. Then he came to the center of the locker room and addressed his troops.

"Be proud of yourselves. You gave it your all. It was a great football game. They just had a little more in their tank at the end. We will work hard and get better, I promise you. I don't want anybody hanging his head down."

Injuries Report

Football is the most brutal of team sports. Your team's assignment is to somehow get the football into your opponent's end zone, no matter what. Across from you and between you and his end zone is your opponent. His task is to prevent you from scoring, no matter what. The result is a series of individual physical clashes conducted at full speed, sometimes resulting in injuries.

The running back takes one final full stride trying to turn the corner on a toss sweep. Suddenly, he pitches to the turf, like a stallion with a

suddenly cracked shin in the Kentucky Derby, as his hamstring muscle in the back of his right thigh ruptures. He crumples helplessly, and acute pain washes through him.

The senior wide receiver crossing the middle leaps high for a pass. His legs get tangled up with the strong safety. As they fall to the ground, all the weight of both players ends up on his right leg, and his ankle collapses the wrong way, folding like a cheap suitcase. As two teammates help him hobble off the field, tears trickle down his cheeks, not from physical pain but because of the realization that he has just played the final down of his high school football career.

Today's football helmets and pads provide more protection than ever. Nonetheless, shoulders get separated, hips get cracked, nerves get pinched and elbows get dislocated. At every level, from youth football through the ranks of high school, the NCAA and the NFL, today's players are bigger, stronger and faster than ever. The net result is that collisions increasingly transpire on the gridiron at higher velocity with more mass. And injuries may result.

Senior defensive end Sean Manzelli made great strides in improvement during the last half of his junior year in 2009. In the off-season, he pushed himself in the weight room to gain speed and strength. For Sean, his big chance had finally arrived. He had always been second fiddle to his older brother Kash, an all-state pitcher in baseball and all-region forward in basketball who, the year before, won an appointment to the United States Naval Academy.

The second day in summer camp, Sean suffered a shoulder injury during a tackling drill. He shook it off and kept practicing. But in the first two games, the injury got aggravated. The pain got worse. He couldn't sleep at night. The team doctors told him there would be no contact in practice for him and that he could not dress out for the next few games. He worked hard to rehab the injury. After he missed two games, he said he wanted to play anyway. Colleges were interested in him, and the team needed him, he pleaded.

He went through practice at full speed. The coaches started him the next Friday night. While making a tackle in the second quarter, his shoulder was reinjured. His high school football career went up in flames. He would miss the playoffs.

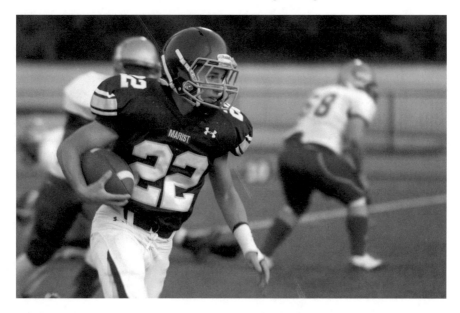

Speedster Gray King (22) turns the corner and eyes the goal line as Marist belts neighborhood rival Chamblee 27–0, September 10, 2010. *Toni James.*

He decided he would get surgery after the season ended and walk on at a college somewhere. His father said he has never been prouder of anyone than Sean because of the courage he displayed.

OPENING ROUND OF GEORGIA HIGH SCHOOL FOOTBALL PLAYOFFS

November 13, 2010
Heritage High School, Home

The kickoff for the first round of the state playoffs was just a little more than forty-eight hours away. Alan Chadwick's face grew red midway through the Wednesday afternoon practice. His offense was floundering and practicing at a lethargic pace.

He blew his whistle stridently three times, pointed to the track that circled the football field and said, "Start running." His assistant coaches

rolled their eyes, crossed their arms and remained silent. After three laps, Chadwick blew his whistle, and his team trotted back and surrounded the head coach.

His words came measured and angry: "We don't have the intensity, the will, the passion, the commitment or the desire to be a winning football team. We look like a one-and-done team."

He shook his head, disgusted. "I give up. You guys just don't have it. While you were running, I decided when I go home tonight I'm going to book a trip. I'll get to go on a vacation early this year because we'll be done. I'm going to a warm-weather place—maybe California, maybe Florida. So I'll book the flight tonight. Now, let's run these plays and get the hell out of here."

The rest of the afternoon's practice was executed crisply and near flawlessly.

Coach Jef Euart walked into the center of the ring of players on the field after practice. He slowly looked around the circle and began with an edge in his strong voice: "I wasn't going to talk to you today, but for the last twenty-four hours, I've been thinking about what's been going on around here for the last twenty-five years. I looked back and remembered how average football teams became great teams with average players. It was because of their undying spirit and their belief in the Ghosts of Marist Football."

He lowered his voice, and the players leaned forward: "I'm going to call some of you out today because I know you can do better. It's nothing personal; I like all of you. Hell, I love some of you!"

He pointed to his center. "You've got an A/C problem. Hell, I remember in 1991 in the state semifinal game when Benji Woods had his shoulder dislocated four times. They carried him off the field. But the doctors couldn't keep him on the sidelines. He came back in and never quit."

He pointed to the starting quarterback, Andy Perez. "You, number 10. I remember quarterbacks like Paul Nichols and Sean McVay who led us to great seasons with their enthusiasm, hard work and leadership. And they didn't have your kind of talent. Are you ready to step up with confidence and make us a good football team?"

Andy nodded his head up and down and whispered, "Yes."

The End and the Beginning

The coach's eyes welled up with tears. "We have to band together and create the enthusiasm that is what Marist football is all about. You have to pay honor to all the hundreds of players who came before you. They were all part of what you are now a part of—the Long Blue Line."

With that, he wiped his eyes and turned away.

The Heritage High Patriots unloaded from their bus near the visitors' locker room at 6:15 p.m. after a long Friday afternoon drive from Conyers. One by one, the players offloaded, glanced down the length of the well-lit gridiron and walked into the visitors' locker room lugging pads and scarlet helmets. The school had never won a road playoff game in its thirty-five-year history.

Quarterback Perez scored early, capping a six-play Marist drive on a four-yard keeper. A short while later, halfback Gray King's block leveled the cornerback and sprung Matthew Barker loose for a twenty-eight-yard sweep for another score. Heritage High was down 14–0.

But the Patriots didn't yield and drove the ball down to the Marist two-yard line. On fourth down, Marist defenders Justin Olderman and Keller Carlock jarred the ball carrier at the line of scrimmage, and nose guard Steve Wallace recovered the resulting fumble.

Defensive coordinator Jef Euart later congratulated his defense for the goal line stand and added, "I put pressure on you at practice so you can handle the pressure in the game."

Late in the second quarter, King followed his fullback Jason Morris through the B-gap, saw daylight and burst for a 38-yard touchdown run. Marist led 21–0 at the half. The sophomore ran for 103 yards on seven carries for the evening as Marist cruised to a 27–10 win to advance in the playoffs.

November 15, 2010
Sunday, 1:00 p.m.
Conference Room, Centennial Center Athletic Complex

Marist would be traveling to Chattahoochee High in north Fulton County for the upcoming second-round playoff game. The opponent's roster was stacked with talented athletes, harvested from its 1,800-member

student body, the largest in AAAA. The powerhouse had rolled through its schedule and was 11-0. It was exactly the challenge that Alan Chadwick thrives on.

The nine varsity coaches took seats at the conference table, staring at the film of a previous game chronicling Chattahoochee's size and athleticism. Suddenly, the head coach shut down the projector, flipped on the overhead lights and addressed his staff: "This is David versus Goliath. No, check that. This is like hunting rhinoceros with BB guns. I want all of you to set the tone and be there early for pre-practice to set an example. This week is going to be so much fun to face such a challenge!"

He slammed his hand smartly down on the table. "Damnit, I want to be practicing on Thanksgiving morning for the quarterfinals. We cannot allow this to be our last Sunday. Our ally is they haven't faced a real physical team yet."

He pointed to the AAAA seeding and future matchups. "Our game this week is for the state championship. There isn't another team left that can beat either of us."

Monday's practice was a disaster. Twenty-one varsity members were absent as a contagious virus had swept through the student body. After wind sprints, the head coach asked his team how many of them had respiratory problems. A majority of the players raised their hands, coughing and wheezing.

Chadwick said, "We want a 'yes' or 'no' e-mail from your parents if our team doctors can treat you for your respiratory problems. Wash your hands, get rest, drink fluids, clean out your lockers every day and be careful. This place is full of germs."

Chattahoochee was ranked Number 5 in the state, had averaged forty-four points while winning eleven straight and would be playing at home before a sold-out stadium. Chadwick reminded his players all of this and added, "I don't know how we are going to do it—but we are going to *win* this game!"

Coach Jef Euart put it this way in a letter to the team:

> *You can come up with a myriad of reasons why we won't prevail Friday night: they're too big, too fast, too polished, too well-coached and have too many students to choose from. We're on the road with too many*

sick players. Our key is recalling that for almost a century Marist has made a living being more than others think we are capable of. Let's evoke memories of past Marist teams by playing with a fury that borders on fanatic—a controlled chaos that makes outsiders wonder out loud, "How do they do it?"

Doc Spurgeon addressed the team after Wednesday's practice. Dressed in black, he cut an imperial figure and commanded the respect of the whole Marist community. Almost eighty years old, he had seen it all. His eyes blazed with passion as he addressed the squad: "I'm going to give you some advice about life. If you follow it you will have a fruitful life. You must let it all hang out. You must give it everything you've got in life and football. And especially against a very good football team Saturday night. You must let it all hang out."

Second Round of Georgia High School Football Playoffs

November 20, 2010
Chattahoochee High School, Away

With the score 14–14 in the second quarter, Marist went eighty yards on seven plays and took the lead when Gray King bolted the final five yards into the end zone. Marist's defense held and forced a Chattahoochee punt. The War Eagles then marched seventy-five yards on another time-consuming fourteen-play drive, culminated by a twenty-one-yard touchdown strike from Perez to wide receiver Jordan Snellings. Marist was up 28–14 when the first half gun sounded.

"You're doing just fine," the coaches reassured the War Eagles in the locker room. "Keep your poise and conviction and we'll keep our dream alive."

In the third quarter, Marist lined up for a thirty-one-yard field goal attempt to add to the lead, an almost automatic feat for elite kicker Austin Hardin. But there was confusion in the huddle that resulted in a late, rushed snap. The defense swarmed in to block the effort. Marist, a team

built on discipline, had a communication problem resulting in a botched kick. But even worse, doubt entered the psyche of the team. The offense suddenly became inept.

Chattahoochee scored a touchdown at the end of the third quarter and trailed 28–21.

Again, Marist couldn't answer on offense.

With less than four minutes remaining in the game, all-state Chattahoochee quarterback Tim Byerly sprinted four yards from the shotgun on a quarterback draw to tie the game at 28 apiece.

The Marist offense once again became stymied and was forced to surrender the football.

With forty-five seconds left, on fourth down, Chattahoochee kicker Ammon Lakip measured a fifty-one-yard field goal attempt. At the snap, he moved forward and drove his right foot into the ball. When he glanced up, he saw his attempt sail between the crossbars.

Marist had lost in the twelfth game for the second straight year. The dream was smashed.

Afterward, one of the coaches put it this way to the team: "This is like losing a child. It is part of your soul, and now only its memory exists."

Chapter 12
Hope Springs Eternal

T he agony suffered the previous two years with early exits in the state playoffs had been cast away. It was August 1, 2011, the first full day of summer camp, and Alan Chadwick optimistically assessed his team's future:

> *Our defense should be able to do the job. But our quarterback, Myles Willis, has zero experience at the varsity level. The learning curve is slow grasping how to execute our triple option. But he's a hard worker, and hopefully we can coach him up sooner rather than later.*
>
> *Our kicker, Austin Hardin, is one of the best in the nation. He has committed to the University of Florida. We have two very talented juniors we are counting on, linebacker Greg Taboada, 6-4, 230, and halfback Gray King, who is a real playmaker. But most importantly, I like our chemistry. We have strong senior leadership, guys who lead by example like Jordan Barrs, William Curran, Matt Orr, Nick Brigham and Danny Coughlin.*

Jordan Barrs described how he prepared all summer getting ready for his senior season:

> *On Monday, Wednesday and Friday mornings I went to the Factory with several teammates and pushed weights hard there. It's a hard-core training facility where a lot of NFL and college players train. After*

having been put through a workout there, I had to rest in the lobby before I could drive home. That place is responsible for me being prepared to play at the highest level I can this year. I lost all my fat and added twenty pounds of muscle.

The lineman laced up his football shoes and continued:

After the Factory, I ate at home, then ran a few miles in my neighborhood because I need to be in such good shape in order to consistently play ninety or more plays each game this year. I don't want to sit out a single play. Then every afternoon I went to Marist for the voluntary workouts. We built a lot of close relationships and team chemistry in the weight room struggling together. The coaches pushed us to our stopping point just to show us the potential we have inside us. Then we went out to the field and ran the sprints. I tried to run the same times required of the backs.

He pulled his blue helmet down over his head and softly said, "People ask me why I worked out three times a day. I tell them I don't want to look back on the season and say, *Well damn, I wish I had run that extra mile or finished that last set of bench presses.*"

The afternoon practice, held in the broiling Georgia summer heat, sucked the oxygen out of the players. Yet the coaching staff ignored the heat, refusing to seek a sliver of shade, take a knee or sit on the sideline bench when water breaks were ordered for the players.

What heat? the coaches' body language implied.

A few weeks later, the *Atlanta Journal-Constitution* Georgia High School Top 10 rankings were published. For the first time in anyone's memory, Marist was not included in the list.

The head coach addressed the omission from the rankings: "We will certainly use it as a motivational tool for our youngsters. But at the same time, it's a slap in the face."

Chadwick told his team just before they hosted Douglass High in the opening game, "Nobody respects us. We're not ranked for the first time I can remember. They think we are like dog crap in the bottom of the kennel. Let's show 'em, starting right now."

The End and the Beginning

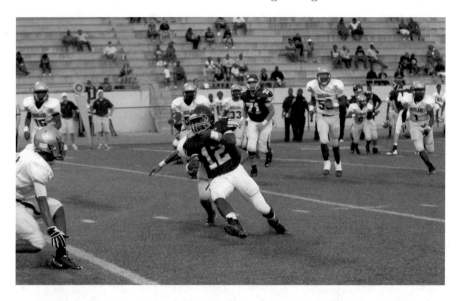

Marist junior quarterback Myles Willis sails for twenty-six yards in the 2011 season-opening victory over Douglass, 44–6, as tackle Danny Coughlin provides a key block, August 26, 2011. *Toni James.*

Marist manhandled Douglass 44–6. Quarterback Myles Willis romped for three touchdowns early. Fullback Jason Morris added a forty-three-yard touchdown run, and the War Eagles posted 37 points in the first half. Alan Chadwick mercifully substituted deeply into his roster in the second half against an outclassed, bewildered foe whose attempts to solve the triple-option puzzle resembled cavemen trying to decipher the concept of quantum physics. Jef Euart's defense stonewalled the opponent into *minus* thirty-seven yards rushing.

Offensive line coach Dan Perez, with a 28–6 lead, knelt in front of his linemen with a chalkboard supported on his knees, adjusting to the Douglass defense with on-the-fly blocking assignments. He was doing what he loved, coaching, teaching and leading. No matter the score, he always worked fervently with his players.

It was satisfying, but the victory proved nothing, as the head coach reminded his charges after the game: "I don't know what we've got here with this team. But we'll find out next Friday night. Get ready to work harder this week than you ever have."

In seven days, Number 1–ranked Tucker would be waiting in their home stadium.

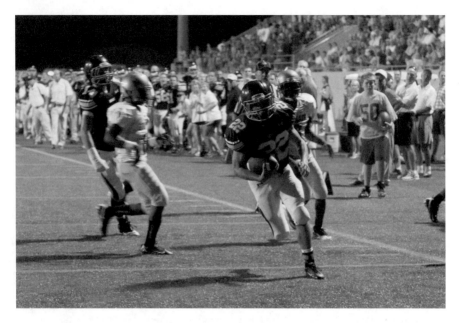

Halfback Gray King (22) takes a pitch and outraces Douglass defenders for an eighteen-yard Marist touchdown run, August 26, 2011. *Toni James.*

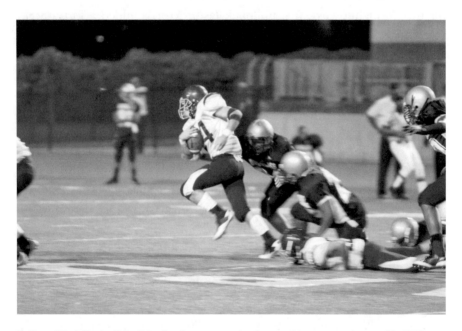

Split end Jack Burke (14) glides for fourteen yards after catching a pass, August 26, 2011. *Marist High School Photo Corps.*

The End and the Beginning

On Sunday afternoon, the offensive coaching staff stared at the big screen in the front of the conference room, watching the film of the previous year's game versus Tucker. The coaches concentrated on Tucker's defensive reactions after the ball was snapped, searching for any vulnerability to exploit. Chadwick was especially interested in one play when the Marist offense ran the triple option to the left side. When the play ended for no gain, he reversed the film and watched it again, *seven* times, pointing with his wireless remote control laser beam at reactions from different Tucker players.

And then, *eureka!*

Chadwick and offensive coordinator Etheridge found the flaw. The weak side cornerback cheated toward the inside instantly, leaving the right flat wide open for a quick pass. The pass play, "878 Halfback Hide," would go into the game plan and be practiced the next day.

Coach Euart described some of what his defense would be facing: "Gosh, their backs run really hard. Hit 'em square and they still spin. They're quick and very strong, and they keep their legs driving. You've got to take them to the ground or they will kill you."

Chadwick responded, "Well, we must finish our tackles. This week, we will stress being physical, more than ever. Tucker is always loaded with great athletes." In fact, a few months later, fifteen Tucker players would sign letters of intent to play football in college.

Chadwick concluded the meeting by saying, "We must give our team the confidence to believe they can beat Tucker Friday night. This year they have a team heavy with seniors, while we are young. We've got to make our guys believe. To win, we must be hungrier than Tucker."

Everyone knew the importance of the game. The winner would have a much easier path through the ordeal of the playoffs. The coaches knew the players understood the magnitude of the game. The week's practices would be demanding, physical and tough, executed at a fast pace.

But first, a transgression needed attention. Twenty players' names were etched on the blackboard in the coaching office. The culprits had reported late for the pregame Mass at the Marist Chapel, disrespecting the priest, the coaches and their teammates. They had been chucking a football around the parking lot and had let the time slip away from them. Coach Euart would administer the punishment after Tuesday's practice

by running the culprits up and down the stadium steps until their tongues hung out.

That Friday night, the game was a war, slugged out on the field of battle by two infantry machines.

Tucker halfback Jordan Landry rocketed the final thirty-five yards on an opening eighty-yard drive to give Tucker an early 8–0 lead. Marist answered with a field goal, but midway in the second quarter, Landry bolted for a seventy-seven-yard scoring dash. Marist was down 15–3 but put together a drive of its own, marching sixty-five yards in seven plays. Halfback Gray King capped the drive with a fifteen-yard touchdown run just before halftime, narrowing the Tucker lead to 15–11.

In the fourth quarter, the Marist defense tried desperately to stop a long Tucker drive. The offense just needed the ball for one final series and victory could belong to Marist.

But for the final nine minutes and twenty-one seconds, Tucker hogged the ball, driving for seventy-five yards in bits and chunks while allowing the clock to wind down to the final allowable second before snapping the ball. The drive didn't result in a score, but it ripped the soul out of Marist. The final score was the same as at halftime, 15–11.

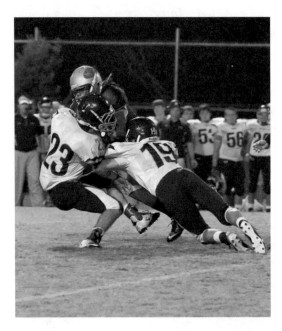

Marist defensive backs William Curran (23) and Nick Carrier (19) corral a rival Tucker wide receiver, September 2, 2011. *Marist High School Photo Corps.*

The End and the Beginning

The Marist coaches found optimism during a quick conference just after the game ended.

"Tucker is a senior-heavy team. They're already as good as they'll get."

"We're young. Our depth chart is loaded with sophomore and juniors. We will definitely improve."

"Our young quarterback will get better and better as he learns our system."

"We just gotta coach 'em up like we always do. Then we can meet Tucker in the Dome for State again."

After the players showered, they dolefully entered the gym and took seats in the first rows of stands. Coach Etheridge walked up in front of the team and raised his voice: "Get those heads up! I don't want to see any of you with your heads in your hands feeling sorry for yourself."

He held his thumb and forefinger aloft: "We were this close to beating the Number 1–ranked team in the state. We still have the whole season in front of us to realize our dream."

Alan Chadwick simply said, "I want to congratulate you for playing hard. We will work to become as good as we can be."

He knew the season had just begun, and he was ready to face the challenges ahead. The goal would be to run the table for the next eight games, all against region opponents.

The following Thursday, Coach Euart licked his chops, anticipating the challenge the Chamblee Bulldogs would present the next evening. "They are exactly what we need right now—a powerful I-formation running team that will run the tailback 'iso' and 'wham' plays."

He addressed the team after the light practice: "So, it's got to be a footrace between you linebackers and their backs to the line of scrimmage. Whoever gets there first, and lowest, will win the battle. You've got to want it more. This is the first game of the rest of our season."

Just before halftime, Marist drove deep into Chamblee territory but failed to punch the ball in for a touchdown. Marist led 14–3, but Alan Chadwick was upset: "We almost slammed the door on them. Now it's wide open and they think they can win it. They'll be fired up now. We've got to go out there and close the damned door shut."

Early in the third quarter, Marist recovered a fumble deep in Chamblee's territory but bobbled the ball right back. The head coach

glared at his backs after the offense trotted to the sideline. None of the players met his gaze.

Three plays later, as Chamblee prepared to punt, Chadwick addressed his offense on the sideline: "If we don't move down the field and score a touchdown right now, we will lose this game. Now go play football like you mean it."

The dressing-down got some attention. In the next six minutes, Marist scored twenty-one points. Suddenly, the triple-option offense erupted to life, guided by vastly improving quarterback Myles Willis.

Marist took a 38–3 lead into the fourth quarter and coasted to the win. The Marist defense, led by linebacker Preston Furry, defensive end Barrs and defensive back Brandon Young, held Chamblee to a scant 113 yards of offense.

Southwest DeKalb would be next up in a must-win situation for both teams. The game would decide the Region 6 AAAA Number 2 seed for the playoffs, which would carry the luxury of at least one playoff game at home. Once again, the game between the rivals would be TV Game of the Week on Georgia Public Broadcasting.

Jon Nelson, chief GPB sportscaster, arrived at the Marist campus for Wednesday's practice to do some homework: "I know that Alan Chadwick will field a well-coached, disciplined, hard-nosed football team. They don't beat themselves. And I know Southwest DeKalb will come in here raring to go with a bunch of big, fast athletes. It should be quite a show."

He was half right.

SWD committed hari-kari in the first half. A forty-yard pass completion was called back when an offensive lineman inexplicably was discovered twenty yards downfield. Two plays later, the SWD punter, on a fourth and twenty-eight-yard situation, chose to tuck the ball and go for it. He was chased down in the shadows of his end zone like a lost lamb by wolves. Marist swiftly scored when Willis tossed a six-yard touchdown pass to King and took a gift-wrapped 10–6 fragile lead into the halftime locker room.

In the players' locker room, Etheridge called his offense around him and drew new schemes on the chalkboard. He glanced down to see team leader Jordan Barrs on the floor looking up at him. The offensive guard had blocked the wrong way on a 43 Triple play, thinking it was 42

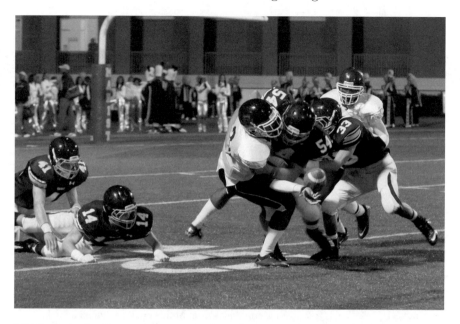

Middle linebacker Preston Furry (54) creates a Southwest DeKalb fumble as Michael Toner (33) helps and Patrick Anhut (41) and Jack Burke (14) observe, September 16, 2011. *Toni James.*

Triple. The play had been blown up by the SWD nose guard. Etheridge playfully tapped the player on the side off his helmet. "Damnit, Barrs, block the right guy!"

Barrs took the criticism stoically and nodded his head up and down, affirmatively. In the second half, Barrs and beefy lineman Nick Brigham made key blocks that sprung Willis loose on a fifty-four-yard majestic touchdown journey, outrunning several speedy SWD defenders. With speed-merchant Gray King at halfback behind Willis in 2011, for a change, the War Eagles were on equal footing with the competition in the speed department.

Late in the game, Alan Chadwick met the junior quarterback on the sideline and congratulated him: "That's what we're looking for, Myles. That's the way to read the defense, adjust and make the play. You're learning!"

While addressing the team after the pivotal 23–6 win, the head coach said:

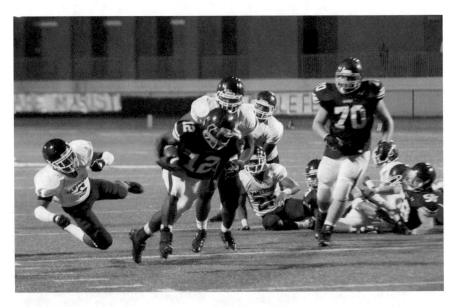

Quarterback Myles Willis (12), assisted by a block from Marist offensive lineman Nick Brigham (70), rips through the Southwest DeKalb defense for a twenty-yard touchdown run as Marist coasts 23–6 against a region rival, September 16, 2011. *Toni James.*

Congratulations! You did a fine job. You flew around. You made more plays. We had a great week of practice, and you made it pay off. But we have to get better. Let's use the next three weeks to do the work that can make our dreams come true.

Our schedule the next three weeks includes a bye week and two opponents that are not in our class. This gives us the chance to work hard and get a lot better. Let's get the work done on the practice field and get ready to make a long run in the playoffs.

But the Georgia High School Football Association (GHSA) threw a monkey wrench into the plan. The game against Carver High School, scheduled for the next Friday night, was peremptorily moved to the following Monday night. Music Midtown was coming Friday and Saturday nights—a get-down music extravaganza featuring a dozen top bands, including Coldplay. The music festival would feature nonstop music on several stages in Piedmont Park, nestled in the heart of midtown Atlanta, drawing tens of thousands of revelers and partygoers. All surface streets surrounding the vast park would be closed. And Grady Stadium,

the venue for the next game, was adjacent to the south portion of the park. The GHSA extended the game's kickoff by three days.

On Monday afternoon, the Marist team buses snaked south to the middle of the city for a football game. The stands were empty. The opponent had impressed no one the first month of the season. Alan Chadwick didn't like the setting. Despite the best efforts of the coaching staff, the team came out flat. Despite an offense plagued by missed opportunities, mental errors, fundamental mistakes and penalties, Marist limped off the field clutching a hollow 21–6 win.

Alan Chadwick stared silently at his team assembled in the gym after the game. Then he began: "I thought we turned the corner last week against Southwest DeKalb. I was wrong. You just lost the right to enjoy your bye week. I suggest *none* of you be late for practice tomorrow."

The bye week was not spent idly. Coaches conducted physically challenging drills to improve fundamentals. Defensive line coach Matt Romano devised a devilish contest to improve the pass rush, which had been tepid the first half of the season. Two defensive linemen lined up opposite two offensive linemen in four-point stances seven yards in front of a five-foot-tall blue leather dummy, which represented a quarterback in the pocket. The object of the drill was for the defensive linemen to fight through the blockers and whack the dummy in five seconds—three times in a row! If a defensive lineman was successful, he was awarded the luxury of going to the end of the line to rest.

Throughout the drill, conducted at great tempo, one could hear the intense voice of the coach counting the seconds, "One thousand one, one thousand two, one thousand three…" The greatest possible gift was extended if the player could just get to that quarterback in five seconds. Linemen Bob Dukes, Jordan Barrs and Steve Wallace recorded the most sacks.

Finally, the coach blew his whistle, smiled and rewarded his players with a break.

After the bye week, Marist faced Lakeside High School, and Alan Chadwick addressed his squad just before kickoff:

Football is not about Xs and Os. It's about Butch, Jimmy and Joe. It's about you, Gray. It's about you, Jordan. It's about you, Nick. It's about each of you.

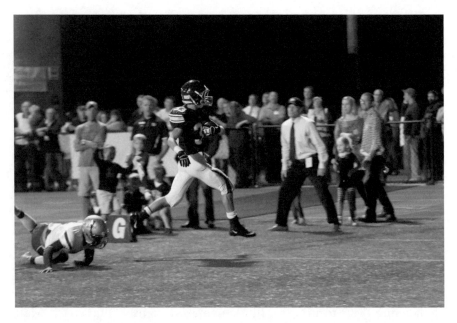

Halfback Michael Toner (33) skips by the Lakeside safety for a touchdown in the 53–0 Marist runaway. Marist director of athletics Tommy Marshall (in tie) watches, October 7, 2011. *Toni James.*

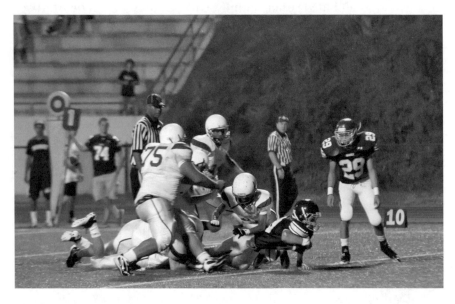

A Marist running back blasts for extra yardage near the goal line in Hughes Spalding Stadium as Devin Kalil (29) assists, 2011. *Toni James.*

The End and the Beginning

It's not about scheme. It's about you being mature enough to listen to your coaches and perform to the best of your ability. Our great teams in the past picked it up this time of the year after a lull. Do you seniors hear that?

Marist took the field and demolished Lakeside, 53–0, while limiting the inferior team to a scant seventy-three yards of total offense. It proved nothing to the coaching staff.

After the game, Alan Chadwick reminded his team that the following week would be different. They had some "unfinished business to take care of next Friday night." Neighborhood rival Dunwoody High was coming to play Marist. The region opponent had soundly and surprisingly beaten Marist the year before.

Coach Dan Perez drew a chart with a red magic marker on the chalkboard. It rose from ground zero and peaked at the Southwest DeKalb victory, then fell off after the dismal Carver game. Would it head back up, symbolizing the improvement of the team, or would it just languish sideways? "Every championship team here has gone through this cycle. And at this point of the year, they really improved."

He extended the line straight up the chart. "Can this team climb this peak? Every year, this staff starts with one goal—a state championship. Can each of you commit to do whatever it takes to win the championship?"

Alan Chadwick wanted revenge for the previous year's Dunwoody loss. To add insult, the opposing coach had been reared by Chadwick himself. Jim Shofety was an assistant coach under Chadwick's tutelage for six years before bolting for greener pastures. He was no longer a member of the tribe. In fact, he was now the enemy. The head coach wanted the win, and he wanted it badly.

At practice, Chadwick was more agitated than usual. During a scrimmage, he instructed the assistant coach directing the defense to line up in a 60, not the 4-3 defense he had placed the defense in. It was one of the defenses Chadwick expected Shofety to employ to stop the Marist running game. The assistant turned away, muttering, as if in disagreement.

The head coach wanted things done his way. He yelled across the line at his assistant, "I don't want any damned lip, you hear me? Put 'em in a 60."

Not only did the assistant coach hear him, but every coach and player involved in the scrimmage did also. Chadwick now had everyone's full attention.

A few minutes later, as quarterback Willis huddled up his offense, Chadwick interrupted. He looked at the shoes of his starting fullback and shook his head. Both shoelaces were untied. "Get out of my huddle! You can't practice like that," the head coach shouted.

It took just a few seconds for the player to address the problem. The next play, the fullback laid a wicked block on the middle linebacker. The head coach smiled at him.

A few minutes later, a halfback failed to execute a block. Chadwick cajoled him, "I'm fifty-nine years old, and I'm meaner than you are!"

Coach Stephens sent the following message to the team on his scouting report:

Marist vs. Dunwoody October 14, 2011

The Warrior!
"Out of every one hundred men, ten shouldn't even be there, eighty are just targets, nine are the real fighters, and we are lucky to have them, for they make the battle. Ah, but the one, one is a warrior, and he will bring the others back." Heraclitus
Which one of these men are you? Only you know which one you are! Who will be our WARRIOR Friday night? I can't wait to find out! For he will lead us to victory!
Good Hunting!
Coach Danny Stephens

Jef Euart advised his defense, "You've seen their offense since the first time you put on that blue helmet in the seventh grade. They run *our* offense, the triple option. Their quarterback is a great athlete. I want him on the ground after every play. Let's attack each and every one of them on each play. So they are beleaguered by halftime."

In his pregame speech, Chadwick reminded the team, "There is a reason we don't have any single-digit numbers on our jerseys. Numbers one through nine do not exist." Left unsaid was another maxim: there is no "I" in "team."

Marist head coach Alan Chadwick (hands behind back) appraises the situation in a home game versus Dunwoody with assistant coaches Matt Miller and Jef Euart, October 14, 2011. *Marist High School Photo Corps.*

Marist received the opening kickoff and cranked up its wishbone offense for a seventy-yard scoring march, capped when halfback William Curran swept the left end for the touchdown.

In the second quarter, the Marist defense forced a Dunwoody fumble. Five plays later, Gray King powered for an eight-yard touchdown run on the belly play.

Euart's defense stymied Dunwoody's offense, allowing only two first-half first downs. Marist took a 17–0 halftime lead.

Euart advised the team just before the second-half kickoff, "We've got them where we want them. All we have to do is finish them off by stepping on their jugular and squeezing the life out of them."

In the third quarter, Etheridge sent in the play he had diagrammed in the classroom just before the kickoff: L Power 323 Roll Counter Boot. It worked, just like it was drawn up. Willis hooked up with split-end Trae Lewis for a twenty-three-yard gain. Then Curran carried on the belly play again and ripped off the final ten yards to paydirt. A few minutes later, fullback Jason Morris ran the veer play off his right

guard for a nineteen-yard touchdown run. Marist coasted to a 38–6 significant win.

The coaching staff was confident the team had matured and improved since the Tucker loss. Three games remained in the regular season, all against region teams that would be underdogs to Marist. But two tasks were paramount. The team needed to continue to improve. And there could be no hiccups against the remaining foes. It would be up to the coaching staff to ensure that both issues were dealt with.

The game the next Friday night against Lithonia High began with an exclamation point. Marist was called for a hold on the opening kickoff and started on its own one-yard line. Quarterback Willis whispered the first play of the game, "L Alpha 876 Trail."

At the snap halfback, Gray King drifted out toward the right sideline and then bolted upfield. Willis lobbed the ball to him. King ran under the ball, tucked it in, made a cut past the cornerback and outraced the other defensive backs to the goal line. The ninety-nine-yard touchdown was the longest pass play in the school's history.

After a Lithonia punt, Willis placed three receivers out to his left. He kept the ball on a midline play and bolted sixty-four yards for another score. The floodgates opened. Marist carted a 42–0 lead into halftime.

Sophomore phenom Kendall Baker, all six feet, six inches, 255 pounds of him, sparkled the first half on defense, making tackles and recovering a fumble. Huge for his age, a young black kid at a mostly white school, Kendall's ready smile and refreshing personality instantly made him a favorite in his class. Coach Chadwick knew he had found something special and helped cultivate the young athlete, not rushing him into varsity action.

Rarely do sophomores become starters at Marist, but in Baker's case, it was a no-brainer. He had grown into his huge body. His improved footwork allowed him to make fear spring from the widened eyes of quarterbacks when he bull-rushed them from the edge. He also was a second-team offensive tackle. His head coach opined that would be the likely position he will call home when he inevitably chooses one of the many colleges that are beginning to take notice.

In fact, on his very first day at summer camp as a freshman, a few of the assistant coaches stared at him and whispered, *"Blind Side!"*—referencing Michael Oher, the true-life hero of the movie by the same name.

The End and the Beginning

Four minutes into the third quarter, with Marist holding a 42–0 lead, Lithonia turned over the football. The sideline offensive coaches yelled, "Second-team offense, you're in!"

Kendall trotted out to man his position. The rest of the starters were through for the evening, enjoying the warm feeling of victory on the sidelines. The coaches wanted backup quarterback Nick Carrier to get some real-game repetitions. They also wanted him surrounded by the rest of the second-team offense so they could gel as a unit.

On the first play from scrimmage, Kendall sprung low to block the huge defensive end playing opposite his left shoulder. The defensive nose guard penetrated into the backfield and was blocked by another Marist lineman. The force of that collision twirled the defensive player into the outside of Baker's planted right leg. Something had to give.

He didn't get up. He remained prone on his twenty-six-yard line, writhing in pain. Team doctors and coaches rushed to his aid. Players looked at one another and shook their heads.

Coach Danny Stephens, a hardened SWAT team Atlanta Police Department commander in the past, had taken on Kendall as a project. Danny was very proud of his young, budding superstar, how he had listened to instructions and asked for more, how he had taken on a leadership role as a mere sophomore. Stephens stared at the throng surrounding his fallen player from the sidelines. He glanced up at the clock and just shook his head.

Then he turned away from the scene and closed his eyes. When he opened them, they were pained and moist. He shook his head and muttered, "Damn! 42–0. Why this?"

In just a few minutes, the verdict was announced. Team orthopedist Dr. Marvin Royster shook his head and softly said, "Torn ACL." A torn anterior cruciate ligament of the knee. A death sentence for the season.

Coach Chadwick gave Kendall's mother a hug when she brought her SUV to a halt behind the bench. The young giant was carefully carried and placed into the rear of the vehicle.

Play resumed. Players shuffled their feet and looked joyless and unnerved. Mercifully, the game soon came to a close. There was no joy on the bus ride back to Marist despite the blowout.

The head coach addressed his team in the gymnasium before releasing them for the next day and a half: "It was a great win." He paused and said, "Look, I know how you all feel about Kendall. But injuries are part of the game. We have a goal, and we will not be diverted from that goal. We are playing very good football, and we will do what it takes together to realize our dream."

The next morning, the Marist eighth-grade team was playing against the school's most bitter longtime rival, Saint Pius X, and Chadwick stood just off the field on the track keenly observing the game. There is bad blood between the two Catholic schools. Often they vie for the same candidates.

In the most recent games that were held between the two schools, several key Saint Pius players who had been denied admission to Marist were big factors. It didn't seem fair to the Marist coaches. And just a few weeks earlier, the teams' junior varsities met. Saint Pius pulled down several seniors from the varsity to play in the JV game. It didn't sit well with the Marist coaching staff.

At one point, the eighth-grade Marist quarterback failed to pitch the ball to his trailing halfback, who had a clear path to the end zone. Chadwick shrieked at the Marist offensive coordinator a few yards away. The coach turned to Chadwick and asked, "Do you want to come take over in this coaching box?"

Chadwick looked hard at the volunteer coach and then smiled and gave a thumbs-up. He liked the answer.

The following Sunday afternoon at the staff meeting, the head coach immediately addressed Kendall's injury and the feeling that somehow it had been unnecessary. "What could we have done differently?" Chadwick asked his assistants.

Paul Etheridge responded for the benefit of all the assistants: "We had to get our backup quarterback, Nick Carrier, some reps—he's got to get better if, God forbid, Myles goes down. All we wanted to do was let him run one series with some good people to support him, people who he could be effective with, not just some scout team members. It was a freak accident. Everyone is frustrated."

The head coach responded, "Look, we are so thin we have to prepare for the future during our games. But injuries are just a part of the game. So blame it on me."

Dan Perez added, "They really love Kendall. Almost every tenth grader in the school has his number on their cellphone. And our quarterback, Myles, just lost his best friend."

Coach Etheridge suggested the season should be devoted to Kendall Baker to get everybody on the same page.

The head coach changed the subject. "I like where we are right now. Our offense is getting dangerous, and our defense is playing lights out. We can be on to something really good. I can't wait to get into the playoffs and play teams that have not faced our offense."

Then the staff headed to the film room to confer with the players about the next opponent, Mays High School. The winner of the ninth regular season game would be rewarded with home field advantage for the first playoff game

On Friday evening, the Mays High Raiders, dressed in white uniforms with baby blue trim, filed out of several yellow City of Atlanta buses, trotted through the west goalposts and began pregame preparations. A bevy of skill-position players pranced leisurely through warm-ups on coil-springed legs, lithe, with quick, darting moves. The linemen were muscular and toned and moved like quick-footed heavyweight boxers. The team from the south side of Atlanta was sleek and full of swagger.

In the locker room, just before kickoff, Coach Danny Stephens dared the team to be heroic. He recalled, "Just a few years ago, they beat us on the last play of the game. They didn't meet us to shake hands. They just raced to our large M logo at midfield and stomped up and down on it. I don't care that tonight is homecoming, with all the alumni and fans. I only care about the people that are in this room, right here. This game means everything. If we lose it, the season is a disaster."

It ended up being much easier than anticipated. In a steady drizzle, Marist's ground game powered for 398 yards rushing, paving the way for a 24–0 win. Mays went to the air forty times, and most of its passes were broken up by ball-hawking Marist defensive backs, forcing a Mays shutout for the first time in nine years.

As the head coach mulled over his next opponent, he considered the game could be a trap. On the surface, Redan High didn't appear dangerous, sporting a lackluster 3-6 record. But the game would be

Members from a past Marist squad enjoy the reunion at homecoming. *Marist High School Photo Corps.*

played away, at Avondale Stadium, which would dictate a wearisome Friday afternoon bus ride.

As Chadwick scrutinized Redan's past game films, he realized that, but for a few mistakes here and there, the team's record could be 6-3. The team had loads of size and speed on both sides of the ball. Once again, Chadwick's team would be behind the eight ball in the talent category, the very challenge the head coach relished.

After pregame warm-ups, Coach Stephens explained to the team that they would be facing a desperate enemy: "Do you know who the most dangerous person in the world is? I'll tell you. It's the person that knows there is no tomorrow. That describes the team you're going to fight tonight. They can't make the playoffs, so this is it for them. They've got nothing to lose. They will come after you like a wounded animal and try to destroy you."

He halted as the Redan High band played the National Anthem. The players stood. When it ended, they took seats back on the grass, and the coach continued: "You better realize right now how dangerous they are. Get them on the ground on the first play and don't let up."

His words proved prophetic.

Marist jumped out to what should have been a comfortable lead. Halfback King sprinted for a sixty-five-yard touchdown run in the game's first minute. On the next possession, Willis bounded past the first Redan line of defense, reversed direction and then outran the Redan secondary for an electrifying fifty-eight-yard scoring romp. Marist led 33–7 after the first quarter. But Redan didn't fold tent.

Redan scored before the half, and Alan Chadwick was concerned about his defense.

The head coach has a halftime ritual—he chugs a Coca-Cola and nibbles a few peanuts furnished by his faithful timekeeper and team physician, Dr. William Hardcastle. The doctor has stood next to Chadwick for twenty-seven years on the sideline, keeping track of the clock between plays. But on this night, the head coach declined the peanuts. "No, thank you," he demurred. "I'm too nervous right now."

Dr. William Hardcastle tapes the sprained fingers of an injured War Eagle before a game, 1979. *Marist High School Photo Corps.*

Redan scored first in the third quarter and then successfully went for a 2-point conversion, whittling the Marist lead down to 43–29.

The Marist coaches became urgent and implored the players to do the same. Coach Jef Euart's defense forced a key fumble. The Marist wishbone took over and bled the fourth-quarter clock. The final score of 57–29 didn't reflect how tight the game really was. The team and coaches hopped on the bus, glad the game was in the books.

Chapter 13
Sudden Death (Part Two)
(Continued from Chapter 2)

I n one long file, the players left the locker room, leaping and touching the painted words above the doorway. "Play Like a Champion!"

And the Marist War Eagles raced out into the chill of the night to the battlefield to face the enemy...

November 11, 2011, 10:30 p.m.
Hughes Spalding Stadium

The Marist coaching staff followed the footsteps of the players in blue helmets who stampeded from the locker room, down the concrete walkway toward the field with cleats pounding a dramatic staccato and into a frenzied circle in the end zone of a packed stadium where the team massed for a communal prayer.

The coaches were confident the team had clear eyes and full hearts for the opening playoff game against Kell High School. They were convinced the maturity, speed and power of their offense would carry the day. The defense, with a swagger in its step, figured it knew what to expect from the Kell offense and how to stop it. Senior leadership and a talented and motivated junior class had joined together to create a unified, jelled team.

There was one question left unsaid. The team had faced little adversity on the field since facing Number 1–ranked Tucker two months prior. The region had been unusually weak. How would the team function against a poised, well-coached opponent?

Marist had won twenty-eight straight playoff games at home against myriad championship-quality football teams, dating back to 1994. An extra incentive, if needed, was that the victory would be the 300th win for the head coach. Only twelve other men in the history of Georgia held that distinction.

And, of course, there were the Ghosts of Marist Football, who had protected this hallowed field for decades. All Marist had to do was go out and execute the game plan the coaches had created by blocking and tackling better than Kell.

No expert in the state of Georgia could have predicted the incredibly one-sided game that unfolded. The first two Marist offensive series consisted of ten plays. Two penalties, two pass incompletions, four total yards gained, one punt and two fumbles, one of which was lost. Marist coughed up the ball on its own twenty-two-yard line, and Kell struck for a quick touchdown when quarterback Clay Dodson hit six-foot, four-inch wide receiver Hunter Marshall with a six-yard toss for an early 9–0 lead.

The Marist offense stalled again. A missed block on a fullback dive resulted in a fumble that was somehow recovered by Marist. A penalty. Then two pass incompletions by harried quarterback Myles Willis, running for his life from blitzing Kell defenders. Three and out. Another Marist punt.

An energized Kell offense lined up on its thirty-nine-yard line after the punt to begin the second quarter. On third down, Dodson took the snap, wheeled and threw a quick pass behind the line of scrimmage to receiver Brendan Langley, who broke a tackle and streaked for a first down. Then Dodson came back with the same play. The Marist secondary wasn't going to let Langley get loose this time and raced up to corral him. But Langley took one step, planted his left foot and threw an arching pass to split end Devon Williams, who had broken clear behind the Marist secondary. The double-pass, an old trick play used in every sandlot league since the game was invented, clicked for a fifty-five-yard touchdown. Kell was taking it to Marist, 16–0.

The End and the Beginning

Once again, the Marist offense committed suicide. An errant pitch resulted in a six-yard loss. A missed block on an off-tackle play caused a three-yard loss. The Kell pitch man grabbed Willis on a keeper for another loss, this one for two yards. Another punt. Three and out, again.

To make matters worse, the Marist defense hadn't responded. After the Marist punt, Kell put together a fifty-six-yard touchdown march in fourteen plays that consumed over five minutes. When contact was made, the hard-charging Kell backs spun out of the grasps of Marist tacklers. The Marist secondary dove ineptly at ball carriers. Kell's game plan was to get wide quickly and outflank the Marist outside defenders.

It was a perfect storm. The Marist faithful looked at the scoreboard and blinked. Marist was behind, *at home*, 23–0, without having come close to one first down.

Willis answered after the Kell kickoff, keeping on the triple option, flashing past the outstretched arms of the Kell safeties and sprinting for a sixty-five-yard touchdown.

Marist went to the locker room at intermission down 23–7, having gained only one first down. The coaches scrambled to address the plight Marist was in, trying to reinvigorate the team's spirit. There was still time, the coaches assured the players. All they had to do was take the kickoff, drive flawlessly down the field for a touchdown and the momentum would swing their way.

But Marist's three drives in the third quarter resulted in two punts and an interception. The defense caused two Kell turnovers, but the clock kept running. Early in the fourth quarter, Marist took over at midfield after a Kell fumble. The team mixed in two incomplete passes with twelve running plays on a fourteen-play drive down to the Kell one-yard line. On fourth down, Willis was stopped in his tracks, inches from the goal line.

It had been a chilly evening, but now the plummeting temperature made the air frigid for the fans, swaddled in blue-and-gold blankets in the concrete stands.

A few minutes later, as Kell padded the lead to 30–7, Willis stood a few yards behind the Marist sideline and stared at the scoreboard, steam rising from his sweat-drenched shoulder pads and forehead. His eyes grew moist as the gnawing realization of defeat finally sunk in while the clock bled off its final minutes.

Ten yards to his right, junior fullback Jason Morris had the same abject look on his face, staring blankly at some unseen object. A tiny frown framed his face glistening with perspiration. Then he let out a deep breath and removed his scarred blue helmet.

The win for Kell had come shockingly easily. For Marist, the defeat was total and humiliating. Kell gained 341 yards of total offense against Marist's meager 178-yard output. Marist fumbled five times, losing possession twice. For once, the Marist ground game was so stalled it lost the time-of-possession category.

The failure to execute came as a complete shock to the Marist coaching staff. It was certainly one of the worst losses in Alan Chadwick's long career. And it was there on TV in living color for the whole state of Georgia to witness.

At midfield, when the lines of the two teams snaked past each other, coaches and players shook hands. Kell players exuberantly said, "Good game!" Marist players disconsolately whispered, "Good win." A Kell coach told his Marist counterpart, Jef Euart, "We knew we couldn't beat you in the weight room, so we attacked your flanks."

The Marist players headed to the locker room in tears. Senior Jordan Barrs knelt by himself in the end zone, his uniform soiled and sweat-soaked, on the verge of exhaustion. His chest heaved, wracked with spasms from sobbing. Coach Stevens rushed over to him, helped him to his feet and hugged him. He collapsed to the ground again, and his father raced to his side and pulled him to his feet once again. The father, who had experienced the same pain at the same age, embraced his son. They stayed locked together, unmoving for what seemed an eternity. Then the son hobbled to the locker room and collapsed on the floor just inside the entrance.

Alan Chadwick came quickly to comfort his team. He went from locker to locker, from player to player, hugging his boys and whispering words of encouragement into their ears. He came to Jordan, bent down and whispered to him.

"He told me he loved me," Barrs recollected. "That meant the world to me. I felt I'd let him and everyone else involved down. But he told me how proud of me he was.

"It was almost an out-of-body experience after the game. I was so exhausted. I played both ways and went over 105 plays. I was so shocked we'd lost. Then I went into the bathroom and looked in the mirror. I will

The End and the Beginning

never forget what I saw—me in that uniform and that blue helmet for the last time, ever."

Five days later, Alan Chadwick explained how the stinging loss transpired:

> *I'm more frustrated than disappointed. Our defense couldn't get the ball back from them. And our offense didn't take advantage of our early possessions. I thought we had called good plays, if we could have just executed them.*
>
> *They overplayed the outside pitch with their aggressive cornerbacks. Their defensive linemen just lunged and dove out into our linemen's laps. Normally, we are able to get lower. They didn't allow us to get our regular push off the ball to help tie up their linebackers. So their linebackers just flowed over to the edge.*

He looked out the office window at his football stadium and shook his head. "We were overmatched physically. That was my biggest disappointment. That's what we stressed the last six weeks of the season—that we had to win the physical matchups."

The head coach discussed what he whispered to each player just after the game in the locker room. Did he say the same thing to each one when he hugged them?

> *No, each player is different, and what each meant to the program was different. So I thanked each one for what he brought to the team, whether through his leadership, or through his effort and commitment, or through his love of the game, or the scout team player who just wanted to be with his buddies. So many of these seniors came so far from where they were in earlier grades. It does my heart good to see that happen—that a kid can actually come as far as he can, from both a physical standpoint and a standpoint of maturity.*

He leaned back and smiled warmly:

> *I remember thanking Jordan Barrs for being such a warrior. He was propped up against the locker room wall, exhausted and devastated. I*

hugged him and thanked him for always going so hard on every single play. He always prepared himself so well. I reminded him what a valuable part of the team he is in terms of his work ethic, his leadership and his warrior-like approach to playing every single snap of every single game. He is a real tribute to the type of student athlete we have here.

No words can describe how you feel for these kids about what they were going through. There was nothing I could say that would make them feel better right then. Hopefully they got something that helped them understand when all the coaches got up and talked to them.

I told them the more you invest, the more you have to lose. And it's obvious they invested a great deal, because they were hurting so bad.

The coach was back in the gym now with his boys, remembering the moment:

The thing I tried to get across to them was how proud I was of them and how much they accomplished this year. Nobody expected us to be as good as we were this year, and nobody expected them to do as well as they did.

So I'll get another chance, but these seniors won't. Hopefully they'll look back and realize it was a good experience for them and that all the hard work and effort was worth it.

He smiled again and said:

Marist football is special. I think by them just being involved in the process we do here helps shape our players for the future. The commitment of time and effort on a day-in day-out basis translates into what you get out of it. And the relationships you develop with your teammates, classmates and coaches are invaluable. In the long run, that will mean more to them down the road than losing one football game.

A calendar on his desk was open to the month of May. A string of days beginning with May 14 leading up to Memorial Day weekend had been highlighted in yellow magic marker ink. That will be when spring football practice is held. The head coach was already preparing for the next season.

About the Author

Franklin Cox was raised in Atlanta. He graduated from Marist High School and later from Saint Bernard College with a degree in English literature. His book *Lullabies for Lieutenants: Memoir of a Marine Forward Observer in Vietnam* was awarded the 2011 Silver Medal for Nonfiction Memoir by the Military Writers Society of America.